EDWARD BURRA

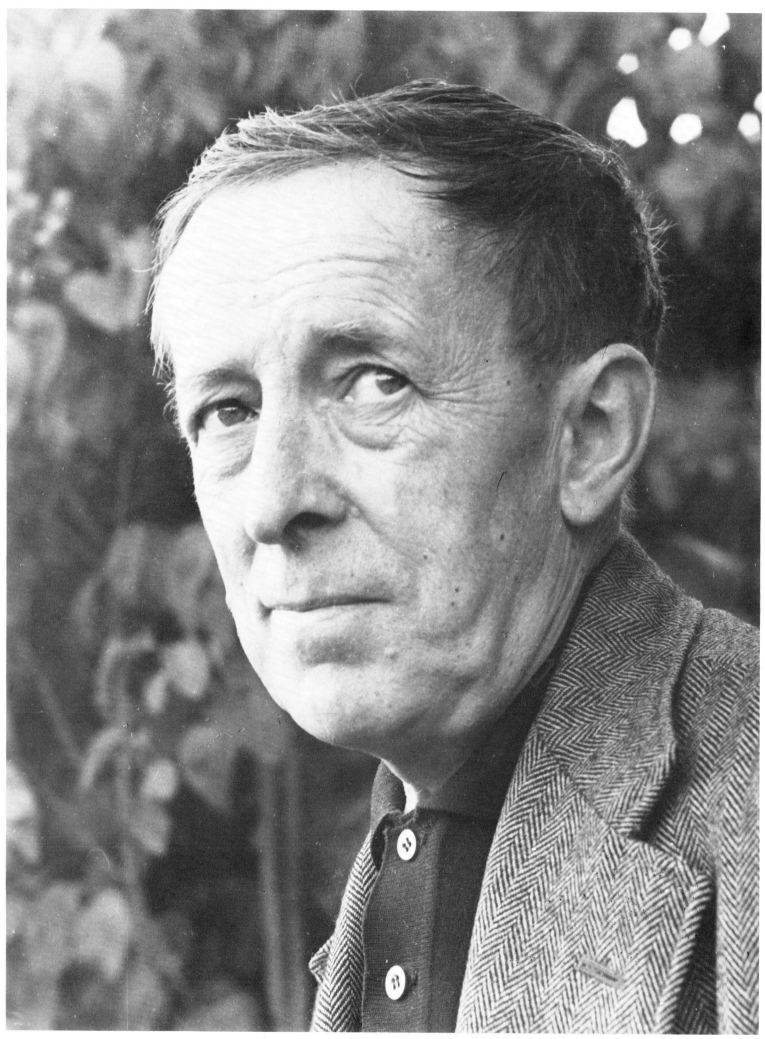

Frontispiece. Edward Burra, 1969. Photograph by Paddy Aiken.

EDWARD BURRA

COMPLETE CATALOGUE

ANDREW CAUSEY

PHAIDON · OXFORD

The Publishers would like to express their gratitude to the Lefevre Gallery for financial assistance, which has made possible the publication of this book.

Phaidon Press Limited, Littlegate House, St. Ebbe's Street, Oxford

First published 1985
© Phaidon Press Limited 1985

British Library Cataloguing in Publication Data

Burra, Edward
 Edward Burra
 1. Burra, Edward
 I. Title II. Causey, Andrew
 759.2 ND1942.B85

ISBN 0-7148-2323-6

Typeset and printed in Great Britain at The Bath Press, Avon

Contents

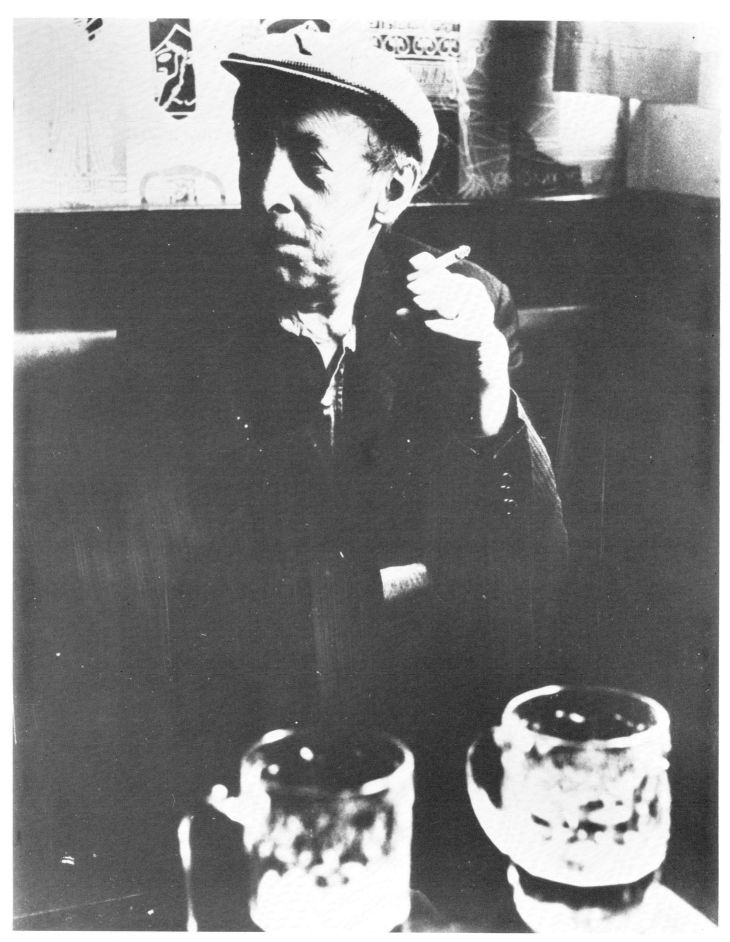

Burra in a pub. 1970/1.

Preface

This book would not have been possible without the help of Lady Ritchie, Edward Burra's sister, and his close friends William Chappell, Barbara Ker-Seymer and Clover de Pertinez. They have provided me with information on every aspect of Burra's life and work, allowed me to read letters, shown me his paintings, drawings and books, and shared the insights of friendships of fifty years and longer. William Chappell has been generous in allowing me to read Burra's letters and his own commentaries on them as he worked on the preparation of his book on Burra's correspondence.

For my knowledge of Burra's paintings I owe a special debt to Desmond Corcoran and the staff of the Lefevre Gallery, who have allowed me to search in their archives on many occasions. For information about Burra's long friendship with Conrad Aiken I am grateful to Mary Hoover Aiken, John Aiken and Jane Aiken Hodge. Clare Colvin and other members of the staff of the Tate Gallery Archive and Library have made it possible for me to study the Burra papers and substantial collection of his books at the Tate. I also wish to thank Richard Buckle, Ruth Clark, Sir Desmond Flower, Professor Joseph Killorin, Richard Morphet, Lucy Norton, Anthony Powell and Sir John Rothenstein. Andrew Stephenson of Edinburgh University has been generous in sharing with me the fruits of his research on Burra for a PhD.

I have had help in tracing pictures and obtaining photographs from Francis Farmar of Christie's, Peyton Skipwith of the Fine Art Society, Andrew Murray of the Mayor Gallery, Robin Vousden of Anthony d'Offay Ltd, James James-Crook of Phillips, John Synge of the Redfern Gallery, Janet Green of Sotheby's and Desmond Zwemmer of A. Zwemmer Ltd. I would like to thank the private collectors and art gallery curators who have provided information about and photographs of the Burra works in their collections, and especially the staffs of the Springfield Museum of Art and the Museum of Art of the Rhode Island School of Design for details of Burra's exhibitions held in their galleries. The administrative staffs of Chelsea School of Art and the Royal College of Art have helped with details of Burra's attendance at art school.

Excerpts from the Burra-Aiken letters are quoted by courtesy of Lady Ritchie, Mary Hoover Aiken and the Huntington Library, San Marino. My research has been generously supported by a grant from the British Academy.

Andrew Causey

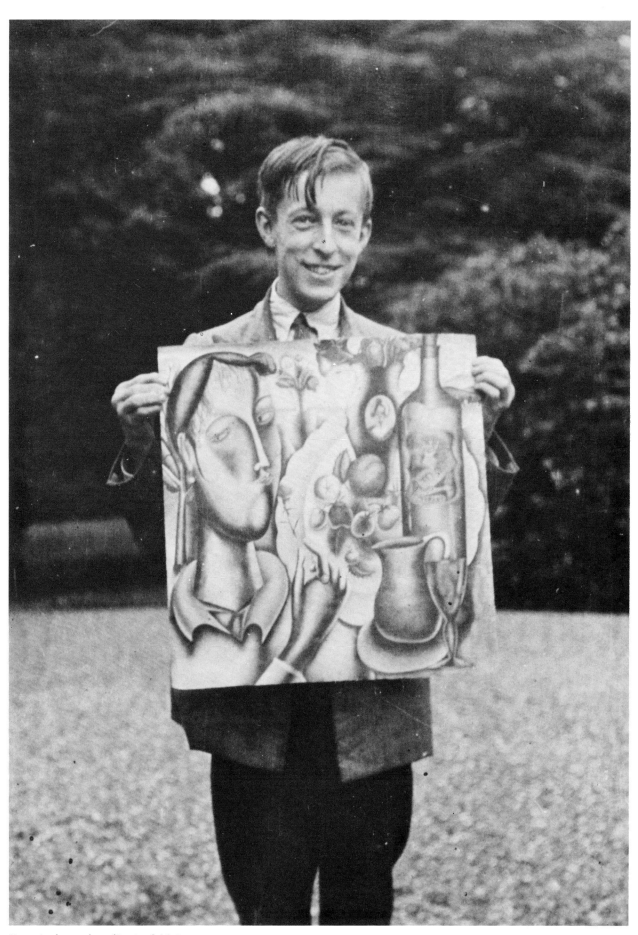

Burra in the garden of Springfield, Rye. *c.* 1929–30.

Chapter One

Burra's primary interest was human energy and style. From childhood he covered sheet after sheet with drawings of figures. At first they were mainly crowded street scenes, but gradually his whole cast began to appear. Some were society people, High Bohemians of the late twenties at parties or lazing on Riviera terraces; many more were drawn from the low life society of sailors, street traders, dancers and prostitutes in the Mediterranean ports of Marseilles, Toulon and Barcelona. They are at bullfights in Spain, music and dance halls in Paris and Harlem, and are habitués of cafés and bars everywhere. Burra liked life on the margins and wherever he saw natural vitality unawed by social conventions; at the top and bottom of his social hierarchy are the dandy and the tramp, both displaced types far from the centre of everyday acceptability. The world of entertainment with its uninhibited physical display, which fostered illusions and compensated for people's inner emptiness, had a special attraction for him.

Born in 1905, Burra emerged as an artist in the 1920s when youth was privileged because so much of it had been sacrificed in the war. An art – such as Burra's – of exteriors, which preferred to describe the surface of things rather than to penetrate or analyse them, suited an exhausted and uncertain society for which brilliant appearances were a distraction from depths they did not want to plumb. Burra's art in the twenties is not a simple statement of what he saw; his point of view is hard to determine because he was both a participant and a critic, he enjoyed the bohemian world and at the same time ridiculed it.

Around 1930 Burra's interests moved further to life on the edges of society, harsh notes become more common, evil and violence are closer to the surface, and in Spain from the mid-thirties, and later in England, soldiers and victims of war become his typical subjects. His soldiers are like vast, beaked, predatory birds or human dinosaurs with shiny metallic skins, who are often seen from the back so that their facelessness reduces their humanity. Sparring among themselves or idly lazing in the sun like carnivorous animals after a feast, they seem to have little of the dynamic of the modern combatant.

After 1942, when he finished with this theme, there followed several years of low output, which the exigencies of war do not quite account for, and not till Burra was in Ireland in 1947 does his momentum fully revive. The emphasis gradually changed to landscape. The force of nature is generally felt as being superior to the power of men, and buildings crumble and decay. Unlike his people, Burra's landscapes are British. Following the Romantics, he looked for remote, sparsely inhabited places: the Lake District, the Yorkshire Moors, the Cheviots, the Peak, the Welsh borders, Norfolk and Cornwall are Burra's country. People inhabit his landscapes, but it is

only when they are workers – East Anglian sugarbeet farmers or Cornish miners – that they have his sympathy. As motorists and motorway builders they are intruders invading and violating the countryside.

Burra's art is unpredictable. Mood changes suddenly from comedy to irony and satire; there is laughter and enjoyment, fear, anger and bitterness. While there is no precise programme to his work, and not too much consistency should be expected from it, it is obvious that Burra's experience is one of alienation, first from privileged society but increasingly from society as a whole, leaving him latterly with only the natural scene to carry the burden of his feelings. Around the end of the Second World War he wrote to William Chappell:

'Im beginning to care about nothing at all except enough to eat & laying down. Painting of course is a kind of drug. The very sight of peoples faces sickens me Ive got no pity it really is terrible sometimes Ime quite frightened at myself I think such awful things I get in such paroxysms of impotent venom.'

Burra's family were well-off professional people, who had lived since 1862 in a substantial early Victorian house, 'Springfield', at Playden outside Rye. His father, a London barrister whose family had come originally from Westmorland, gave up practice early and devoted himself to local affairs, being for many years chairman of East Sussex County Council. His mother, from a Sussex family, was of Scottish and Irish ancestry. A major influence on his early life was the family nanny, who came from Edinburgh and inspired him with her love of Scotland, particularly Edinburgh and Glasgow. One of her brothers was a carpenter who worked on the building of the *Titanic*, and Burra was raised on stories of catastrophes, especially those, like the Tay Bridge disaster, that related to Scotland.

Ill health was a serious family problem. Edward was the survivor of two sons, the elder of whom died as a baby. One of his sisters, Betsy, died of meningitis in 1929, and though the event does not seem to have marked Edward's life on the surface, the brief references in letters suggest unexpressed grief. He himself, arthritic from childhood and a sufferer from chronic anaemia, was withdrawn from his boarding preparatory school on this account, and, recognizing that Edward's health would not permit a conventional career, his parents encouraged his interest in drawing and organized tuition from a Miss Bradley in Rye. Burra is an example of the many artists and writers in whom, on account of early physical weakness, the imaginative life of childhood was carried relatively unbroken into adult life, and whose characters have been formed more than usually under the influence of their mothers.

Burra entered the art department of Chelsea Polytechnic in the autumn of 1921. He remained there till 1923, when he was old enough to study at the Royal College of Art where he spent the next two years. He thrived on drawing and in the summer of 1925 wrote to his fellow student William Chappell that he was thinking of returning to Chelsea for the next year: 'I should like to draw all day without stopping.' At Chelsea he had a daily life-class, made measured architectural drawings, did illustration about once a week, and drew outside the school – an early sketchbook contains studies of animals probably done in the Natural History Museum. Life drawings exist dated between May 1922 and March 1924, some of them academic studio exercises with firm outlines and detailed pencil shading, but in all of them particular attention is paid to the face. Caricature creeps in, and Burra's interest in different kinds of style – clothes, hair arrangements, make-up and posture – is already clear. By 1924 he had evolved a highly personal drawing technique

based on broad outlines formed of clustered pen hatchings reminiscent of engraving. In *The Artist's Grandmother with a Jigsaw* (Drawing 12), for instance, there is a mature sense of design in the simply stated divisions of space, such as the vertical lines coming down from the top, and an interest in curves and curlicues, which are first signs of a feeling for Beardsley.

Burra's earliest illustrative works, such as the designs for 'The Thief at Robin's Castle' from Walter de la Mare's *Peacock Pie* (1913) – about a thief who stole children, threw them into a sack and carried them off to a foreign country – date from 1922, and were Chelsea set subjects. In his sketchbook he drew the thief with his sack fleeing from a cataclysmic scene involving a monster with a hideous nose (Cat. 10), prophetic of the later 'birdmen' but unrelated to de la Mare, while in the finished picture (Cat. 11) one of the children swings its doll contentedly in the air and both seem happy in their new country. The clear design and colours in the latter are equivalent to the easily comprehensible rhythms and diction of Georgian poetry, and as yet Burra's sense of evil was confined to the privacy of his sketchbook. In style his earliest work bears a close, but perhaps deceptive, resemblance to that of Claud Lovat Fraser, who made small coloured designs as headings for rhyme-sheets and broadsides, in an attempt to bring poetry and visual art together in a revival of eighteenth-century vernacular taste. Burra's bright decorative colours, for which he tended to use ink rather than watercolour, are close to Fraser's, but in contrast to the ingenuousness of Fraser there is a knowingness about Burra's work, which suggests that what he was making were not pastiches of Fraser but parodies.

On the walls at Chelsea were hung reproductions of drawings by Augustus John, whose pre-war romany cult was part of the revival of rural themes in art after the Decadence and an early appearance of the back-to-nature movement that was strengthened by the war. Burra's sketch of hikers setting out with rucksacks and knobbly sticks (Cat. 12) ostensibly belongs to the same kind of expression as E.V. Lucas's literary anthology *The Open Road* (1899), the verses of the tramp poet, W. H. Davies, or, in the realm of actual experience, Dorelia and Gwen John's great walk across France in 1903. But the crowd at the bottom of Burra's design is drawn so as to leave in question whether it is cheering or jeering, and thus illustrates the problem that crops up all through Burra's work: recognizing what is parody or satire and what is to be taken at face value.

Burra's gipsies are rougher types than John's, who are partly the product of a middle-class affectation of romany living. The transfer of coarse-featured figures from an urban scene of pavement and street barrows (Cat. 4) to a rural context with birds, butterflies and flowers (Cat. 5) shows that what is acceptable in an urban setting offends in an idealized country scene. Burra felt a bond with gipsies and others who lived outside comfortable bourgeois life, and his painting of unidealized types signifies no lack of affection, but suggests rather that he is poking fun at the Lovat Fraser convention of the countryside.

Early pictures such as *Out for a Walk* (Cat. 5) led on to others like *Girl in a Windy Landscape* (Cat. 16) and *The Three Graces* (Cat. 19), with their roads, railways and rivers – in the background of *St Anne, St Agnes and St John Zachary* (Cat. 14) there is also an aeroplane: images of mobility implying freedom and independence and perhaps also reflecting the increased popularity of travel, especially motoring, as a popular pastime. As in much of Burra's work, these designs lack atmosphere, so that even the distance is sharply focused, and this suggests the stimulus of graphic sources such as posters and, in particular, the covers of *Vogue*, which Burra regularly looked

at. During the war years the fussy Edwardian covers had given way to clearer, more modern work by artists like Helen Dryden, who initiated about 1916 the kind of design Burra adopted in *Girl in a Windy Landscape:* a low viewpoint on a model prominently positioned in the scene. Georges Lepape, a favourite of Burra, developed this idiom and became the dominant influence in *Vogue* cover designs in the mid-twenties. Lepape often did the covers of special travel and motoring numbers, which probably stimulated Burra's interest in these areas, while Burra's spring flowers and autumn leaves are the easily recognizable emblems of the changing seasons, so important in a fashion magazine.

Chapter Two

Burra's first trips abroad were with his mother, who took him to Switzerland around 1920 and to Bordighera in the spring of 1925. But that autumn he started travelling with his friends. He went to Paris with William Chappell, under the watchful eye of Florence Rushbury, who had been a mature student with him at Chelsea, was married to a Royal College tutor Henry Rushbury, and was now working in a studio in Montparnasse. The following April Burra was with his family in Florence, where his sister Anne was at finishing school, and did the full round of galleries and churches. On the way home they visited Paris, and Edward stayed on when the others left. He was back there in January 1927, again with Chappell, and that September the two went south for the first time to Cassis, Marseilles and Toulon.

In the twenties foreign travel and breaking free from the constrictions of national frontiers became a universal symbol both of independence from local ties and responsibilities and of the decade's aspirations towards a new brotherhood between races. Genuine fraternal feeling mingled with a generalized Romantic escapism as the lure of the Americas, especially, began to replace the nineteenth-century's longing for the East. For the arts the versatile Blaise Cendrars, whose achievements in poetry, the novel and film Burra followed with interest, had typified this trans-nationalism at its most uninhibited since his pre-war *Pâques à New York* and *Prose du Transsibérien*. Foreign travel – in terms of people encountered rather than places in themselves – was at the core of Burra's art in the twenties and thirties. His reactions fit a pattern common to many in which the elation of the twenties, when freedom to explore seemed boundless and responsibilities minimal, was matched only by subsequent distress as the rise of fascism and the fratricide of the Spanish war smashed the dream.

Burra's response to his new independence was immediate; the new pictures are intense, vital and urban. *French Scene* (Cat. 21), *Fiesta* (Cat. 22) and *Market Day* (Cat. 23, Colour Plate 3) record his sense of freedom not just at being abroad but at being independent. Names of newspapers, aperitifs and liqueurs, film posters and tram destinations stress the foreign locations, though the mixture of languages in some pictures indicates that they are not true records of individual places, indeed the flowerseller in *French Scene* is a portrait of the family nanny. Like much of Burra's work these are composites, put together with the aid of magazine and other graphic material.

Burra read in French and was exploring French literature and poetry from Romanticism onwards. He was interested in the Unanimists, the poets of the crowd and urban life, especially Jules Romains, while he admired Cendrars for images and style drawn from the streets, the dance hall, the circus and the cinema. The common

theme among the writers Burra respected was truth to personal experience; they were not concerned with the complexities of Symbolism, the justification for their work was not primarily intellectual, and though their concern for the exact description of particular sensations was shared with the writers of the Decadence, theirs was a reaction against most aspects of the fin-de-siècle. Essentially they were optimists and rejected the preoccupation of the late nineteenth century with such forms of escape as myth, history and fantasy paradises. Their view of the city was sometimes affected by a kind of fraternal socialism (in which they were successors of Whitman), and in place of the defunct heroes of the previous centuries they put the small man, the member of the crowd. They tried to define the spirit that merged the city and its inhabitants in a single identity, intending not to diminish the individual but to relate him to an urban social context. Equally important for Burra, Unanimism was a dynamic movement, inspired by Bergsonian *élan vital*, by which it implicitly condemned the dreamy contemplativeness of the fin-de-siècle. Euphoria at people's vitality is reflected in Burra's work only when, as in the first urban scenes, he felt in complete sympathy with his subjects. Some of his American pictures, like *Savoy Ballroom* (Cat. 120), share this elation, which is in contrast to the languor and enervation of the figures in, for instance, *On the Shore* (Cat. 50).

Burra's trips to Paris followed in the wake of *l' esprit nouveau* and coincided with the high reputation of Léger whose work Burra admired and could have seen at his exhibition at the Galerie des Quatres Chemins in May 1926. Burra's new work relates particularly to Léger's slightly earlier city pictures of 1918–19, sharing a feeling for the rhythms that bring people and their city environment together. It has the same sharp overall focus, which denies the existence of atmosphere more radically than his early landscapes under the influence of graphic and poster techniques had done; it was something Burra saw as a positive negation of Impressionism's concern with weather effects. On the other hand, while Léger was a classical painter, his designs closely controlled, his forms aspiring to the typical, with architecture and inanimate objects more dominant than figures, Burra was more of an illustrator, with a Romantic's sense of the particular and an almost Pre-Raphaelite insistence on detail; he was obsessively involved with human activity, so that architecture seems to be relegated to the background, which is where his pictures compare most closely with Léger's. Burra's concept of modern life was a Romantic one, a Whitmanesque brotherhood of races and types; and his approach was sensuous rather than intellectual, evoking the whole feel of the city street, not just its visual aspect.

The themes to which Burra was turning, urban subjects, crowds and dancing, had been concerns of Vorticism at the beginning of the war, and though Burra's art, in common with that of most others in the mid-twenties, was not involved with abstraction, as Vorticism had been, there are parallels with the earlier movement in Burra's bright colours, sharply defined forms and absence of atmosphere. Further, it was former Vorticists, Wyndham Lewis and William Roberts, who opened up for post-war British painting the art of satire, which Burra was to develop. Burra must have seen Roberts's pictures, with the sheer physical ebullience that makes them unique in the art of the twenties, when they were exhibited at the Chenil Galleries in Chelsea in 1923, since the gallery was only a few hundred yards from the art school. His debt can be seen in the way the left-hand figure in his *French Scene* is taken, in reverse, from the right-hand one in Roberts's *The Char* (Fig. 1), which was bought in 1926 by Sir Joseph Duveen and presented to the Tate. Burra and Roberts shared

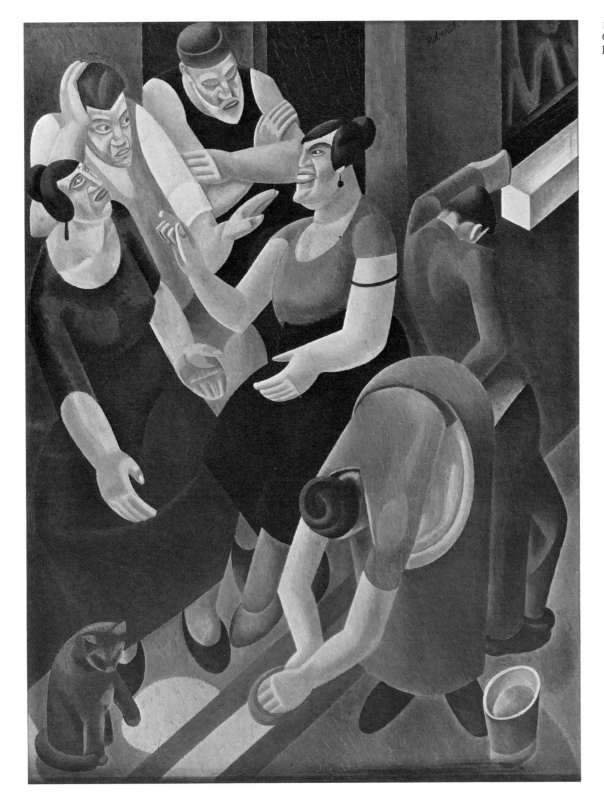

many interests in their art: bars, music hall, cinema and outdoor urban life, and Roberts's concern for working people attracted Burra. However, the appeal of Roberts's characters, such as the figure of the char, a bulky raconteur with a toothy grin, lies in the unabashed naturalism of gesture; though there are counterparts in Burra's painting – the unfinished right-hand figure in *Fiesta*, for instance – Burra's wit is generally more covert than this. The direct, explosive humour of Roberts's

figures makes him a modern counterpart of Rowlandson, whom Burra admired while himself remaining by nature more ironic and oblique.

Burra's forms are luxurious compared with the drier handling of Roberts; his shiny surfaces emphasize the outsides of things, and the proliferation of still life detail in a picture like *French Scene* recalls Mark Gertler, whose still lifes in the twenties were Victorian in the degree objects were particularized, but modern in the way every surface was alive and sensuous. In his great wartime painting *The Merry-Go-Round* Gertler had shown how the vitality and richness of Vorticism could be interpreted for a world that was losing the taste for abstraction, and in this respect Burra was his successor. What is more, Gertler's subjects, like John's, were the society portrait on the one hand and the gipsy and costerwoman on the other; like Burra he saw in John's concept of the bohemian an attraction to the top and bottom of the social scene but not the middle.

Burra's first burst of activity as a city painter was followed in the summer of 1927 by a series of landscapes (Cat. 27 and 29–32), the last he was to paint for ten years, in the mould of those being shown then at the London Group and Seven and Five Society, and rather sedate by comparison with his urban scenes. It was probably Paul Nash, sixteen years older than Burra and a tutor at the Royal College when Burra was there – although their paths may not have crossed then – who drew Burra back into landscape painting. Nash was now living at Iden just outside Rye, and their friendship, which lasted till Nash's death in 1946, certainly existed by the beginning of 1927. Nash's prestige was sufficient at this stage to attract Burra to his own concern, landscape, but when their artistic interests next coincided, as a result of their trip to Marseilles and Toulon together in 1930, it was Burra who was Nash's guide and inspiration. Implied in the choice Burra was making between landscapes and urban subject matter was the contrast between a Rousseauesque concept of the life-giving power of nature as a moral restorative after the catastrophe of the war – which was the pattern of Nash's thought – and the conviction – commoner in France than England, but increasingly of interest to Burra – that the invention and artifice of urban culture were necessary to conceal human imperfections. Burra's preference over the next few years for an urban painting closely reflecting the style and manners of the day was stimulated by his reading Baudelaire, who made the distinction between style – manifested in such things as fashion and make-up – through which the cultural identity of any age is distinguished, and nature, which 'teaches us nothing, or practically nothing', and the natural man, in whom 'you will find nothing but frightfulness'[1].

Chapter Three

Marseilles and Toulon, which Burra visited for the first time in 1927, became favourite haunts for the next five years. In each case it was the old maritime quarters that attracted him, the Rade in Toulon and the Vieux Port in Marseilles, where different nationalities, including French, Arabs and Negroes mixed, and life in cafés and bars was lively and informal. In September 1928 he was in Toulon with Chappell and a former Royal College student, Irene Hodgkins, who met the painter Tristram Hillier there and married him. On their way home through Paris, Chappell, who had trained as a dancer after Chelsea, joined Frederick Ashton in the Ida Rubinstein ballet company which was then being formed. Burra spent the rest of the autumn living in hotels in Montparnasse largely in the company of another Royal College friend Lucy Norton, painting in his room during the day and spending the evenings in cafés, cinemas and dance halls. He saw a lot of Sophie Fedorovich, a designer and painter who was then exhibiting with the Seven and Five Society but was later to turn mainly to theatre work; he met Robert Medley who was there with Rupert Doone, Cedric Morris and his friend Lett Haines, and John Banting, all of whom knew Paris as well as or better than he did. Burra was in contact with a number of Parisian art world figures at different times, but he remained a private person who felt his way towards friendships slowly and enjoyed the independence of the spectator's role.

Burra's stay in Paris in the autumn of 1928 extended his contact with the world of ballet, and in 1931 he became one of the group painters, including John Armstrong, Banting and Christopher Wood, who participated as designers in the birth of modern ballet in England, when he made the first of his many set and costume designs (see Cat. 75) for Constant Lambert's version of Sacheverell Sitwell's poem 'Rio Grande' as the ballet *A Day in a Southern Port*.

Burra's Paris trips familiarized him with the new realism that had begun with Picasso and Gris during the war, had led in Germany to the *Neue Sachlichkeit,* and showed itself in the writings of Severini and others in stress on craftsmanship and the discipline offered by study of the historic techniques of Italian art. The implication of this trend was not a denial of modernism but a new definition that saw it in terms of an active engagement with tradition. Burra, catholic in his tastes and always ready to explore the art of the museums, responded positively to this feeling for classicism and order, without slavishly pursuing the past for its own sake or letting it subdue his irrational impulses.

The universal anti-Victorianism of the twenties, and the accompanying revival of interest in everything to do with the eighteenth century, reached a popular climax at this time with the unveiling of the Rex Whistler murals in the tea-room of the Tate

Gallery in November 1927. Burra found many aspects of the eighteenth century congenial: the links between painting and theatre, the artifice of the conversation piece, the gentle eroticism of Watteau and the French *petits maîtres*, the satire of Hogarth, and the fantasy of the Venetian carnival scenes all appealed to him; later he was to come to the neurotic fantasies of Magnasco and to Goya, and finally to turn back in the direction of landscape with the reappraisal of Romanticism at the beginning of the War.

The conversation piece was a genre that Henry Lamb and the Bloomsbury artists had explored, round which a major exhibition was staged in 1930 at 25, Park Lane, and which Sacheverell Sitwell made the subject of a book in 1936. Burra had tried it out rather tentatively in 1927 in *The Garden* (Cat. 28), but it was in 1929 that he evolved his personal urban variation on the theme in *Balcony, Toulon* (Cat. 43) and *The Two Sisters* (Cat. 54). The eighteenth-century artist of the conversation piece, though he took all his figures from life, did not necessarily pose them together, and was expected to exercise his powers of ingenuity in arranging them; it had thus always been an exercise in artifice, if not quite to the degree to which Burra developed it now.

As source material Burra was relying partly on coloured postcards and magazine illustrations, and in a picture like *The Two Sisters* – in which the woman with a tray was drawn from life, based on a male friend, while the sisters were taken from a postcard or cut-out illustration of the popular American Jewish entertainers, the Dolly Sisters – an element of disjunction is evident, caused by the disparity between the sources; Burra was beginning to find his way towards the montage effects he was to achieve the following year.

Nash was not without justification in calling Burra the modern Hogarth: satire was for both the natural manifestation of their visions of social order in decay, and both relied heavily not only on gesture and expression but also on external objects through which people project themselves.[1] In *Marriage à la Mode* (Cat. 41) Burra identified with Hogarth through the title, though for Burra 'mode' was probably meant to draw attention more exclusively to dress. Parallels for the cupids watering the bride's and groom's flowers exist in both Hogarth and Rowlandson, and in the painting by Hogarth that is closest to Burra's in several respects, *The Wedding of Stephen Beckingham and Mary Cox*, cupids are tipping a cornucopia of flowers and fruit over the couple, which, like the watering, is perhaps intended to suggest procreation. Burra, who enjoyed excesses as well as ridiculing them, was a pragmatist, seizing opportunities for satire as they presented themselves, but evolving no equivalent for Hogarth's 'modern moral subject'.

Burra needs to be seen here in the context of the 1920s, the decade that broke once and for all the Victorian resistance to satire. Though basically directed at the social class of his origin, his satire was anarchic and picaresque, more remarkable for its range and versatility than its force; it had much in common with that of Aldous Huxley's earliest novels, which Burra read at Chelsea, and the ubiquitous but loosely directed satire of Thomas Love Peacock, whom Huxley helped to bring back into fashion.

Satire in Burra's painting went hand in hand with a vein of fantasy that, among English artists, he shared only with John Armstrong. The appeal of pictures like *Le Bal* (Cat. 35), *Les Folies de Belleville* (Cat. 36) and *The Tea-Shop* (Cat. 52) relates to the contradiction between an underlying classical austerity and Burra's delight in excess, expressed through a self-consciously libertine make-believe. A different kind

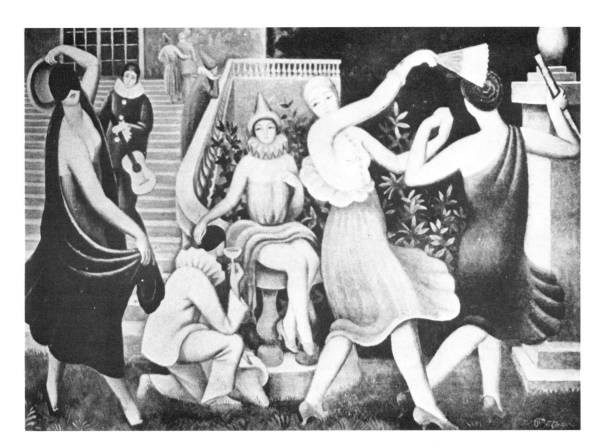

2. Jean Metzinger. *Bal Masqué*, c. 1923–5. Oil. From *Artwork*, January–March 1926

of fantasy is expressed in *Dancing Cows* (Cat. 46) and *The Kite* (Cat. 49, Colour Plate 4), harlequinades related to the new interest in carnival scenes and the *Commedia dell' Arte* on the part of painters such as Picasso, Derain and Severini, and widely popularized through the Diaghilev ballet *Carnaval*. The design, and even the poses and gestures, of Burra's comparable *Arcadia* (Cat. 38) relate it to Metzinger's *Bal Masqué* (Fig. 2), which was in London in the mid-twenties; it is as much the differences, however, as the similarities between the two that identify Burra's particular talents for ambiguity and innuendo, by the standards of which Metzinger's picture is straightforward and relaxed.[2]

The contrast in these pictures between austerity and excess, Classicism constantly moderated by the desire to surprise, relates to Burra's admiration for Jean Cocteau. Cocteau had interested him at least since 1926, the year in which *Parade*, the 1917 ballet on which Cocteau and Picasso had collaborated for Diaghilev, was revived in London, and the year Cocteau's book *Le Coq et l'Arlequin* was published in England as *A Call to Order*. About that time Burra had written to Chappell, admiring the drawings of Picasso and Cocteau, but specially praising Cocteau for the breadth of his talents encompassing music and poetry as well.[3] In 1930 Burra visited Le Boeuf sur le Toit, the Paris nightclub that Cocteau patronized, and used it as the basis of a design (Cat. 56).

Cocteau's importance for Burra had several aspects: his modernity and ability to give an original and elegant gloss to many aspects of modern life; his eclectic stylishness, the belief that it was necessary 'to have style instead of to have *a* style';[4] and his incisive, aphoristic expression, which gave a kind of unity to his quixotic and unpredictable moods and interests. Burra is seen at his most Cocteau-like in the whimsical humour of *Dancing Cows* or *The Kite* on the one hand, and, on the other,

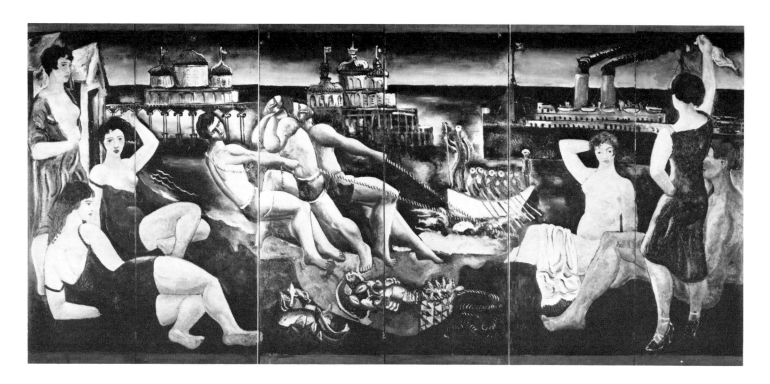

3. Christopher Wood. Six-part decorative screen. 1925. London, Redfern Gallery

in the doleful mocking and self-conscious air of a picture like *On the Shore*, which was probably based – as were some of Cocteau's drawings – on coloured postcards, and relates to the decorative screen of Christopher Wood (Fig. 3), the English painter closest to Cocteau.

Burra's experiments with new media and techniques in the late twenties are linked with his desire to attain greater realism. He started to use oil in 1927, and shortly afterwards introduced gouache, tempera and bodycolour, while ink contour drawings, though not new for him, became for the first time a major form of expression. Gouache, tempera and bodycolour are denser than ordinary watercolour, and enabled Burra to paint with a miniaturist's detail, leaving no brushmark to impair the minute realism of the finish or challenge the completeness of the illusion. Burra's immediate example was Edward Wadsworth, whose precisely executed harbour scenes in tempera, regularly exhibited at the Leicester Galleries, guided a number of artists, such as Burra, who were in touch with Paris and could see them in the context of post-war classicism and the recovery of tradition there. Of the Parisian artists, including Picasso, who had experimented with tempera, by far the most important for Burra was Severini, who was well known in the English avant-garde partly because he had received a major commission in 1921 from the Sitwell family to decorate part of their castle at Montegufoni outside Florence with scenes from the *Commedia dell'Arte*. In his *Du Cubisme au Classicisme* (1921), which was founded on a comprehensive knowledge of the mathematical and technical bases of historic art, Severini argued for calculation and craftsmanship as cornerstones of the new, precise classicism to replace the loose and approximate pre-war art of Cubism. The similarity of handling between a 1929 Burra such as *The Two Sisters* and a Severini tempera painting like *Pulcinella in a Room* of 1923 (Fig. 4) is clear, as is the way the mathematics of Severini's space are more loosely imitated by Burra in interiors such as *The Café* of 1930 (Cat. 57). But Severini was, like Burra, an artist who operated in the realm of fantasy as well as that of theory. In his Montegufoni frescoes, for example, he creates the kind of figures (Fig. 5), like Burra's in *The Kite*, who are half

4. Gino Severini. *Pulcinella in a Room*, 1923. Tempera. Private Collection

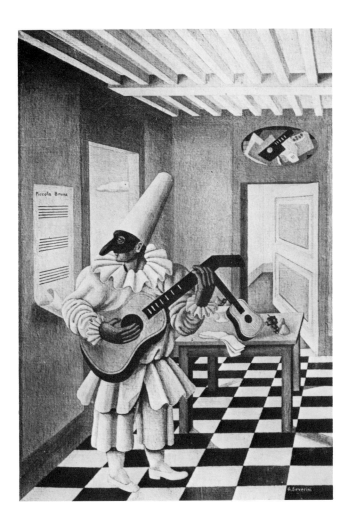

5. Gino Severini. *Serenade*, 1922. Fresco. Florence, Castello di Montegufoni

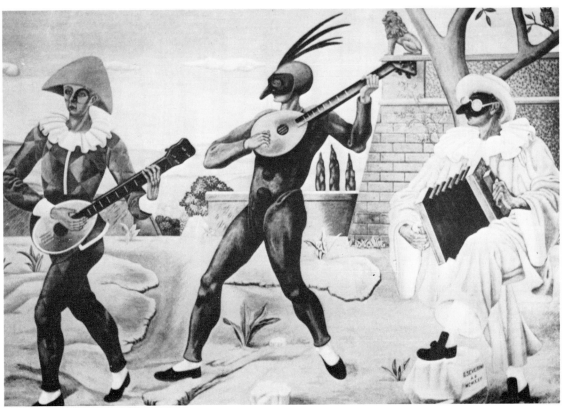

detached from the world they seem to inhabit because they lack logical scale in relation to their surroundings and are not properly anchored to the ground by means of shadows.

Of the few known oil paintings by Burra the earliest is *Cedar at Springfield* of 1927 (Cat. 25) and the last are *The Ham* and *The Hand* of 1931 (Cats. 70 and 71), though a few other very unfinished works suggest he was thinking of further oils until about 1935. It has been suggested that he painted so little in oil because the public did not want it; because his health made oil painting difficult; and because a watercolour kit was easier to carry on his travels. But Burra never properly tested the public response (which would hardly have interested him in any case), the health argument wrongly assumes that he would have had to paint standing up, which tired him and which he always avoided, while the third theory is called in question by one oil painting, the *Portrait of William Chappell* (Cat. 37), which was painted abroad, in Paris in the autumn of 1928. The real reason was entirely professional: the loosely treated paint of *The Cedar*, compared with the minutely imitative handling of *The Ham*, shows that over the the course of the four years that divides them Burra was motivated by the same ambition to achieve a smooth finish that led him to modify his watercolour medium; but oil paint, however used, could never produce the objectivity of tempera.

Burra was also working towards a kind a classicism in his ink contour drawings. Generally of groups of people, at parties or in bars and cafés, or outdoors in the street, they are neither sketches nor studies but finished works in their own right, and groups were included in his first one-man shows at the Leicester Galleries in 1929 and 1932. There is an interesting comparison between *The Café* (Drawing 23), and the drawings of the Victorian illustrator Charles Bennett in his *London People Sketched from the Life* (1863), the kind of book that existed in the substantial library at Springfield. Bennett claimed that his drawings were 'designed to exhibit faithful delineations of different classes of London people as they appear, not aiming at humorous exaggeration on the one hand or at ideal grace on the other...my aim being to indicate the impress of habits and society upon the countenance of individuals who might be taken as types of the class they belong to'[5]. For Bennett in his theatre drawing *The Gallery* (Fig. 6), as for Burra, the defence – which both made – against the charge of being caricaturists was that they selected situations and moments when character was most strongly reflected in facial expression.

Although Burra was not a caricaturist, he was certainly a satirist, and his drawings are particularly significant in this respect, because most of their subjects are the society amateurs who swamped artistic life in the twenties and were christened Champagne Bohemia by Wyndham Lewis. They were universal targets of literary sniping around 1930, appearing in the early novels of Evelyn Waugh and Anthony Powell, and they were Lewis's 'apes of God' in his satirical trumpet blast published under that title in 1930. Burra's drawings are full of motifs that quickly identify weaknesses, such as the meaningless smile and the nobody attempting to be somebody by means of clothes; he was sharp to spot shallowness and the loneliness that can be felt in a crowd.

Critics of the early exhibitions compared Burra's work – not only these drawings – with Beardsley's more than with any other artist's, and Burra's use of outline does owe much to Beardsley's exploitation of the line block technique of reproduction, which permits line and flat colour but not intermediate tones. By the twenties Picasso's return to outline figure drawing had helped to establish it as a norm, and in

6. Charles Bennett, 'At the Play – the Gallery', from *London People Sketched from the Life*, 1863. Engraving

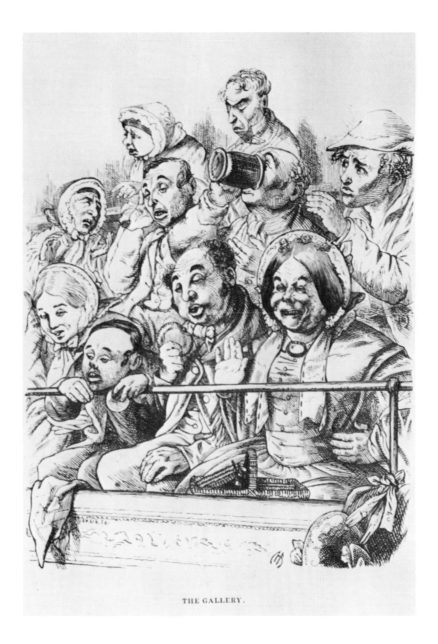

THE GALLERY.

England it was Lewis who formulated a theoretical justification for it, which seems appropriate to Burra also, when in 1918 he defined art as the 'science of the outside of things', and added later, in 1930, 'the only thing that interests me is *the shell*'.[6] Burra learned a great deal at this time through Lewis, who passionately upheld a classicism that involved a relentless hounding of anything connected with 'stream of consciousness' expression in art or literature, and later recalled his fighting stance through Baudelaire's words, 'je haïs le mouvement qui déplace les lignes'.[7] Burra, concerned with the surfaces of things rather than their workings, evolved in these drawings a technique appropriate to their subject, smart-set society with its stress on appearances, style, fashion and make-up, just those things that Baudelaire had said ought to be the concerns of the artist.

Chapter Four

By the time he was in Toulon in 1930 the celebratory character of Burra's mid-twenties paintings of southern ports had gone. He was no longer concerned with cheerful crowds but with pairs or small groups of suspicious characters in bars and cafés; knives and guns begin to appear; dice and cards have a sinister significance that makes them more than just café games.

Burra's letters from Toulon in 1931 show that French writers and painters there included Cocteau, Jean Desbordes, Gide, Maurois, Christian Bérard, and Tchelitchew. From 1929 Burra would stay at the Hôtel du Port et des Négociants on the Rade close to the naval dockyard, where Cocteau was also to be found if not at the Hôtel de la Rade further down the quay. Cocteau was anglophile and there was a regular exchange between the English and French at the Café de la Rade and Raymond's Bar; in 1931 Burra's friend Barbara Ker-Seymer took photographs of Cocteau and Desbordes.

A large naval base such as Toulon with its multi-racial and mobile population offered companionship across class barriers: it was less a question of social equality than of the neurasthenic intellectual aristocracy, of which Cocteau was a representative, attempting to renew itself through contact with a natural vitality, lower class and non-European. For this dandyish and largely homosexual milieu the sailor was alternately a sex object and an appeal to sentiment – a boyish face in a beret with a red pom-pom smiling out from a hand-tinted colour postcard.

By 1930 Burra's art was striking a deeper note, with a sense of mystery and presentiment coming to the fore. Since Cocteau's conversion to Catholicism in 1925, his concern with death and the unknown had shown itself in works like *Orphée* (1926); Burra's cards and dice, and the strange disembodied hand of an unseen protagonist in Cat. 71, are images shared with the Neo-Romantic painters in the Cocteau circle. However a comparison of similar subjects treated by Burra and Cocteau's English protégé, Christopher Wood (Cat. 71 and Fig. 7), shows that Burra's images are concrete and specific, supported by drawing of a high order, against which Wood's painting seems tentative.

A considerable mythology surrounded the subject of ports and sailors in art and literature between the wars. The Romantics' love of faraway places found an echo in the twenties' frustration with the present, as well as being reinterpreted in the context of increased transatlantic travel. An expression of this was the devotion of the whole of the May 1929 issue of *Variétés*, the Surrealist-oriented periodical to which Burra and Nash shared a subscription, to the subject of boats and ports. Other English artists and writers were drawn to the exotic foreign underworld of the southern ports. What were to Burra unspecific undercurrents of small-time vice,

7. Christopher Wood. *The Card Players*, 1930 (?). Oil. Whereabouts unknown

suspicious goings-on in bars, were more plainly stated by Wadsworth in his 1926 painting of prostitutes outside the brothels in the rue de la Reynarde in Marseilles, the street where the hapless Paul Pennyfeather in Waugh's *Decline and Fall* (1928) was hustled by prostitutes and negro sailors while searching for Mrs Beste-Chetwynd's girls. A parallel picture of Toulon, vital but corrupt, forms the background of *What's Become of Waring?* (1939) by Anthony Powell, whom Burra got to know when they were there together in 1931.

The sense in Burra's pictures that the covers are being lifted on some petty criminal underworld also relates to his reading of Pierre Mac Orlan, author of *Quai des Brumes* (1927) and *Port d'eaux mortes* (1926), and of Mac Orlan's friend and former literary collaborator, Francis Carco. Carco's novels about artists and gangsters, prostitutes and drug addicts have a realism involving precise knowledge of criminal habits and conventions. Sharing the disillusion that led Burra not to expect too much from people, Carco gave an edge to his writing through the suggestion of ever-present evil. Their common approach to the criminal underworld as a source of entertainment and their freedom from moralizing was shared with Blaise Cendrars's slightly later reporting on criminal society in Paris and Marseilles in *Panorama de la Pègre* (1935).

Mac Orlan's *Port d'eaux mortes* was illustrated by his friend George Grosz who moved in the same circles when in Paris. Burra was a great admirer of Grosz, whose volumes of satirical and other works circulated in England in the twenties; his work was shown in London in 1926 at the Tri-National exhibition at the Chenil Galleries,

8. Photographs of Hands.
Reproduced from *Der
Querschnitt*, January 1931

and Burra would have seen it in *Der Querschnitt*, the cultural periodical published by Grosz's Berlin dealer, Alfred Flechtheim, which he is known to have looked at regularly.

Notorious for their splenetic attacks on the German political and military élites, Grosz's satires appealed to Burra, but were nevertheless particular to Germany and inimitable in England, where Burra's attention focused on social matters rather than politics or the military. The closest parallels between the two lay in their approach to urban realism: both liked the contrast of high and low life, bars, cinemas, jazz and anything connected with America (both made drawings of American scenes before they went there), and both were inspired by the Mediterranean ports – Grosz published his first drawing of a Marseilles street scene in 1919. In his attempt to recreate the feel of life in the modern city Grosz merged interiors and outdoor scenes as Burra did in *Toulon* (Cat. 33) and *The Tram* (Cat. 42), peering into apartments to bring the public and private aspects of city life into one complete experience: although what Burra experienced was tame compared with the rapes and murders witnessed by Grosz.

At Toulon Burra's painting showed the first influence of photography, which was rapidly expanding both as a profession and an interest to painters. Although he possessed a camera himself, Burra did not use his own photographs as material for

9. Herbert Bayer. *Juli.*
Photograph. Reproduced
from *Der Querschnitt,*
February 1929

pictures, as Nash did when he took up photography at much the same time. Burra was in touch with developments through his photographer friend Barbara Ker-Seymer, and subjects currently popular in photography emerge in his painting. Burra's mysteriously detached hand (Cat. 71), for example, had been used by Man Ray in his 1925 photograph of a hand shuffling dominoes, *Pièces de résistance,* which was reproduced by Breton in *Le Surréalisme et la peinture,* and the idea was frequently re-used, as in Fig. 8, which appeared in *Der Querschnitt* in January 1931.

Burra also adopted viewpoints that belonged to photography rather than painting, such as the effect of looking down over a man's shoulder from behind in *The Café* (Cat. 57), which relates to images like Herbert Bayer's *Juli* (Fig. 9), also reproduced in *Der Querschnitt* (February 1929). Nash, writing in *The Listener* beside a reproduction of *The Café,* pointed to Burra's 'passion for solid, individual shapes, rounded and stippled to a high degree of finish with intense concentration on highlights', and his 'peculiar concentration upon isolated objects... to which he gives unusual prominence, articulating the forms with the keenest appreciation of their surface properties'. Photography was a new kind of realism for Burra, which he valued for its ability to produce images that were mysterious on account of their unusual intensity.

Chapter Five

Burra's many visits to Paris at the end of the twenties had helped to create a style that, while remaining personal, was recognizably a part of post-war classicism. The falling off of Cocteau's prestige by the end of the decade, and the rising influence of his arch-rival Breton, marked the decline of this taste, and for an artist as sensitive to continental developments as Burra some consideration of Surrealism was inevitable. Despite its maverick character, his classicism obeyed a certain logic of drawing and space as a result of which his late twenties paintings form a distinct group. The new currents in his art in the early thirties proved so liberating that unifying threads are much harder to find.

By contrast to the situation in Paris, there was no serious attempt in England before 1935 to establish a theoretical base for Surrealism. Innovative painting was called 'advanced' to cover all manifestations from Surrealism to abstraction, and writers such as Herbert Read and Paul Nash, in his role as critic, tended to regard all new lines of discovery as equally valid. It was a situation that suited Burra, who was

10. Photographs showing the application of mechanical invention to human protection, from *Variétés*, 15 January 1930

Aboutissements de la mécanique

La protection des hommes

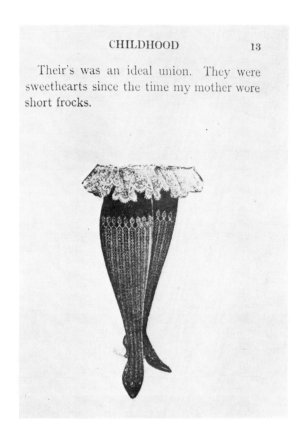

CHILDHOOD 13

Their's was an ideal union. They were sweethearts since the time my mother wore short frocks.

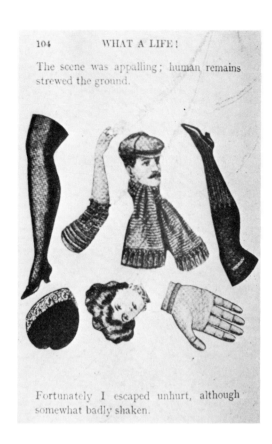

104 WHAT A LIFE!

The scene was appalling; human remains strewed the ground.

Fortunately I escaped unhurt, although somewhat badly shaken.

11 and 12. Pages from EVL and GM, *What a Life!*, 1911. Reproduced from *Documents* vol. 2 no. 5, 1930

eclectic and inclined to ignore boundaries of this kind, and to admit sympathies with Surrealism while resisting full commitment.

An important element in Burra's new freedom was use of collage, a medium he began to explore around the end of 1929, coming to it at a moment when Surrealists, including Dalí and Miró, were also taking it up. In 1930 there was a major exhibition of collage at the Galerie Pierre Colle, for which Louis Aragon wrote a small book on the subject, *La Peinture au défi*. Burra and Nash worked together in the medium, as in *Rough on Rats* (Cat. 66), probably aware of the Grosz-Heartfield collaborations during the war, and of the Parisian Surrealists' game, adaptable to collage and known as *Cadavre exquis*, in which each participant was assigned a part of the human body, the contributions being concealed by folding till the image was complete. For Nash collage-making was a pastime – he often used it to make humorous Christmas cards – but for Burra it was a valued form of artistic expression. *Eruption of Vesuvius* (Cat. 62) was one of his rare submissions to the London Group (December 1930) and was reproduced in *Cahiers d'Art* in 1938 as the single representation of Burra's work in an anthology of avant-garde British art;[1] others of his collages were included in the International Surrealist Exhibitions in London (1936) and Paris (1938).

Eruption of Vesuvius may have been a response to reproductions in *Variétés* for January 1930, the month this work – which was described in a letter to Barbara Ker-Seymer of 23 January 1930 – was probably made. *Variétés* carried photographs of machines that relate to the human head, including a piece of eye-testing equipment (Fig. 10). Although it was obviously the intention of *Variétés* to draw attention to the machines' visual curosity, the pictures clearly demonstrated their functions, and thus expressed a basically sympathetic attitude towards machinery parallel to that of post-war *esprit nouveau*. However in Burra's hands machines

became divorced from their original purposes and were treated with a mocking humour that looked back across the optimistic years of the twenties to Dada. The anarchic humour current in Surrealist circles, and which *Eruption of Vesuvius* reflects, is found in an eccentric book *What a Life!* (1911), pages from which (Figs. 11 and 12) were reproduced in the Surrealist-directed periodical *Documents* later in 1930;[2] its text was inspired by the plates, which were random cuttings from a Whiteley's mail order catalogue.

Burra always used collage, like the Dadaists, to intensify images and increase their impact, and not for the plastic or abstract purposes of the Cubists. It was in the Dada movement in Berlin and in Russia that collage as Burra used it in Cat. 45 originated, and his inclusion here of a cutting from *Pravda* should be seen as a reference to this; it is an aesthetic comment – an acknowledgement of Russian artists such as Lissitzky or Rodchenko who used the medium in this way – and not a political statement. The context of Berlin Dada had been lost by 1930, and its methods were now popularized in such forms as postcards, such as Fig. 13, which was sent to Burra by Sophie Fedorovich in 1929. Burra's collages belong not to politics but the world of entertainment and leisure. The architectural cutouts in Cat. 45 (Colour Plate 1) refer back to the Dutchman Paul Citroen's 1924 *Metropolis* collages and the skyscrapers invented for the cinema in Fritz Lang's *Metropolis* (1926) and Walter Ruttmann's *Berlin* (1927); the heads are those of the actors Lon Chaney and Louise Brooks and the heavyweight boxer Primo Carnera.

Though Burra quickly tired of making collages, the liberating effect of the medium persisted. Ernst, especially, through his collages of the early twenties had given himself up to an imaginative abandon and detachment from logical associations, which was a lesson Burra learned in collage-like paintings of this period, such as *Still Life with a Pistol* (Cat. 76). At the same time the influence of other media was

helping Burra to break through the constraints of classical pictorial conventions. Cinematic devices – like quick cutting from close-ups to distance in pictures such as *Saturday Market* (Cat. 87) and *Spanish Dancer in a White Dress* (Cat. 121)– interested him, as did the adaptation of the graphic design technique of picture page layouts in compartmentalized designs of the kind Magritte was also exploring at this time. *Still Life with a Pistol* appears to be more Cubist than Burra's previous work because space is shallow and images are on the surface, but in reality the collaged effect is a technique used by graphic artists and the image of the smoking pistol suggests that Burra may have taken it from the page of a book on Chicago gangsterism, *X Marks the Spot*, which was reproduced in *Documents* in 1930.[3]

Collage-type paintings like *Still Life with a Pistol* are a minority in Burra's work, and his attachment to Surrealism was possible because the movement was becoming more concerned with images in deep space: the new adherence of Dalí and the central role given by Breton to the early work of de Chirico in *Le Surréalisme et la peinture* accompanied Surrealism's retreat from automatism and abstraction, neither of which Burra cared for, and which were not emphasized in Breton's Second Surrealist Manifesto in December 1929.

Burra was drawn closest to Surrealism by his treatment of the image of woman, a subject which in turn bound Surrealism to Symbolism and the *fin-de-siècle*. Burra's image of woman grew in large measure from his interest in Beardsley, whose malign Messalina can be seen as the equivalent of Burra's aggressive *Mae West* (Cat. 116). Both artists approached their subject with a mixture of adulation, fear and hostility; both were concerned largely with externals like clothes, shoes and hair or hats. Both worked in the overlap between fiction and reality, Burra with cinema and music hall, Beardsley with history and myth. But unlike Beardsley's, Burra's eroticism is generally covert. In *Saturday Market* a stallholder caresses green peppers while a screen vamp stands by enticingly; in *Revolver Dream* (Cat. 74) a shot is fired in the direction of a naked woman who, again, is not actually touched, the sensuality of the tableau being insisted upon through soft, fleshy peaches, bananas and exotic flowers. Behind even the most apparently realist of Burra's paintings are veiled erotic correspondences: the carving of meat, in association with a lubricious glance, suggests a sexual interpretation for *The Snack Bar* (Cat. 68), as do the peeling of fruit or the opening of an oyster in many seventeenth-century Dutch paintings.

Surrealism became a force in Burra's art at the same time as his understanding of the Decadence deepened; not only Beardsley but Baudelaire – the satanic poet rather than the urbane critic he had known up to now – and Huysmans became major influences. Baudelaire's *correspondances* presented Burra with possibilities he exploited for the rest of his life, of strange flowers becoming images of temptation; in Huysmans's *A Rebours*, des Esseintes, obsessed with exotic flowers, gave them a key position in the artificial world isolated from people which he built for himself – a device which particularly appealed to Burra. For the present such fruits and flowers were adjuncts and decorations to Burra's world, but towards the end of his life they became more dominant; the flowers of Cats. 304 and 399 (Colour Plates 22 and 32) are the very core of his imaginative world. For the flamboyant colours which are a special feature of Burra's art in 1931–3 he was indebted less to any contemporary artists than to the Douanier Rousseau, in his readiness to abandon himself to luxurious illusions, and to the literary descriptions of those, like Baudelaire and Huysmans, who found that intense and unnatural colours could represent the basest aspects of the human mind.

14. Joan Miró. *Portrait of Mrs Mills in 1750 (after George Engelheart)*, 1929. Oil. New York, Museum of Modern Art

Surrealism introduced Burra to paintings such as Miró's coquettish *Portrait of Mrs Mills in 1750 (after George Engelheart)* (1929; Fig. 14), which probably provided him with ideas for *The Hostesses* (Cat. 86); and Picasso's ruthless dismemberment of the female body offered motifs which Burra reworked in a more decorative idiom in *Composition* (Cat. 100). The haunts of Burra's women are often buildings seen in vertiginous perspective, like those in the early de Chirico, or vortexes like the hell-mouths of Symbolist art. As in Symbolist painting, the image of woman is linked with that of death, and Burra's painting begins to include skulls and bones; the morbidity which was later to appeal to him in Spanish painting first appears now in his own. In the twenties women in his pictures lounging on terraces and relaxing in gardens had been accompanied by dogs or cats; the equivalent now is a crab or some insect which the mythology of Surrealism had established as being hostile to man.

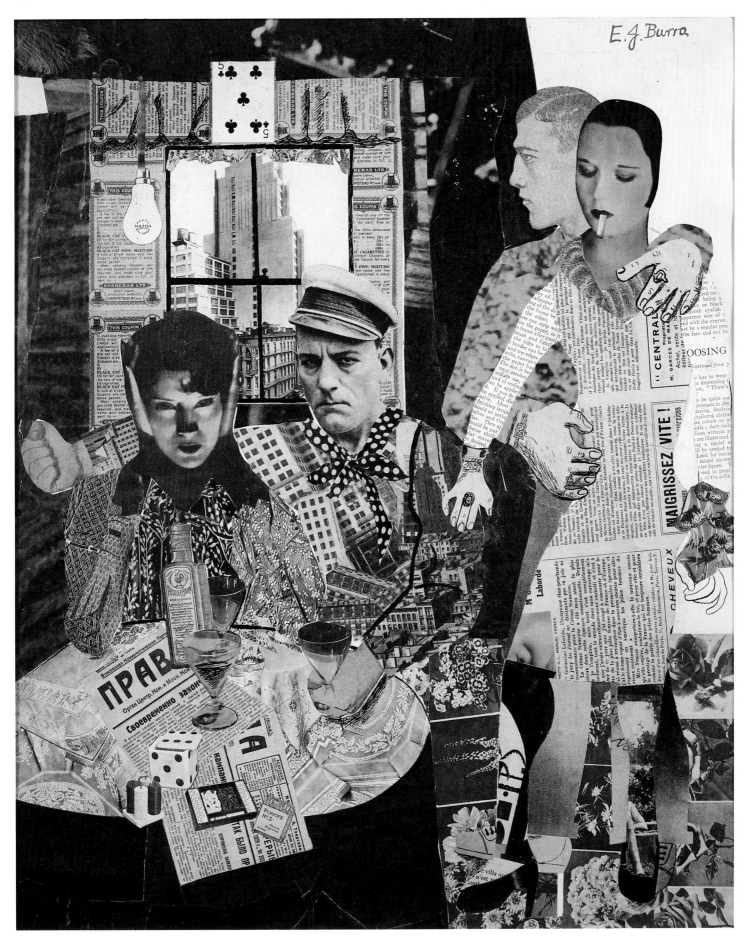

1. *Composition Collage.* 1929. Private collection. Cat. 45.

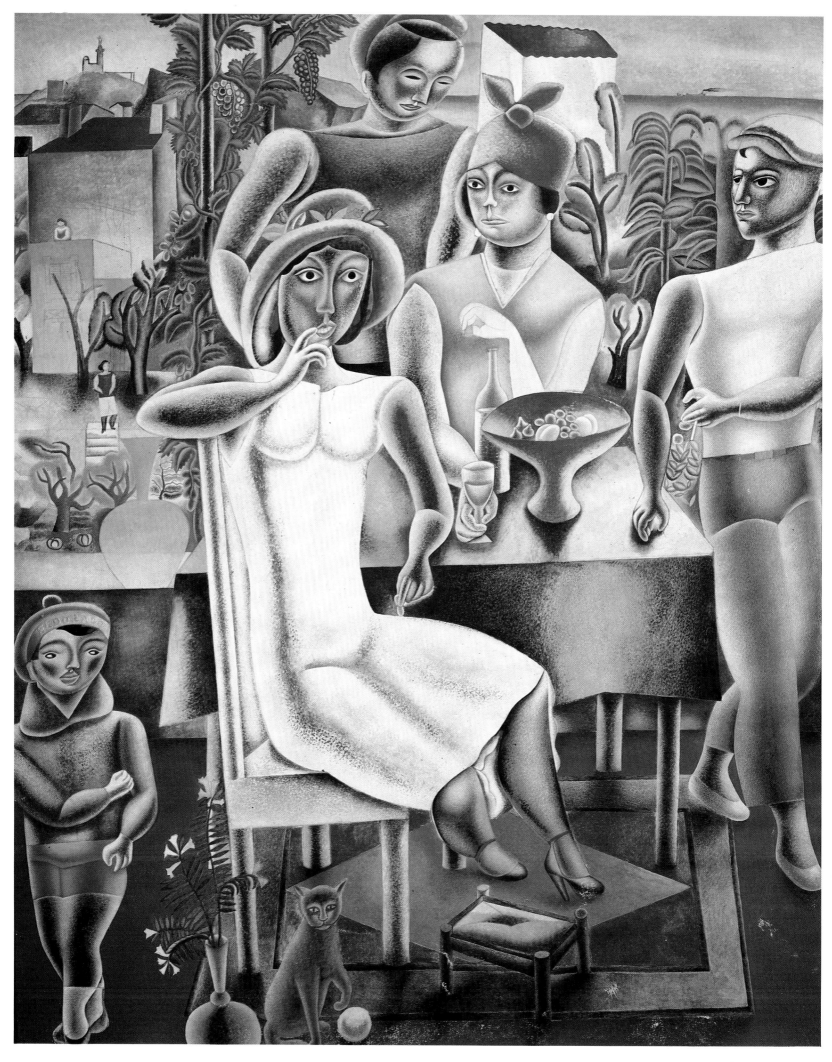

2. *Dessert.* 1929. Private collection. Cat. 47.

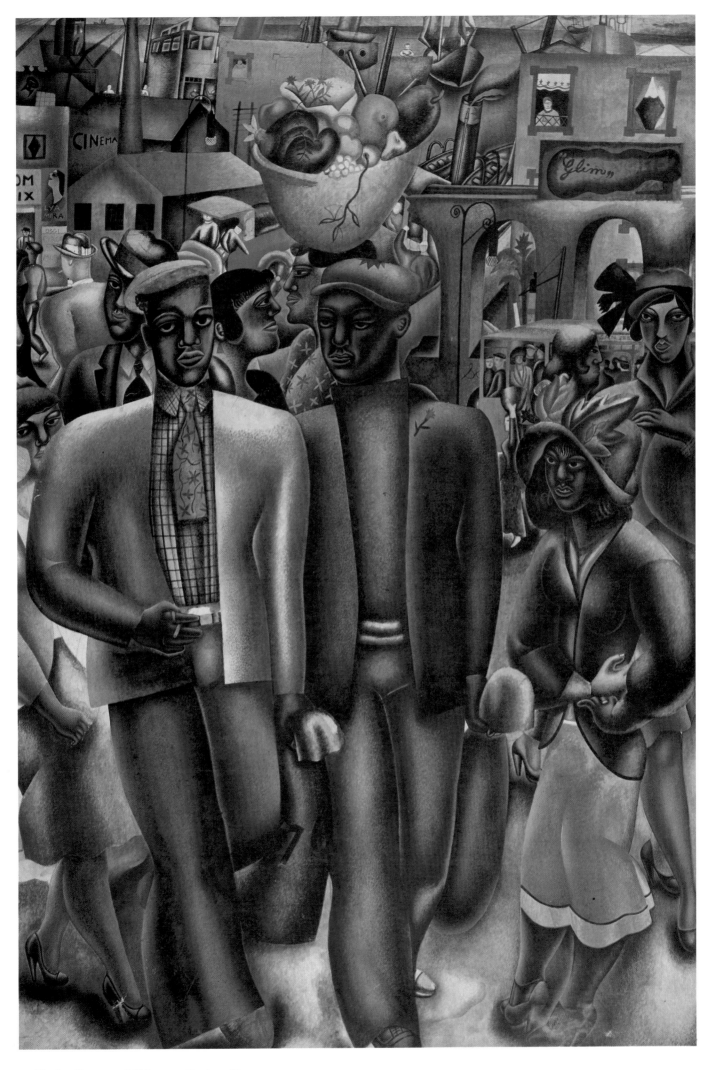

3. *Market Day.* 1926. Private collection. Cat. 23.

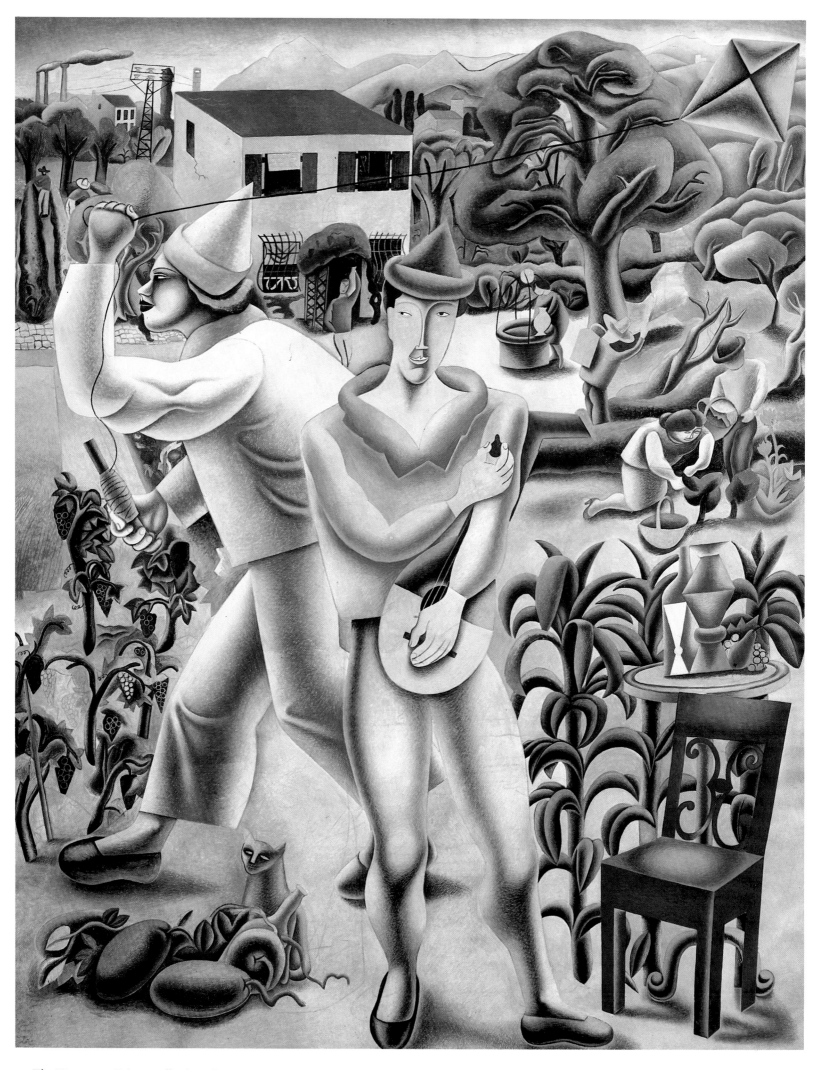

4. *The Kite.* 1929. Private collection. Cat. 49.

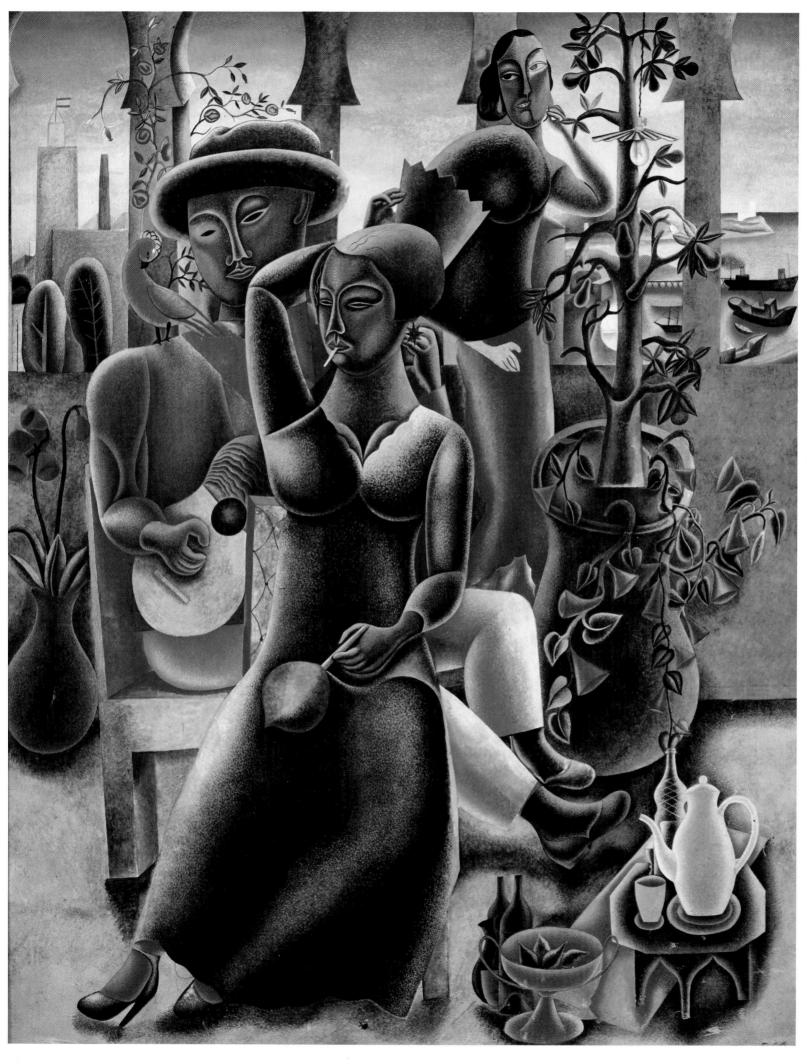

5. *The Terrace*. 1929. Private collection. Cat. 53.

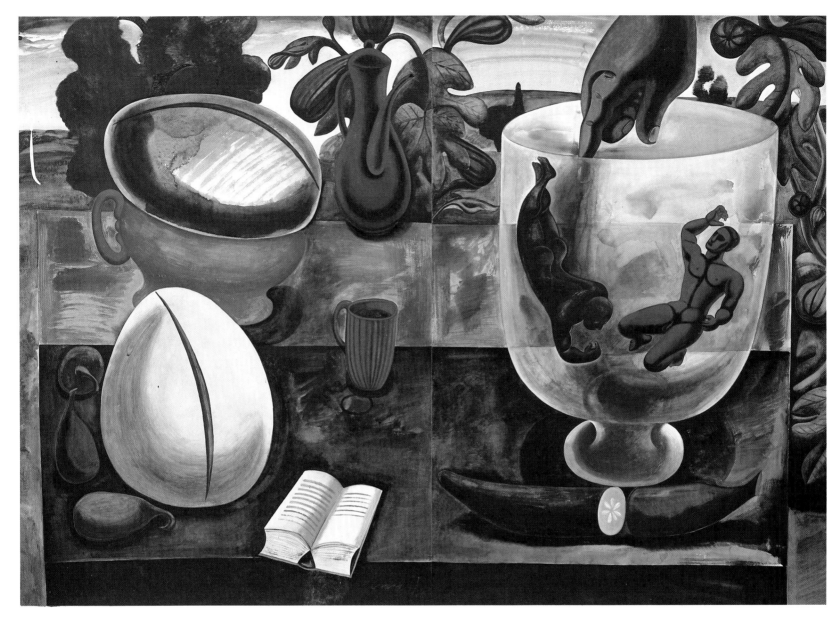

6. *Still Life with Figures in a Glass*. 1933. Private collection. Cat. 98.

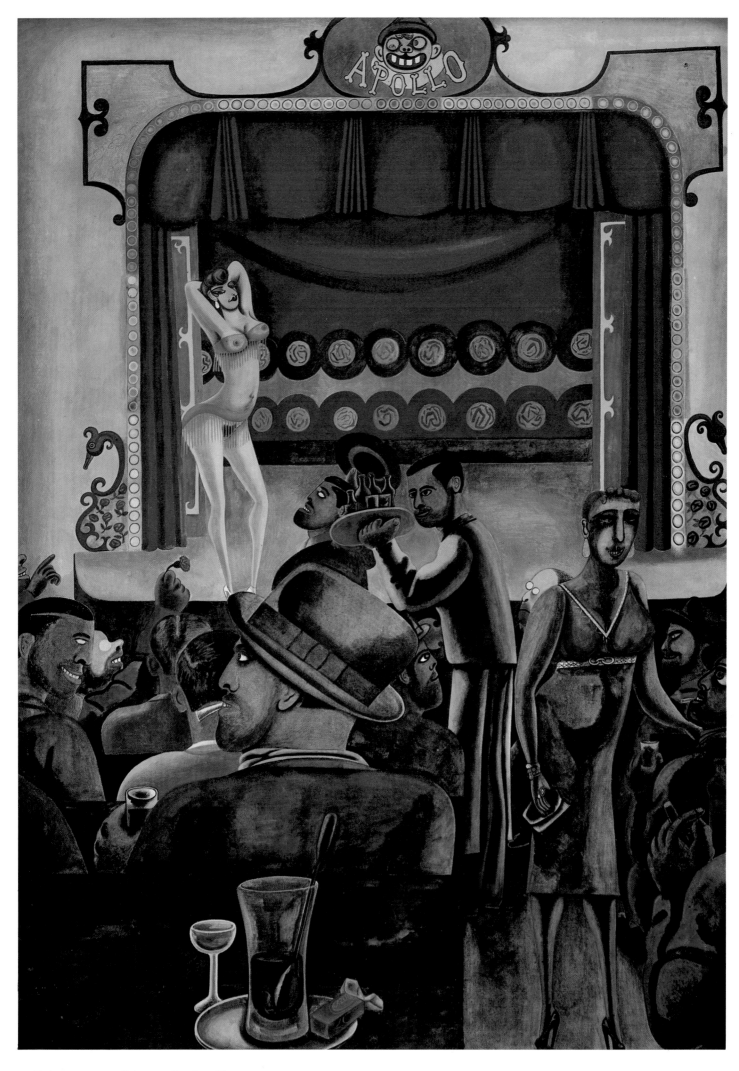

7. *Striptease.* 1934. Private collection. Cat. 112.

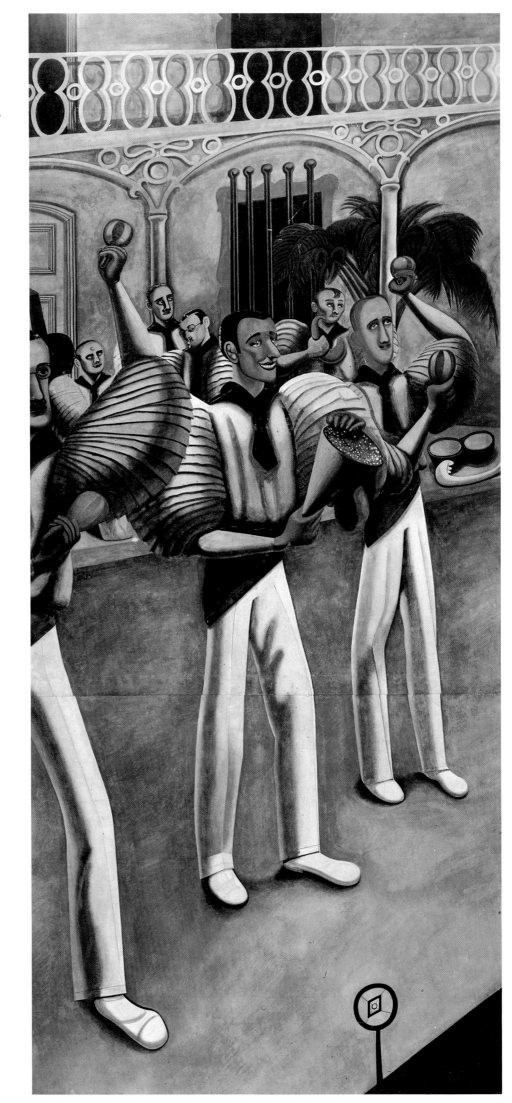

8. *Cuban Band*. 1934–5.
Private collection. Cat. 113.

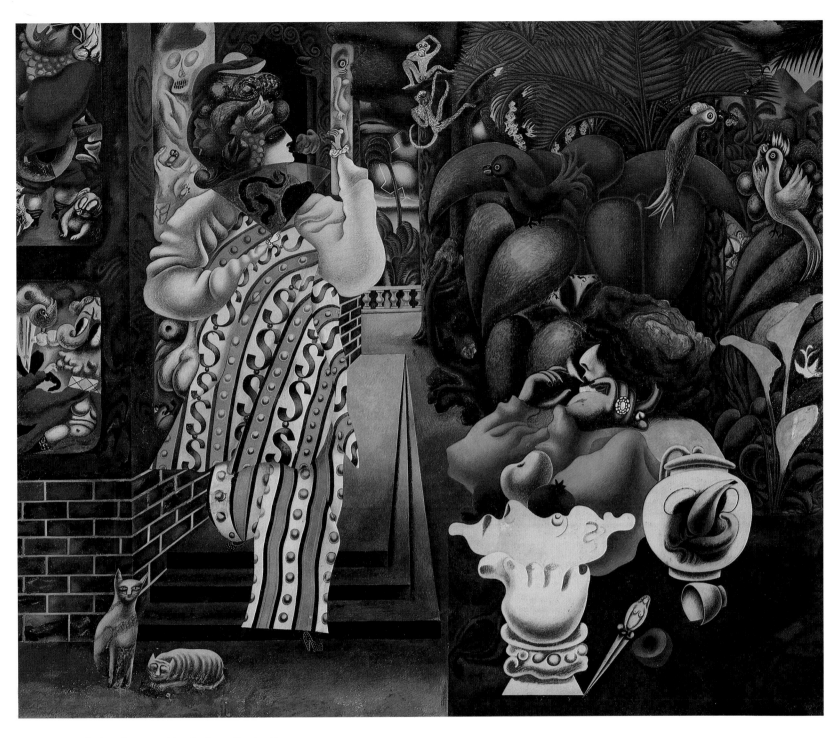

9. *Storm in the Jungle*. 1931. Nottingham Castle. Cat. 77.

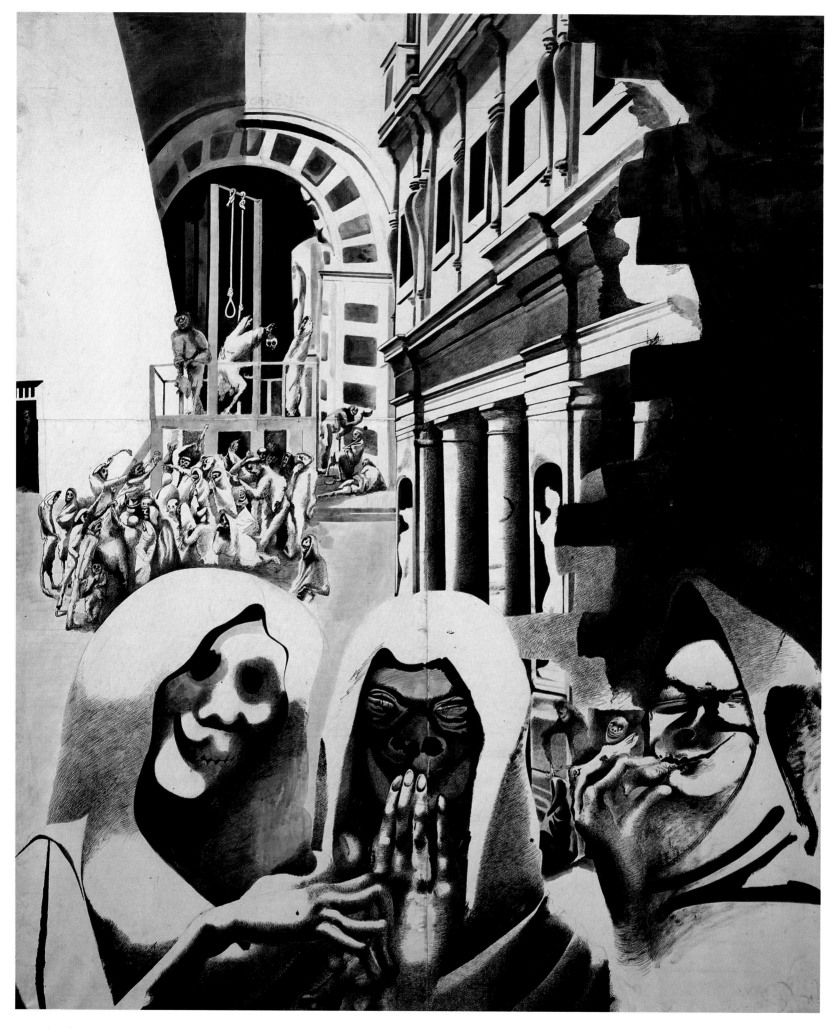

10. *The Three Fates. c.* 1937. Private collection. Cat. 136.

11. *The Torturers*. 1935. Private collection. Cat. 126.

12. Detail of *Camouflage. c.* 1938. Private collection. Cat. 144.

13. *Medusa. c.* 1938. Private collection. Cat. 145.

14. *Figures in a Landscape*. 1937–9. Private collection.

15. *Old Iron. c.* 1938. Private collection. Cat. 147.

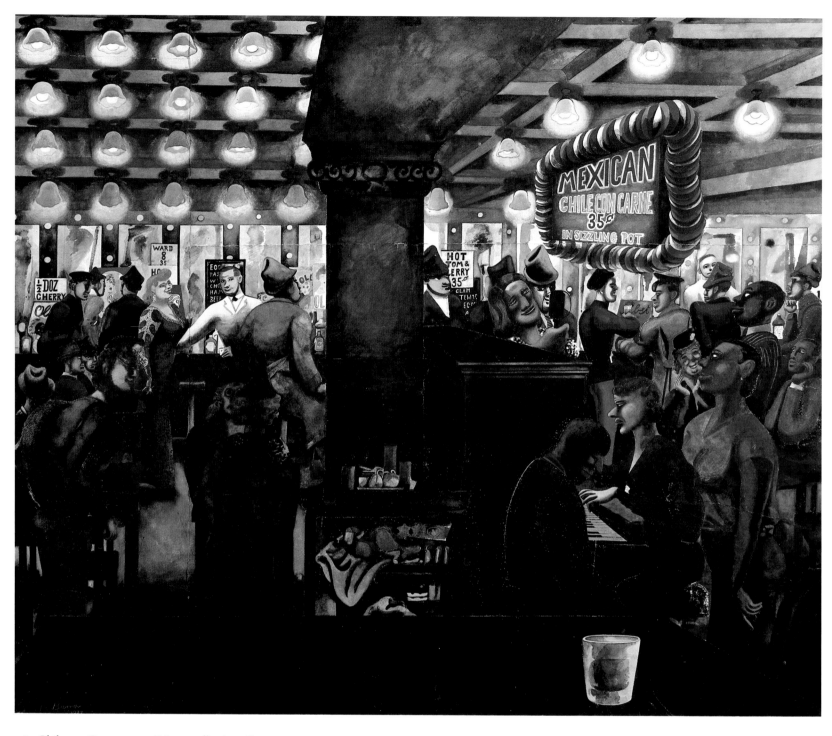

16. *Chile con Carne*. 1937. Private collection. Cat. 130.

Chapter Six

In 1931 Burra was introduced to Conrad Aiken by Nash, who had first met the poet in 1922 but only got to know him well when Aiken returned to Rye in 1930 after a period in America. The friendship between all three grew fast, and by the summer of 1931 Nash, with Aiken's approval, proposed to Desmond Flower of Cassells and Oliver Simon of the Curwen Press that Burra should illustrate a de luxe edition of Aiken's poem *John Deth*, written in 1922–4, but only just published and proving a great success. The project did not go far because of the economic depression, but it led to a friendship that was the closest Burra made after leaving art school, as well as being the most significant for his art. It was with Aiken that Burra visited Spain in 1933 and Mexico in 1937, and when Aiken returned to live in America after the war, Burra made two trips to see him.

Aiken was a southerner from Savannah, described as 'the most distinguished southern poet since Edgar Allen Poe; lover, dreamer, musician, searcher of the horrible and grotesque'.[1] His childhood was a tragic one, marked by the violent death of both parents which haunted his life: his first biographer, Houston Peterson, whose book was published in 1931, the year Burra got to know Aiken, described him as 'enslaved to his dreams; luxurious, terrifying experiences which persist vividly in his memory. They have frequently contained skeletons and disclosed his own death.'[2]

Aiken was an early Freudian, believing that art was escape into illusion caused by inability to act positively, and was drawn especially to 'those parts of society which are as yet least civilized, most emotional, most unrestrained, most *active*': to those, in fact, whose characteristic pleasures, the popular cinema and the music hall, he shared.[3] Living in Boston during the first world war he had drawn in his poetry on the coarse language and uninhibited performances of the vaudeville and burlesque theatres, making a conscious riposte to Puritan pretensions. While all this complemented Burra's own experience and feelings, there were other respects in which Aiken's pessimism with regard to the superficiality of modern society drew Burra in new directions, which he might not otherwise have explored, or not so deeply. After the war Aiken had found himself, like his near-contemporary at Harvard, T. S. Eliot, rejecting the vision of universal brotherhood proposed by the Unanimists, which Burra had at first accepted, and, like Eliot, Aiken saw in the present world a mirror of the crisis of late Elizabethan and Jacobean England, and felt that the satirists of that period, such as Marston and Tourneur, its image of the malcontent, and its feeling for the proximity of death as manifested especially in Webster, were a lesson for his own age; the poets and writers of the sixteenth and seventeenth centuries, he felt, had put all their feelings and experience into their work. Suspicious of art for

art's sake, mistrustful of Bloomsbury, and vigorously insistent on the primacy of content over form, Aiken had never accepted what he saw as the too easily achieved optimism of the twenties; now, as it disintegrated, he was well poised to offer a lead. The meeting with Burra came at the right moment for both. In his autobiography, *Ushant,* Aiken recalled his friendship with Burra and Nash as 'that farther extension of the range into yet dizzier vistas, weren't those two visions alone worth more than anything on the literary scene?'[4]

The only existing design for *John Deth* (Cat. 72) – also known from the inscription on the back as *Homage to Conrad Aiken* – is a picture Burra especially valued, and used to represent him at such exhibitions as the Museum of Modern Art's 'Fantastic Art, Dada, Surrealism' (1936) and the International Surrealist Exhibition in Paris in 1938. It shows Deth with a scythe at a gaudy party which, in its excess, is Aiken's expression of the Freudian death-wish in each of the guests, while Millicent, representing Deth's opposite – the urge to consciousness – tries to repel him. Burra would have known from Peterson's book, if not from Aiken himself, that his initial idea had come from Holbein's *Dance of Death,* in which the figure of death comes up behind each of his victims individually, as he approaches Millicent here. Burra's idiom is nevertheless very different from Holbein's; he was indebted to Grosz in his representation of Deth's rapacious, overfed victims, both for the figure types and the unnatural colours, reds and blues, which add to the hellish atmosphere and recall Grosz's wartime paintings. The tortuous drawing and crowded design belong to the tradition of English caricature and the grotesque, and E. F. Burney was the kind of artist Burra was looking at, some of whose satirical drawings, including Fig. 15, were rediscovered in 1931 and shown at a big exhibition of caricature at the Burlington Fine Arts Club in December.

The design is one of highly polished surfaces which are no longer those of *Arcadia,* for instance, where the figures have a certain sculptural classicism despite the quirky drawing. Here the elements are related dynamically, the eye is drawn restlessly from surface to surface. Lighting still stresses exteriors, reflecting off rather than penetrating them; but now the comparison is not with sculpture so much as with the typical achievement of anti-classicist styles such as Mannerism or the Rococo, the work of the silversmith or jeweller, the craftsman working on a small scale with materials that can be elaborately wrought into complicated decorations. Beardsley, who did much to overthrow Victorian classicism with his love of fantastic detail, had prepared Burra for this change; it conformed to a pattern of thinking expressed in Surrealist-oriented periodicals, such as *Documents,* which published articles on the French Mannerist artists Jacques Bellange and Antoine Caron. [5] Surrealism and the concurrent revival of Mannerism were products of the same anti-rational forces. Specific links between Burra and Mannerism cannot be made as early as 1931, but it was now that a framework of ideas was being established which was confirmed before the end of the decade in Burra's admiration for late Mannerist French artists such as Jacques Callot and Monsù Desiderio.

The appearance in Burra's art of skulls and skeletons reflects not only the interests of Aiken but also Burra's discovery of the macabre elements in the Flemish Symbolism of James Ensor and Félicien Rops. This came through the Surrealist magazines, especially *Variétés* which was published in Brussels; in the case of Rops it can be linked to Burra's reading of Huysmans and of recent books on Rops such as Mac Orlan's of 1928. Peterson's study of Aiken, which was based on conversations, records the poet's interest in Flaubert, who 'could not see a beautiful woman

15. E.F. Burney. *Amateurs of Tie Wig Music, c.* 1820. Watercolour. Whereabouts unknown

without seeing her skeleton', and notes his following Eliot's admiration for Webster, of whom Eliot had written that he was 'much possessed by death/and saw the skull beneath the skin'; Peterson also describes Aiken's delight in a dinner-jacketed skeleton by Rops, whose scatalogical designs had a grotesque humour that delighted Burra.[6]

As a *memento mori, Dancing Skeletons* (1934, Cat. 107), a moonlit revel among ruins, is in a slightly different tradition from that of *John Deth*, namely the return of the dead at night to remind the living of their mortality. In the background Burra included corpses swinging on a gibbet, for which in those disturbed years there was no shortage of sources in real life: photographs of lynched negroes hanging from trees in the southern states of America were reproduced in British papers, while Fig. 16 had appeared in what was virtually a negro number of *Variétés* in November 1928.[7] In April 1933 Burra had made his first visit to Spain with Aiken and Malcolm Lowry; they were based on Granada where they would have seen in the Carthusian monastery the baroque painter Sanchez Cotan's representations of the brutal maltreatment of the monks, sometimes ending with violent death on the gallows.

But comparisons with atrocities in real life and the high art tradition cannot alone account for *Dancing Skeletons*. Surrealism, with its belief that the imagination was ubiquitous, confined neither to particular individuals nor to specific modes of expression, encouraged Burra to cast his net widely. Reviewers of the Unit One exhibition in 1934, the first occasion on which Burra had shown with abstract

16. 'After a Rebellion in
Africa', page from *Variétés*,
November 1928

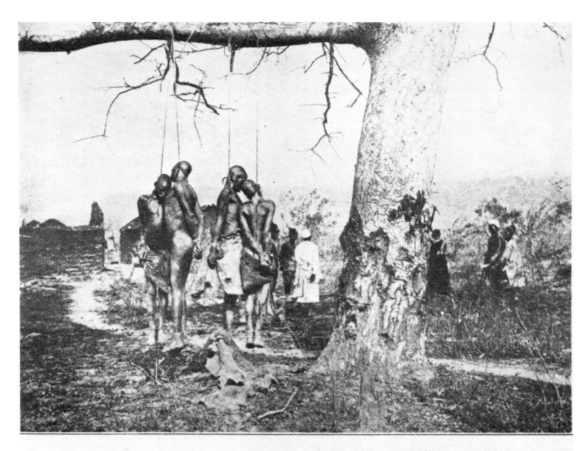

Après une révolte, en Afrique...

17. Walt Disney. Drawing
for *The Skeleton Dance*
from the *Silly Symphony*
series, 1929

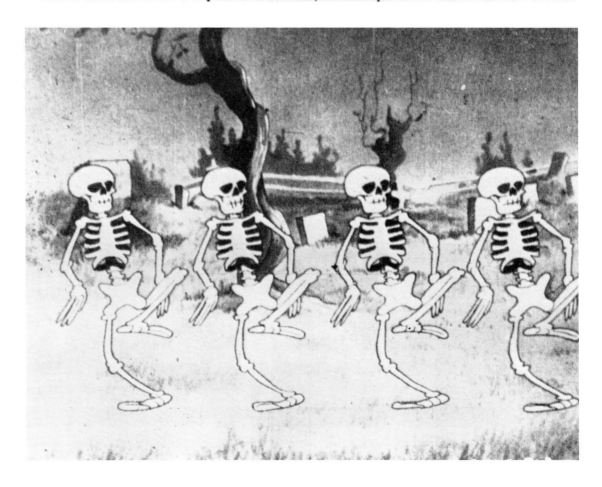

artists, recognized that his art had a different ancestry from theirs, but Osbert Lancaster identified a particular historical context when he said, 'Burra, whether he knows it or not, is a traditionalist. His kinship... is with those anonymous masters who until a few years ago decorated merry-go-rounds and ice cream carts with the last genuine examples of baroque art in Europe.'[8] Burra ignored conventional artistic hierarchies, and had no prejudice against the popular arts. The comic aspect of *Dancing Skeletons,* for example, resembles Walt Disney's *The Skeleton Dance* (Fig. 17), the first of his 'Silly Symphony' animated cartoons, a great popular success when it was first shown in America in 1929, and a favourite of Burra's. The picture also has something in it of the traditional toy theatre, with both skeletons and hanged resembling marionettes, and the whole scene possesses an eighteenth-century Gothick quality in its combination of humour, romance and devilry.

Chapter Seven

John Rothenstein tells the story of how Burra left Springfield one day in October 1933 without a word to anyone, and reappeared equally suddenly five months later having been in New York.[1] The lesson of this is not that Burra went on impulse, but that he liked to maintain a certain independence of his family. Several friends, including the Nashes in 1931, had already been to America, and he hesitated to go straight away when he heard Paul's report of New York only because he feared the expense. Burra's trip coincided with Aiken's temporary return to Boston (which provided him with a base when not in New York), with the visit that autumn by Sophie Fedorovich and her photographer friend Olivia Wyndham, who were his travelling companions, and with the expected arrival in December of Frederick Ashton to direct a ballet section in Virgil Thomson's all-black opera, *Four Saints in Three Acts*. Introduced by Barbara Ker-Seymer, Burra was at 1890 Seventh Avenue in Harlem until around Christmas, with Edna Lloyd Thomas, a distinguished negro actress and friend of the coloured cabaret singer Jimmy Daniels; from January he was at 125 East 15th Street on the lower east side, a district he particularly liked because of its wide mixture of races.

Burra's letters, which generally give a good sense of what he was looking at when abroad, say nothing of visits to the Manhattan dealers' galleries, to such exhibitions as Dalí's at Julien Levy's or Miró's at the Pierre Matisse gallery, and it was now, as his painting clearly shows, that his interest in European modernism began to fade. On the other hand his painting does correspond to a new pattern emerging in American art. On his return from New York two years earlier Nash had written in *The Listener* that there was 'a great deal of talk about American art in America. An idea has become prevalent that there may arise a school of American painting independent – let us say – of the École de Paris.'[2] While Burra was there the Museum of Modern Art showed Edward Hopper, the Whitney Museum showed 'Twentieth-century New York in Paintings and Prints', and the Metropolitan was operating a policy of buying American scene painting, urban and rural. The American tradition and independence from Paris were championed by the New York critics, Carlyle Burrows of the *Herald Tribune* and Henry McBride of *The Sun*. Implied in this and in the widespread admiration for Reginald Marsh, in particular, was a revival of interest in such subjects as street scenes, bars and burlesque shows, which had been popular in the pre-Cubist years around the turn of the century. These were the subjects Burra had been concerned with in Paris and the French ports, and though his technique was quite different from Marsh's, his Harlem subjects related to this new direction in American art; when, in 1939, Aiken told Rothenstein that he considered Burra the most distinguished painter of the American scene, he may have

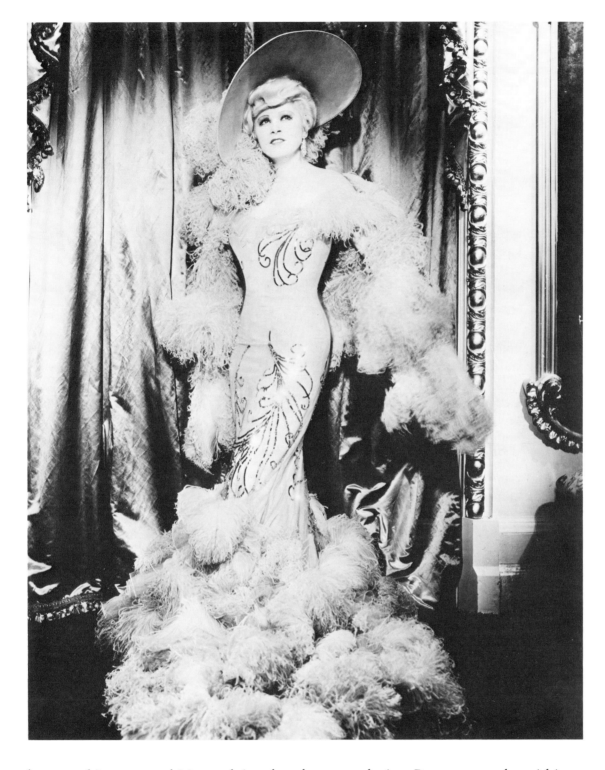

been making an ambitious claim, but he was placing Burra correctly within a recognizable American context. In stylistic terms, the legacy of the first American trip was in a return to the realism of legible images in deep space. Film stills were important – *Mae West* relates to stills from *Belle of the Nineties* (Fig. 18), which opened while Burra was in New York – and so, probably, were posters, as the extraordinary clarity of *Cuban Band* (Cat. 113; Colour Plate 8), in association with its unprecedentedly large size, suggests.

Most of Burra's pictures of this visit are of his familiar urban subjects, but in the new setting of Harlem; concerned with style, decor and human physique, they tell a

lot about life in the district, the streets with their brownstones, restaurants with menus and prices easily readable, even the shape of the contemporary Coca-Cola bottle. As affirmations of a lifestyle that Burra revelled in they are comparable only with the port paintings of the mid-twenties. The Harlem Burra came to was at the end of its twenties 'Renaissance', when negroes from the South had flooded in to find good employment and pay, and artists and authors – with support from a few whites, like Carl van Vechten – had promoted the idea of a specific black artistic identity to extend beyond music – where negro leadership in jazz was obvious – into poetry and literature. The twenties was the decade of self-confidence in Harlem negroes, described by H.L. Mencken when he spoke in 1927 of 'the coloured brother, once so lonely... who bursts through into the sunlight all along the line'.[3] What Burra shows in *Harlem* (Cat. 109) is the negro as described by a *New York Times* correspondent who comes from the southern plantations 'a seedy collarless slouching fellow... slow in motion', whom Harlem transforms so that after a while he and those like him are seen 'strutting the streets, of enviable physique, with slim waists and broad shoulders. Working as stevedores on the piers, they receive good wages and can afford to wear good clothes.'[4] This was the clientele for whom such places as the Savoy Ballroom, the subject of Cat. 120, was opened in 1926 as the sensation of Harlem and one of the grandest dance halls anywhere, occupying the entire block north of 140th street on Lenox Avenue with a dance floor 200 feet by 50.

Harlem had gained its European reputation on account of jazz, which had begun its conquest of Europe during the war when American negroes were involved in the fighting and negro bands began to appear at parties. French painters and poets, such as Picabia and Cendrars, had discovered new sources of vitality in New York before the war, and negro rhythms soon affected European music; Poulenc composed his *Rhapsodie nègre* in 1917, and Milhaud declared that he 'never missed the slightest opportunity of visiting Harlem', where the music was 'absolutely different from anything I heard before the war and a revelation to me'.[5] Cendrars published his *Anthologie nègre* in 1922, and collaborated in 1923 with Léger and Milhaud on the jazz-inspired ballet *La Création du monde*. Paris was becoming known as 'le coeur de la race noire'.

Burra had started to collect jazz records when he was a student, going to Levy's at Aldgate, which held a good stock, and used to paint to jazz at least till the late thirties. In 1925 he went to his first black performance when he saw Josephine Baker's debut in the *Revue nègre* in the Champs-Élysées, and two years later in Cassis he saw her first film, *Siren of the Tropics*. In 1926 he admired Florence Mills in Lew Leslie's *Blackbirds* in London, in October 1928 he first went to the *Bal nègre* in the rue de Lappe, and in the late twenties went regularly to black entertainment when it came to the London Pavilion.

A relevant precedent in English art for Burra's painting of negroes was Stanley Spencer's *A Resurrection, Cookham*, a work that had acquired great critical prestige when it was shown in 1927 at the Goupil Gallery and had been bought by Sir Joseph Duveen for the Tate. It showed negroes and whites emerging from their graves at the Last Judgement, and was originally subtitled *An Allegory of the Saving of the Black and White Races: the Instinctive and the Intellectual*. This contrast between instinct and intellect formed the main ground for a debate in England on the portrayal of the negro in the arts which is relevant to Burra's later Harlem paintings: a debate for which Wyndham Lewis laid down the battle lines in his literary polemic *Paleface*

(1927). Lewis there took up the theme of the separation of mind and body which he had often explored as painter and writer, and now extended it into a full scale attack on the fashionable vogue for the non-European races. Writing against the emotionalism of D. H. Lawrence, 'I would rather have an ounce of human "consciousness" than a universe full of "abdominal" afflatus and hot, unconscious, "soulless", mystical throbbing', he was attacking a European response to the non-European which he perceived as a threat to the rational, self-critical approach of the modern movement.

Burra admired Lewis, primarily as a writer, but also as a painter, especially of portraits. He seems to have bought all Lewis's books on publication, starting with *The Wild Body* (1927), while a reference to Lawrence in a letter of 1925 shows Burra's response to him to have been not dissimilar to Lewis's. But on the subject of the non-European races Burra felt differently from Lewis – or, at least from the Lewis of 1927 – because it was precisely the 'body' side of Lewis's equation that attracted him about negroes. But Lewis liked to assume extreme and sometimes contradictory positions: his *Paleface* argument reflected the dominance of the intellect over the emotions, in accordance with twenties classicism, while another side of him, exemplified in early oil paintings of seafarers and dancers, *Gens de Mer* and *Kermesse*, expresses a physicality close to that which Burra was trying to achieve now.

When he was in New York Burra met Nancy Cunard, an earlier acquaintance who was then concluding her massive anthology *Negro*, published in 1934, in which she presented the view that the negroes have a zest for life, are 'real', while the American white, by contrast, is 'dim', and visits Harlem out of curosity and jealousy: a crude argument but not altogether without truth. Variations of it were expressed by other authors in the anthology, such as V. F. Calverton who, writing on dance, argued that, for the white, Harlem represented an escape from a dull unsympathetic world into one that was dynamic and exhilarating; this was the attraction felt in the Cocteau circle and also by Burra.

Chapter Eight

In spring 1935 Burra made a second visit to Spain. Travelling with Clover de Pertinez, a friend since art school days, he went to Barcelona and then Madrid. When his father became ill in August he returned home, but was back the following April for three months, until the violence preceding the civil war drove him home for good.

The period between the abolition of the Spanish monarchy in 1931 and the civil war was marked by political uncertainty, bouts of anarchy, separatism and killings, as succeeding attempts were made to bridge the gap between the traditional sources of authority – aristocracy, church and army– and the urban working class emerging to political consciousness through increasingly active trade unions, in a society that lacked the stabilizing influence of established middle-class institutions. Burra was anxious as outbursts of violence testified to the explosiveness of the situation, but also excited by the tension. The dynamics of extremist politics provided an element of sensationalism, which was important to him in a similar way to the uninhibited expression of physicality in the music halls, flamenco dancing and bullfights. At the same time the current violence had a kind of inevitability for Burra, who saw it as endemic to Spain and pervading for centuries its art of strong contrasts: realistic and down to earth, dramatic and mystical, courtly, inquisitorial and cruel, but rarely bourgeois or middle of the road. Burra loved Spain, but his only subsequent visit was a brief one to Barcelona in 1952. His reluctance to return to Madrid, though he had friends there always ready to welcome him, did not stem from distaste for Franco – politics did not interest him enough for that – but rather from a fear of finding the city lifeless.

Burra did not take sides in the war. He had an anarchic strain, but also a deep-rooted respect for order and continuity. His dislike of Rye and the privileged class of his birth was not ideological, but a practical contempt for complacent and spurious values, especially those based on money – increased by frustration at the way poor health left him dependent on his family and unable to break free. His view of the role of government – in so far as he had one – was to provide a stable framework for the exercise of individual freedom. On his first visit to Spain in 1933 he had witnessed an outbreak of church burning, which was part of the anti-clerical follow-up to the abolition of the monarchy. Horror at the reality of violence and destruction inclined Burra then to the side of order. But his reaction varied according to the contemporary situation. Later on he hated the arrogance of the Nationalists, the obsequiousness to Franco of the socialist Blum government in France in rejecting pleas to help with arms for the Republicans and the passage of refugees, and the feebleness of Anthony Eden (identifiable as the puppet in Plate 134 on account of his

Homburg hat) in refusing to balance German aid to the Nationalists with help for the Republic. Burra was not interested in ideal political structures, but could react passionately to individual injustices.

Burra shared a contemporary view of Spain as a country offering raw and vivid sensations, inclined to excess and conflict; a place where society had not yet come to terms with God as it had elsewhere in Europe, and was still trapped in a circle of guilt and penitence, dominated by a fear of death upon which the authority of the church was sustained. In *Printemps d'Espagne* (1929), Francis Carco described Holy Week in Seville, emphasizing the extremes of faith and sensuality to give a picture of contrasts and inconsistencies: the busy churches, the fervour of the mendicants' procession (compare Cat. 154) with crowds gathered to watch and participate, paralleled by ecstatic applause for the bullfight; brothels enjoying great popularity, but each room furnished with a statue of the Virgin. In contemporary Spanish art this idea of Spain was reflected in the work of José Guttierez Solana, whom Burra discovered in Madrid and developed an enthusiasm for. Solana's dark, Post-Impressionist style was very different from Burra's own, but he was drawn to Solana's subjects – processions, carnival scenes, torture, penitence, war, death and skeletons – which the artist also explored in a book *L'España Negra* (1920).

Spain dominated Burra's art in the late thirties. He did not approach the war as an objective witness, but was concerned, as before, with its effect on people, the ways they accommodate themselves to violence and destruction, their energies sapped to exhaustion. Buildings – emblems of the urban civilization with which he had identified – crumble, and human beings are reduced to the basest level where mere survival is the best they can hope for; brutalized by one another in a conflict which is bewildering because it has no sense or explanation, men end up maimed and on crutches (Cat. 135) or warming themselves over a small fire among the ruins (Cat. 129). Sinister, hooded female personages lurk in the shadows. As fates goading men to self-destruction they can be gleeful and coquettish like the duennas of the early thirties paintings (e.g. Cats. 86 and 96), but – their work achieved – they are often pitying as much as hostile and seem to grieve at the sadness of human self-destruction (Cat. 129).

In America Burra had begun to draw away from the modern movement, and the later thirties saw him going further in the same direction of clearly drawn figures in deep space which was in part a recovery of his twenties classicism. Now, as then, he saw new art as feeding on tradition rather than reacting against it, and just as then he had looked back on the eighteenth century, so now he drew on the baroque and Goya. In the same way that his earlier classicism had been part of a move among artists towards a wider acceptance of tradition, so his present direction reflected Surrealism's increasing awareness – as interest in abstraction and automatism diminished – of its ancestry in the veins of irrationality running through old master painting from Mannerism to the Romantics. David Gascoyne in *A Short Survey of Surrealism* (1935) referred to the movement's debt to Bosch, Brueghel, Callot, El Greco and Goya, some of whom were included in the Museum of Modern Art's 'Fantastic Art, Dada, Surrealism' exhibition, which Burra saw and was included in.

The Prado, to which he devoted more time than he had to any foreign gallery hitherto, attracted Burra on account both of the Spanish painting and also of the art brought by Philip II from the Habsburgs' Netherlands kingdom in the sixteenth century. The macabre and grotesque in the Flemish Symbolist art of Ensor and Rops, together with Surrealism, had prepared Burra for the scabrous and bitter excesses of

Bosch's *Garden of Earthly Delights* and Brueghel's *Triumph of Death*, two pictures to which he constantly returned. Like many Surrealists Burra admired El Greco, the size and tall shape of whose pictures – repeated in his own *Holy Week, Seville* (Cat. 154) – particularly impressed him when he saw them at first hand. But it was Goya, especially in the etchings and Black Paintings, who excited him the most.

Just as Goya started as a court painter only to be brought face to face with an exceptionally cruel war, so Burra had painted the glamorous Bohemia of the twenties, and now saw its insubstantial fabric unable to cope with the moral issues of the thirties. Except in a few pictures, Goya was not a straightforward chronicler of war, but a commentator on human nature in times of extreme unrest. In this Burra followed him, identifying with the Decadents' attraction to the Goya of the *Caprichos,* the inventor of wild dreams involving bizarre animals and birds and malign women haunting a dark world without specific identity in time or place. This side of Goya was reflected in works of earlier influence on Burra, in Baudelaire's *Les Phares* and Huysmans's *À Rebours*. It was important also to the image of Goya in contemporary Spanish writers whom Burra learned the language in order to read, such as Ramon Gomez de la Serna and Garcia Lorca: they saw Goya not so much as interpreter of a particular moment as of a fundamental Spanish tendency to violence and fantasy. In England, in the introduction to Goya's *Complete Etchings* (1943), Aldous Huxley wrote in language to which Burra would have assented, of the 'unplumbed depths of original sin and original stupidity' expressed in *The Disasters of War*.

Parallels exist in Goya for many of Burra's personages: the mendicant, penitent, torturer, the animal figures, duennas, fates and other hooded women. On a technical level Burra's introduction of ink hatching in a picture with such a Goya-like subject as *The Three Fates* (Cat. 136; Colour Plate 10) also suggests a debt. Burra at his most monumental, as in *Bal des Pendus* (Cat. 132), could draw on Goya's *Colossus* and the fantastic constructions of Dalí to produce a credible nightmare, while in *The Riot* (Cat. 155), *The Three Fates* and *Beelzebub* (Cat. 138), he could also produce pictures of surprising violence. If the latter ultimately have a less overwhelming impact than Goya's scenes it is not because Burra's use, for instance, of Japanese actors' masks makes the scenes less real – Goya was adept at using masks and, like Burra in *The Riot*, could achieve a telling ambiguity between mask and reality. Goya is different from Burra in that, obscure though the meaning of his etchings may be, his presentation is always unequivocal, there are no hints that his terrors may not be real; his work is dramatic but never – as Burra's is – theatrical. Both artists were satirists, but Burra was also here in a small but significant degree a caricaturist. His Beelzebub, like many devils in art, has a comic aspect which releases tension and implicitly diminishes his power; he is something of a jester, related to Callot's Pantaloon (see, for example, Fig. 19) from the *Commedia dell'Arte*, and may even be in part a muscle man from a contemporary comic strip. The difference between the two artists is also connected with degree of involvement and the fact that Goya remained in Spain at the centre of the events his art reflects while Burra left before the outbreak of war. Burra's sources included magazine photographs, which inevitably have a certain distance from the reality they represent.

In the same way that Burra's *Dancing Skeletons* had made use of fiction, in the form of Disney's animations, to convey the violence of the real world, pictures like *The Torturers* (Cat. 126; Colour Plate 11) and *Beelzebub* reflect the world with the help of fiction in the form of the devil-possessed protagonists in the Gothick novels

19. Jacques Callot. *The Two Pantaloons*, 1616. Etching

of Mrs Radcliffe, 'Monk' Lewis and Charles Mathurin. Burra's delight in these rogue heroes was enhanced by their status within Surrealism, and the Surrealists' respect for the appealing scoundrel in the person of Fantômas. As early as the First Surrealist Manifesto in 1924 Breton had singled out the English Gothick novel as a high point in the history of imaginative literature, and had returned to praise it in his essay 'Limits, not Frontiers of Surrealism' in Herbert Read's *Surrealism* (1936). Mario Praz in his *The Romantic Agony* (1933), which Burra read at this time, considered as central to Romanticism cults of devil-worship and witchcraft, together with love of contaminated beauty and the feeling for the enhancement of beauty by horror. The Gothick figure of Burra's Beelzebub bears comparison with descriptions in the works of authors cited by Praz: Frederic Soulié, in his *Mémoires du Diable* (1837), described a dandyish Beelzebub with a hideous smile about to assault his victims, and Edith Birkhead refers in *The Tale of Terror. A Study of Gothic Romance* to Beelzebub's 'sarcastic grin which became so typical of Romantic Satanism'.

Chapter Nine

Spain did much to set Burra's art on a new course, which a six-month visit to the United States and Mexico in the first half of 1937, and a trip to north Italy in the summer of 1938, were to confirm. Between January and May 1937 Burra lived with Aiken at his Charlestown home, which had the view across the river to Boston seen in *Destiny* (Cat. 131). In April he visited the New York Museum of Modern Art's 'Fantastic Art, Dada, Surrealism' exhibition, which was on tour at the Springfield Museum of Art, and he was there again shortly afterwards for a one-man show of his own work. In May he went with the Aikens by train to Mexico, first to Mexico City, and then on to stay with Malcolm Lowry, whom Burra had met with Aiken in Granada, and who was now living some fifty miles south of the capital at Cuernavaca.

Between D.H. Lawrence's arrival in Mexico in 1923 and the Second World War, the country acquired a particular mythology for the British writers, such as Huxley, Waugh, Greene and Lowry, who visited it. It was seen as a land of cultural extremes, with its background of Aztec paganism and Catholicism, of striking physical contrasts, and as a country whose rich if largely ruined heritage of architectural monuments recalled a history that had been as dynamic and bloody as recent Mexican politics had been unstable. It presented in starker terms many of the contrasts of Latin Europe and, especially, of Spain. In Cuernavaca Aiken read the first draft of Lowry's novel *Under the Volcano,* in which the hero's drunkenness and terror at his own inner chaos was a metaphor for disintegration in the world at large, what Lowry called 'the universal drunkenness of mankind'.[1] Though Burra may not himself have read *Under the Volcano* before its publication in 1946, he always admired the scale of Lowry's ambitions, the compulsive quality of his writing and freedom from conventional formal restraints. 'I don't think anyone took any notice of *Volcano'*, he wrote to Aiken in America about the novel's weak reception in England, 'as it isn't a subtle little psychological novel about a bunch of Bloomsbury cook-housekeepers letting their hair down in lovely prose.'[2]

Lowry, considering the setting of his book, referred to the Mexicans as 'a colourful people of genius... [with] a religion that we can roughly describe as one of death'.[3] Burra's preoccupation with violence and death, the result of his interest in Spain, was reinforced by themes that ran through Mexican art from the early civilizations and the Catholic baroque to the modern muralists. It was an art he never ceased to admire, visiting the big post-war exhibition twice, in Paris in 1952 and again when it came to London early the following year. He was interested not only in the historical treasures, but also admired the extravagant sugar skulls, pride of Mexican confectioners' art, which were included in the show, and the popular

EL JARABE EN ULTRATUMBA

20. José Guadalupe Posada
(1852–1913), *A Jig in the
Beyond*. Relief engraving
on metal

nineteenth-century *memento mori* prints by José Guadalupe Posada (Fig. 20), who revived his interest in the skeleton dance (Cat. 107).

In Mexico City Burra's attention focused first on the baroque churches, which were already known to him through the writings of Sacheverell Sitwell, and appealed to him on account of their dominating size and ornate, sculpture-encrusted surfaces. His current concern with decay gave an added interest to their crumbling magnificence, the result of general neglect and deliberate damage in earlier, anti-Catholic stages of the Mexican revolution.

The design of *Mexican Church* (Cat. 146) was taken directly from two postcards, one of the crucified Christ in the same recumbent pose in the church of Santa Catarina in Mexico City, the other showing the gilded reredos and tabernacle, surpliced priests and naked cherubs, in the cathedral at Taxco, which Burra also visited. His principle addition was of shrouded worshippers whom he included, perhaps, because he was concerned not only to emphasize Christ's suffering, but also to make the most of its human value through the proximity of the crucified body to ordinary people.

Mexican Church is one among several pictures at this time which express Burra's interest in sculpture within painting. He has invented a progressive scale of figures, from the conventionally dressed man at the very front through the cloaked women, the carved priests and cherubs, to Christ: a scale which corresponds to a change of level from the human to the divine and from the painting of living figures to sculpted ones. The sculpted image implies closeness to human life on account of physical resemblance, but also distance, because it has been taken out of time and frozen apart from everyday reality. Sculptural or masked images, with their ambiguous relationship to human form, were especially useful to Burra in the later thirties, a

21. Giorgio de Chirico. *The Song of Love*, 1914. Oil. New York, Museum of Modern Art

time when he was exploring in a number of ways the overlap between the temporal and infernal worlds. This overlap, and the use of masks to represent it, had originated in the late twenties and early thirties through his interest in the *Commedia dell'Arte* and the Venetian carnival. With the added introduction in *Medusa* (Cat. 145; Colour Plate 13) of mythological subject matter such as is found in late nineteenth-century art, Burra's debt to Symbolism was increasingly evident. But most important of all now was the precedent of de Chirico, who had reinterpreted for the twentieth century the Symbolists' half-human lunar world, and used

sculpture (compare Fig. 21 with Cat. 150) to convey a sense of longing for what is not attainable in the temporal sphere.

Burra's inclination to satirize false sentiment and dubious ritual makes his real attitude to Catholicism hard to gauge. Interested in the expression of energy in others, he was naturally attracted to the manifestations of faith in an earlier art like the baroque which tended to emotional extremes. But remaining himself independent of institutions and unwilling to accept any framework of dogma, Burra followed no religious observance. What he did share with Catholicism was a sense of evil as something real, as many of his paintings of the late thirties show – not only those with religious subjects. To the extent that his mind worked concretely in terms of images, and imitation was as much at the root of his art as effigies were essential to Catholicism, his determined rejection of simplicity, clarity and austerity – claimed as virtues by those working on the abstract side of advanced art – was a denial of the Puritan tradition.

There is a division in Burra's art between those scenes of violence which relate generally to the Spanish war, but also, like *Beelzebub*, have a mythical aspect, and pictures that are actually of soldiers. Among the latter, a few, like *Soldiers in a Lorry* (Cat. 162), refer directly to the presence of troops in Rye during the Second World War and include identifiable local landscapes. Others, however, even some made after the start of the European war, have no specific location. *Soldiers at Rye* (Cat. 157; Colour Plate 18), for example, was first exhibited and reproduced simply as *Soldiers*; but when John Rothenstein in conversation with Burra referred to the figures, reasonably enough, as conquistadors, Burra replied that they were soldiers at Rye and subsequently the picture was given this title.[4] Both in fact were right, as Burra's mind obviously worked on several levels at once. Most of the pictures are reflections of war in a very wide context and some, like *War in the Sun* (Cat. 149), a theatrical painting with historical costumes alongside modern weaponry, are concerned with war as a recurrent feature of Spanish history. It was probably this painting that Wyndham Lewis was referring to when he said, 'I share Burra's emotions regarding war: when I see the purple bottoms of his military ruffians in athletic action, I recognize a brother.'[5]

Lewis may also have recognized common ground of another kind, since his own *Surrender of Barcelona* (1936), though probably inspired by the civil war, is in historic costume and refers to a siege in the fifteenth century. Both artists thought of their pictures not in terms of documentary records, but as paintings within a tradition of war art. Though Burra's pictures of soldiers include tanks and trucks, and are full of menace, in most there is very little of the actual grime and carnage of war. *War in the Sun* and *Camouflage* (Cats. 149 and 144; Colour Plate 12) do not make their impact through immediacy or evident truth to conditions as the First World War pictures of Nash and Nevinson had; they show awareness of historical precedents and artistic conventions, possessing the bright colours and sharply defined forms of heraldry, and part of their artistic ancestry is in such paintings as Uccello's *Rout of San Romano*.

The sharp, clear forms of Uccello are of a kind also found in the work of Diego Rivera which Burra saw in Cuernavaca. Rivera had been commissioned by the American ambassador in 1929 to paint a set of murals there as a gift to the Mexican government, showing a panorama of Mexican history including the conquest of the Indians by the Spaniards and the liberation of the workers and peasants by the revolution. Spaniards in armour confront Indians with vast beaked masks, the

designs of which were derived from Aztec art. The beaked Indians became a feature of Rivera's painting, and appear again in his paintings in the National Palace in Mexico City done between 1930 and 1935, which Burra may also have seen. Burra, already familiar with the predatory bird masks of Max Ernst and George Grosz's pig-headed men, would have had no difficulty in accepting Rivera's bird and animal equivalents, and was stimulated by the size of Rivera's murals to rework such images in his own art on the much larger scale of a picture like *Soldiers at Rye*.

Burra's Italian trip in 1938 was his first since 1926, and took him to Milan, the Lombard cities and Venice. He was to make two later visits to Italy, in 1965 and 1966, to stay with friends in Florence, but it was obvious that that city, with its storehouse of early treasures, no longer held his attention, and subsequent letters written when he was no longer able to travel long distances abroad, regret that he had never been to Rome. Burra had a roving eye that picked up ideas from numerous sources, and it would be wrong to see his foreign travel as targeted on specific objectives, it is nonetheless clear that already by the late thirties his interests had turned to later Italian art.

Though Venice was a place Burra had always wanted to see, the Venetians he admired were the rococo painters, above all Tiepolo, and in so far as their subjects were leisure and fashion, executed with a light touch and pale colours, their art was closer to Burra's of the twenties than now. The bulkier forms, richer chiaroscuro and dramatic shadows of his current painting had their origins in the baroque, where also was to be found the interest in the common man and social outcasts more than ever visible in his own art.

One focus of Burra's interest now was art in the period of the Thirty Years War, which presented problems similar to those of his own day. Jacques Callot appealed to Burra because his work possessed the elegance and artifice of Mannerist court art but also reflected the extreme brutality of the war in his home province of Lorraine. Monsù Desiderio, another Frenchman of this generation, who, like Callot, worked in Italy, painted extraordinary visions of decay such as the picture Burra would have known in the National Gallery, *Fantastic Ruins with the Vision of St Augustine* (Fig. 22); this has crumbling buildings and ghostly statuary in niches – such as Burra used in Cat. 135 – and tiny figures of the saint and a child dwarfed by the nightmare environment under a pitch black sky.[6]

When Burra showed his pictures of the war in 1942 it was with the early eighteenth-century Genoese painter Alessandro Magnasco, in particular, that he felt comparison was due. Magnasco's interests lay on the margins of society in groups of bandits, beggars and gipsies, monks and soldiers – leaderless rabbles rather than organised military troupes. Like Burra's, Magnasco's subjects were alternately febrile and manic; paintings of enervated soldiery contrast with others of monks in frenzied self-mortification. His figures may be war-weary and disenchanted with life, but they exist in a world in which religion was obviously still a driving force, though, as with Burra, true faith borders both on sorcery and empty ritual.

For Magnasco, as for the Neapolitan Salvator Rosa in the previous generation, whom Burra also admired, landscape was a major element in his painting, and the natural counterpart of the wild and undisciplined human existence he portrayed. Burra's turn to urban subject matter in the twenties had implied support for a classical ideal that saw urban civilization as an expression of cultural achievement and nature by contrast as raw and unformed. In 1937 Burra had taken up landscape again alongside his war pictures in which ruins register the collapse of this urban

22. François de Nomé
called Monsù Desiderio.
*Fantastic Ruins with the
Vision of St Augustine,*
1623. Oil. London,
National Gallery

ideal. Though nature was not yet the dominant force in his painting, it was gradually
to become so, and already provides a habitat, as in the work of Magnasco and Rosa,
for the alienated gipsyish figures of Cat. 142.

Landscape has tended to play a larger part in English art than in that of other
European countries. Its role in English Surrealism was central, and it is not
surprising that Burra should have been at the front of what was about to be a major
revival of interest in artists such as Magnasco and Rosa. Magnasco was too
disorderly and anarchic for nineteenth-century sensibilities, and it is significant that
the foundation in 1923 of the Magnasco Society which took his name – though its
purpose was the promotion of seventeenth- and eighteenth-century Italian painting
as a whole – occurred as part of the reaction in the 1920s against Victorian cultural
values. The Sitwell family, who were the Society's prime movers, were concerned not
only to overthrow accepted tastes in the old masters and reinstate the baroque and
rococo, but, as friends immediately after the war of such writers as Ronald Firbank,
Aldous Huxley and Wyndham Lewis, were champions of the anarchic and satirical
in literature. More than anywhere else in England it was in the Sitwell circle – of
which Burra was aware, though, by his own choice, not a member – that a strain of
intellectual independence was created which Surrealism was able to feed on and
extend. Burra's interest in Magnasco and others coincided with the opening up of a
taste for fantasy and a vision of decay on a more popular level in William Gaunt's
book *Bandits in a Landscape. A Study of Romantic Landscape from Caravaggio to
Delacroix* (1937). Interestingly, the first of a number of Magnasco exhibitions in
modern times was held in 1938 at the Springfield Museum of Art which had shown
'Fantastic Art, Dada, Surrealism' as well as Burra's own work the year before.

Chapter Ten

After his 1942 exhibition at the Redfern Gallery Burra's output was low for several years. Obtaining materials was difficult, but lack of stimulus and the general wartime confusion was the real problem: Burra was at Rye, his friends were scattered, even short journeys were difficult and there was relatively little art to be seen in London. Above all the trips abroad which had opened up so many new ideas for him since the mid-twenties were impossible. Burra spent more of his time reading; he followed the new British poetry through the upsurge of journals and anthologies and kept in touch with literary developments on a wider front through *Horizon*. Aiken sent him copies of the American late Surrealist periodical *View* which sustained his interest in unorthodox religions and the occult. In poetry Burra was quick to recognize the talent of Dylan Thomas and other younger poets and was among the first, at the beginning of 1942, to consider the new poetry in its relationship to Romanticism.[1] When Aiken left for America in 1940 he invited Burra to take any books he wanted from Jeakes House, the Rye home to which he never returned on a permanent basis.[2] The books Burra borrowed led him to a renewed interest in the Elizabethans and the seventeenth century, especially Webster, and an increased admiration for Eliot, on account of what he called his 'picture of social disintegration and isolation of the individual'.[3]

In 1937 Burra had started exploring landscape again for the first time in ten years. The new designs generally include some human presence, a stately sentinel walking through the forest in *Blue-Robed Figure under a Tree* (Cat. 140), a puffed-up, self-important little demon figure lording it over the confusion in *Landscape with Red Wheels* (Cat. 141), and elsewhere various gipsies, vagabonds and outcasts. Burra's turn to natural subjects coincided with a wider revival triggered off by Nash's Surrealist landscapes of 1934–36 and by writers on Surrealism. Hugh Sykes Davies, contributing to Herbert Read's *Surrealism* (1936) and closely followed by Nash, drew attention to the importance of Wordsworth for the expression of the imagination through landscape, while Read himself, who had written extensively on Romantic poetry, called for the rescue from neglect of Samuel Palmer – a rehabilitation carried out over the next ten years by Geoffrey Grigson.[4]

Although Burra's technique shows that he was looking at Nash and the early English watercolourists, his landscapes do not fit easily into the pattern of the Romantic revival in England. They share neither the eschatological vision of Nash's last work, nor Sutherland's metamorphic Surrealism (though Burra's individual tree shapes certainly betray Sutherland's influence). Despite the considerable discussion that surrounded the work of the Romantic landscapists in the forties, their names do not crop up in Burra's letters, as those of Blake, Fuseli and John Martin do. Burra's

landscapes of this period are neither domestic like Constable's, nor sublime like Turner's; his nature, wild and tangled or bleak and bare, with broken wheels as recurring emblems of civilizations in decay, have nothing of Palmer's vision of a partnership of man and nature under God's guiding hand. Enemy attack focused the attention of an artist like Nash on the English landscape as a symbol of the will to resist. But Burra never had that kind of Englishness; he had never wanted to be an official war artist, and his war pictures reflected the tragedy of the human condition rather than having any partisan, propagandist function. They have a restrained passivity that allows that landscape may be an ultimate resting place for the dispossessed (Cats. 142 and 173), as it was in Magnasco, but not that it is necessarily friendly or reassuring.

Burra can too easily be identified with Latin culture. Although he never visited Germany (or Holland until 1964) and, Paris apart, hardly knew northern Europe outside Britain, his relationship with the Mediterranean south was always ambivalent, his classicism eccentric and flawed. His love for the south was at least as much for its easygoing lifestyle and the possibility of independence it offered as for any strongly felt cultural affinity. Difficult though it is to fit Burra's landscape paintings into the north European tradition, that is where they and all his late work belong. He had as firmly rooted a sense of man as a wanderer in a hostile world as any of his British contemporaries, and his gnarled tree forms, reaching branches, clusters of prickly twigs and swathes of dense undergrowth have all the restlessness and complicated linearity of north European art. British Neo-Romanticism in the forties was short-lived partly because several of the artists involved, led by Sutherland, headed for the Mediterranean as soon as the end of the war made it possible. With Burra the opposite occurred. The Mediterranean had been his second home for fifteen years, but now, partly because of the weakness of his health, and because of the disappearance of the specific milieu that made the south so appealing, England was to be Burra's almost exclusive base. It was to take him a long time to find his way to the roots of Romanticism, and it was not until the 1960s that the ideas hinted at now came to maturity.

Two visits to Ireland in 1947 and 1948 restored the momentum Burra's art had lost since 1942. His first sight of the country had been in 1937 from a transatlantic liner, and going there the following year as a result, he had discovered the quiet barren landscapes and decaying Georgian cities that were to be features of his painting ten years later. 'There are no lack of ruins here', he told Nash on that first visit, 'Ireland is one of the most beautiful countries I've ever seen. Galway is full of crumbling warehouses... such beautiful country it really is extraordinary.'[5] In Limerick ten years later he described the 'eighteenth-century houses and doorways and stone Greek temples etc. I'm afraid that some of the loveliest eighteenth-century houses are at such a pitch of degringolade... and inhabited by crones who vanish into portals... Many are too far gone and are falling down, as are many of the stone warehouses glowering down the Shannon with their hollow windows.'[6]

The slow decay of Irish Georgian architecture interested Burra at least as much as the sudden changes caused by bombing in Rye (which he recorded in letters in considerable detail); he was attracted to the contrasts and the down to earth character of Irish life, the peasants' horse-drawn cart in the elegant Dublin street and popular take over of the grand Georgian terraces (Cat. 183). He had been concerned since 1936 with survival at a basic level, and once the war and violence were past, his interest began to focus on the sort of everyday stoicism evident in *Dublin Street*

Scene, people's quiet acceptance that life is hard and limited in its possibilities, that it must be taken as it comes. Burra nonetheless passes his own comment. In declaring 'the Galway girls by George Grosz and not John are my favourites two inches high and draped in black bedspreads', he was rejecting Augustus John's mythologizing of the Irish peasant as a tall blond Venus;[7] but to prefer Grosz to John is to exchange one convention for another; Burra's hooded figures scurrying through the streets, guarding doorways and peered at through windows are part real and part fictionalized equivalents of Grosz's downtrodden proletarians, with whom they share a singleminded intentness on the business of survival.

Although English Neo-Romanticism was chiefly concerned with rural themes, it inherited from French Neo-Romantics of the Cocteau circle like Eugene Berman a vision of decaying buildings as metaphors for the crumbling of civilization. The more Paris-orientated English Neo-Romantics, like Michael Ayrton, and those like Ayrton and John Minton who shared Burra's connections with the stage, developed a theatrical mode of representing urban decay. Burra nevertheless avoided the nostalgia typical of this kind of painting because the illustrative vein in his work, clear in a picture like *Dublin Street Scene,* sustained his interest in everyday reality.

The 1950s opened with Burra painting a remarkable series of biblical scenes, isolated in their emotional intensity from what either preceded or followed them. *Judith and Holofernes* (Cat. 202), a commission from the Arts Council for a large painting on a subject of the artist's choice for their Festival of Britain exhibition 'Sixty Paintings for '51' was the first, followed by a group which was shown together at Burra's first exhibition at the Lefevre Gallery in 1952; as multi-figure compositions on religious themes they are linked with late thirties pictures like *Agony in the Garden* (Cat. 152). Burra had rejected there the traditional representation of the subject in the paintings by Mantegna and Bellini in the National Gallery, where the atmosphere is calm, with Christ turned away from the spectator to pray, the disciples sleeping in the background, and only a hint of action from the approaching soldiers. Closer in time to Burra, Gauguin's *Christ in the Garden of Olives* anticipates him in turning Christ to face the spectator, though Gauguin's remains a quiet, contemplative picture. In taking up the subject himself, Burra wanted above all to express passion. His soldiers come rushing from behind at a Christ who sweats with anguish, a sufferer, a Man of Sorrows, rather than the quietly confident Christ of tradition. Passion manifested in activity was Burra's ambition in these pictures, and he attacked most readily and succesfully scenes of decisive action, such as *The Expulsion of the Moneychangers* (Cat. 209) and *Peter and the High Priest's Servant* (Cat. 211): the protagonists here are vengeful and more in keeping with the spirit of the Old Testament than the loving and redeeming God of the New. In *Simon of Cyrene* (Cat. 214) Jesus is seen as the victim of a ghoulish crowd that seems to be part Irish and part Spanish; but at the same time the homage paid to him in *The Entry into Jerusalem* (Cat. 208) is that due to a man apart, such as a charismatic war lord, not a man of the people; even when, as in *The Pool of Bethesda* (Cat. 212), the role of Jesus is a healing one, he has the intense, possessed features of a shaman.

The verve and sheer skill of these pictures is undeniably impressive. More consistent in handling than earlier comparable designs, the new works avoid the awkward montage effects of some of the latter – sudden cuts from tall foreground figures to distance – and Burra's manipulation of baroque design and lighting is very skilful. Murillo's *Pool of Bethesda* and El Greco's *Expulsion of the Moneychangers* in the National Gallery were certainly in Burra's mind, and the upsurge of religious

painting in the forties, with the treatment of the Crucifixion theme by Sutherland and Bacon, provide something of a context. At the time of the Bacon retrospective at the Tate in 1962 Burra was to admire the 'impact of a mule kick' he got from the paintings, and became friendly with the artist when introduced to him by John Banting.[8] Though it was precisely the 'mule kick' effect that Burra wanted in his biblical paintings, he achieved this by means of an open and direct expression of emotion by comparison with which even Bacon's paintings seem ambiguous and veiled.

Burra's engagement with Christian themes does not necessarily imply religious commitment, and the pictures are better seen as an attempt – ultimately frustrated, as the absence of any development from them shows – to relate his paintings to public issues that aroused and divided people's passions. Wartime interest in Christian themes persisted for a time, as was shown by the lavish public enthusiasm for Dali's *Crucifixion* (Glasgow Art Gallery) – endorsed wholeheartedly by Burra when it was shown at the Lefevre Gallery in 1951 – but was moribund by the time of the Tate's 1958 exhibition 'The Religious Theme'. Britain lacked a tradition of left-wing social realist painting like that in France which seems relevant to Burra's preoccupations at the end of the forties when he started revisiting Paris. He had been aware before the war of Francis Gruber, when his 1936 *Portrait of Jacques Callot* – the seventeenth-century artist whom Burra admired for his exposure of the cruelty of war – was carried in processions of the Front Populaire. The war period had directed Gruber onto an apparently different tack, his painting *Judith* (1946) being of the subject that started Burra's post-war religious series. André Fougeron's *Hommage à André Houiller* – a murdered Communist pamphleteer – (1949), Edouard Pignon's *Ouvrier Mort* (1951), and Picasso's *Massacre in Korea* of the same year, reflect the deep antagonism on the part of these artists to elements in contemporary politics. At the height of the cold war, as in the Spanish Civil War period, Burra's anger at what he saw as social and political betrayal by leaders and establishments pursuing false aims lacked the particular social or political expression of the French artists, but found its outlet in these impassioned religious subjects. To the extent that they stress power and authority rather than celebrating love and redemption, they represent a personal and unorthodox view of Christianity.

The quiet stoicism of the Irish scenes set against the demonic passions of the religious pictures is evidence of volatility in Burra's mood. Energy and lassitude, commitment and passivity, had alternated before in his art, but not to this degree. In retrospect these years can be seen as a time when Burra faced the choice between an engagement in public debate and isolation, and finally opted for the latter. In its widest context his dilemma was that expressed by Sartre in *La Nausée* (1938), a book which Burra described to Aiken around 1947 as compelling reading.[9] Sartre's novel in effect expressed dissatisfaction with the commitment to independence and disengagement he saw in a writer such as Gide, and the directionless freedom from responsibility of the youthful heroes of Cocteau and Radiguet; it presented a challenge, in fact, to the culture Burra had substantially identified with in the twenties. For if Sartre's outsider, Roquentin – satirically and contemptuously critical of those whose self-esteem relates only to position and convention – has much in common with Burra, the personal crisis which led Roquentin to recognize the pointlessness of unfettered independence in effect asked the same question about freedom and responsibility of a reader like Burra. Sartre and Camus, whose *L'Etranger* (1942) Burra also read soon after the war, attracted him because he

shared the disillusionment with social systems which led them to demand active commitment from the individual. But although his art was stimulated by the issues of the day, Burra remained essentially an observer, a perceptive commentator from the sidelines rather than a participant in the action.

Chapter Eleven

A large proportion of Burra's work in the fifties was still life, which was not only virtually a new genre for him but one which he pursued with an impassive sobriety, in contrast to the passion of his biblical works. 'All flowers and still lifes. All sweetness and light', is the way he described the pictures in his 1957 exhibition;[1] these were done from life and were 'perfectly straight much to everyone's horror or not as the case may be'.[2] A generally favourable, if reserved, critical response had been building up since 1942, and though the pictorial qualities of the new work were endorsed, there was also some sense of expectation disappointed. David Sylvester in the *New Statesman* described the 'drama in the flowerpieces' as 'perhaps the most pungent things Burra has ever given us, because they are more subtle pictorially than the subject pictures: they are also more vividly, more intensely, striking and disturbing, precisely because they need nothing other than their spiky shapes and clashing colours to make them so'.[3] *The Times* critic referred to Burra's settling down to a 'comfortable orthodoxy', and concluded 'it will be a pity if we are to be denied in future the fruits of Mr Burra's strange imagination', while pointing out that Burra's precise observation nevertheless made his forms vivid, intense and disturbing, without the need for exaggeration.[4]

Disturbing these works may be by the standards of most flower paintings, but for Burra they are strangely formal, entering no dialogue with the spectator and suggesting that he is reserving himself behind a facade, finding a means of going underground. Much English painting in the fifties was marked by an earnestness that Burra found prosaic, and there was nothing to compare with the glamour of the twenties or the imaginative release activated by Surrealism. Kitchen sink realism had features that might have appealed to Burra, but it was a tame affair by his standards, lacking the display and excess, stylishness and nonconformity which he was to admire in certain aspects of Pop a decade later. By then, when the urban avant-garde Burra so badly needed was being reborn, his interests had moved almost entirely beyond contemporary art.

Although Burra was visiting Paris again, and made a single trip to Barcelona in 1952, he could not rediscover the vitality these places had had for him before. The nearest he came to recapturing the feel of the pre-war period was in America, which he visited twice in the fifties, in the early summer of 1953 and for a six-month period between January and June 1955.[5] In 1955 Burra was under pressure to provide work for three exhibitions, at Lefevre, at the Magdalene Sothmann Gallery in Amsterdam, and at the Swetzoff Gallery in Boston. For the last, while living with the Aikens in Boston he painted scenes derived from visits to nightspots which gave picture titles such as *Izzy Ort's* (Cat. 234) and *Silver Dollar Bar* (Cat. 235). Reminiscent of

pre-war work, though not mere pastiches, these pictures show the liberating effect on Burra of a long period away from Rye with intimate friends like the Aikens.

Burra's isolation went beyond lack of sympathy with contemporary artistic directions. As he grew older he became increasingly solitary, confining himself to the society of family and a few old friends and to the painting that was the focus of his life. When the Royal Academy approached him in 1963 to become an Associate, he recognized that the conservative direction of his painting made acceptance sensible, and hesitated for some time. But at the same time he wrote with passion: 'I wish to God they'd leave me alone. After all I've been alone for forty years or more.'[6] His sense of isolation also took the form of increasing unconcern for property: 'I don't care about furniture or bathrooms. I've got the horror of anything but an orange crate', he wrote in 1966 when he was first considering the move he was to make three years later to a former gardener's cottage at Springfield.[7]

Burra's art had long been associated with gipsies, tramps and people displaced by war, types whose affinity and contact with society was minimal. He himself increasingly identified with such people, as what had originally been for him an assertion of freedom turned into a kind of social exile. In so far as this exile was self-sought a starting point for the process of his detachment was the work of Samuel Beckett. Introduced by Clover de Pertinez to Beckett's *Molloy* around 1951–2, soon after its first publication in French, Burra described it to Aiken as 'full of crowds of people all unable to speak and exchanging signs'.[8] He soon read other works, and told Aiken at the beginning of 1954, 'I am getting like the hero(?) of Samuel Beckett's new book [*L'Innommable*] who is finally reduced only to a trunk and lives in an urn full of sawdust outside a restaurant by the abattoirs. Marguerite the proprietress empties the jar every week and puts the contents on her lettuces. She also throws a tarpaulin over his head when it snows. All I want is a jar big enough.'[9] Beckett appealed to Burra as a humorist of the grotesque, but the attraction was also more personal than this. Coming to Beckett through the trilogy *Molloy*, *Malone Meurt* and *L'Innommable*, Burra found in its principal characters reflections of his sense of the meaninglessness of much human activity. In the contrasts between their silences and compulsive talking, their inertia and passivity against the will to stay on the move and continue their ultimately pointless searching, Burra saw something of his own situation; and though he liked to appear humorously resigned to identification with the Beckettian hero, he was nervous of that degree of isolation. Beckett was closer to Burra than was Sartre, because for Beckett disillusion led not to freedom and a new morality of action but to despair.

If the 1950s seems to have been a period of reserve for Burra, the sixties was one of regeneration and expansion, and the last decade and a half to his death in 1976 introduced a new range of ideas expressed mainly through landscape. Burra remained alert to developments in art and visited exhibitions of younger as well as established artists, even though his own painting was little influenced by new developments. The rejuvenation of British art with Pop and the new abstraction can be seen as a stimulus to Burra even though his own switch to landscape was against the trend of the decade. Burra's breakaway from still life was stimulated, in particular, by a renewed interest in Romanticism after the big Romantic exhibition at the Tate in 1959. It was a concern that dated back to the 1940s, but had not been followed through. Burra had shown enthusiasm for the 1948 Blake exhibition at the Tate, had further developed an existing taste for Fuseli through Ruthven Todd's book *Tracks in the Snow* (1946) and the Arts Council's show in 1950; John Martin,

23. Joseph Wright of Derby. *Earth Stopper on the Banks of the Derwent*, 1773. Derby Museum and Art Gallery

whose cataclysmic vision of great empires in decline particularly appealed, was known to him also through Todd and Thomas Balston's biography (1947). In *Landscape with Birdman Piper and Fisherwoman* (1946, Cat. 171), Burra had invented a species of earth spirit, less frightening than Fuseli's ghosts, but inspired by them and the work of Romantic and Victorian illustrators and certainly not Surrealist; his *Limbo* (Cat. 189) and the watercolours including angels (Cats. 190 and 191) suggest that Burra was beginning to think in terms of a Blake-like mythology. But the sudden collapse of the Neo-Romantic movement at the end of the decade meant that these ideas were not developed, and it was only after the 1959 Romantic exhibition that he began to pursue them afresh.

In the late forties and early fifties Burra had maintained some commitment to Surrealism which discouraged deeper exploration into Romanticism. Alongside his new ghosts and angels he continued to invent great beaky birdwomen and aggressive, coquettish females with animal or bird heads, manifestly hostile beings even if their precise identity is hard to define. The example of Ernst comes together here with those of Grandville, Cruikshank and other nineteenth-century illustrators, the Venetian carnival mask, and beyond that Bosch and the medieval bestiary. But whatever the origins of the forms, and Burra was aware of many, the metamorphoses his figures underwent were still essentially Surrealist. From around 1960 Burra's imps and demons are of a different nature: they are not metamorphosed humans but part of a separate and integral world of spirits. They may be teasing, threatening and subversive like the Surrealist personage, and they may have related art-historical

origins – in Bosch, for instance, who remains a force, or Beardsley who becomes a renewed attraction. But because their environment is a magical one of their own and they are not intrusions into the normal world they are – in so far as a precise distinction can be made – Romantic rather than Surrealist.

The sense of menace in Burra's paintings derives not only from demons like those in *The Burning House* (Cat. 266), who gloat as the building is razed to the ground. It stems also from the hallucinatory intensity of Burra's vision: a bed of yellow lupins (Cat. 257) and swathes of cherry blossom (Cat. 284) seem to melt under his gaze, and the flowers in each case become a soft glutinous mass; this is not really a Surrealist metamorphosis because identity is not being changed, there is no use of symbol or metaphor. In Samuel Palmer's *In a Shoreham Garden*, where the fruit tree blossom is so dense that the underlying form is lost, the result is joyful, while with Burra life at its most burgeoning seems to become sickly through excess; something from which pleasure might be expected becomes distasteful. Rigid pointing fingers representing the branches of espalier-trained fruit trees that have not yet come into flower are seen against trees already covered with swags of luxurious blossom – an expression of the Romantic theme of the cycle of life and death in nature; for Burra it is more death in life than the opposite because of the frailty of the blossom against the hard skeletal frames of the dormant trees.

In *The Allotments* (Cat. 283) Burra creates menace of a different kind, suggesting furtiveness in the man digging by means of the Romantics' technique of implying his own and the spectator's unseen presence behind the labourer. Mystery is further evoked by the rickety potting shed which, because it has no visible entrance, seems a riddle, an unknown in the middle of the known, its blocklike shape mirrored by other smaller but similar forms resembling gravestones. The allotment holder becomes a gravedigger and the bird watching from a nearby branch a messenger of death. Burra's purpose was to stimulate the imagination rather than persuade the viewer to see the picture in one particular way. *The Allotments* helps to define Burra's relationship to the English narrative tradition, and a useful comparison in this respect is with a painter whom Burra came to admire particularly, Joseph Wright of Derby. Wright's *Earth Stopper on the Banks of the Derwent* (Fig. 23) offers an apparently similar mystery as to why the man should be digging in the night. While Wright, however, for all the magic that Burra and the twentieth century as a whole have read into his painting, was at base a documentary painter (the earth stopper's activity has a straightforward explanation), for Burra the evocation of mystery was an end in itself.

In 1953 the Burras had moved from Springfield into the town to Chapel House which was built for them on the site of a Methodist chapel bombed in the war. Chapel House looked over a steep escarpment to Romney Marsh, the view seen, for example, in *The Ramparts* (Cat. 277), and it was the level, unbroken panorama of the marsh that established the pattern of many of Burra's late landscapes. Three visits to East Anglia, the Fen country and Lincolnshire with his sister Anne between 1965 and 1967 confirmed the appeal of flat, bare countryside. Subsequent motor trips, with his sister and Clover de Pertinez when she lived in Harrogate between 1965 and 1970, were mainly round the lightly populated peripheries of the country, Yorkshire, the moorlands of northern England, the Lake District, North Wales, the Welsh border country and Cornwall. Burra never sketched on these trips, but sat in the car at places chosen by the driver and studied the scene intently as he had café life before the war. At home he worked with pencil, crayons and felt-tipped pens on

24. George Cruikshank,
The Railway Dragon from
*George Cruikshank's Table
Book*, 1845

sketch pads, working out designs that may be composites of more than one scene together with invented sections. He was searching for particular effects and was not primarily a topographer.

Burra's landscapes often have deep distances mapped out with extraordinary clarity. Sharp horizons and clear, hazeless air give the feeling of places just washed by rain. Noiseless and motionless, often seeming as if experienced in a dream, the scenes are the antithesis of Impressionist landscapes; while the latter tend to bear the marks of human habitation and work, Burra's distance themselves from the spectator, often focus on the remote at the expense of the foreground, and are commonly sunless and uningratiating.

In such a picture as *The Tunnel* (Cat. 336) the layout is schematic with characteristics of both a poster and a map, the high viewpoint helping to detach the spectator from the scene; both the train in the cutting and the distant road traffic seem so motionless that they appear less than real. Burra liked to exaggerate tonal

contrasts, as with the unnatural whiteness of downland chalkpits against surrounding woodlands in the backgrounds of *The Tunnel*, or the winding river and its overspills against the marsh in *River Rother, Early Morning* (Cat. 291). Distance is used there for emotional purposes. The winding river recalls the turning paths and rivers of Maurice Denis and other Symbolists, in which distance in space is linked with the idea of passing of time, a notion more explicity expressed in *Connemara* (Cat. 285) where three figures (or the same figure repeated three times) are spaced out on a primitive boulder-strewn path.

Burra had always been interested in the emotional potency of perspective, and the legacy of de Chirico is seen in the way his motorways enforce their hard geometry on the landscape, generally plunging straight from front to back of the picture. Occasionally, as in *English Countryside* (Cat. 325) there is a seductive Romantic lonelinesss reminiscent of early motoring posters enticing drivers to explore the remoter parts of Britain. But even here a characteristic melancholy predominates, and for the most part Burra drew motorways as he felt them to be, hostile intrusions carved into the countryside. The organization of fields bordering the road in *Motorway* (Cat. 383) has been carefully mapped out to show how the flat sheets of tarmac obliterate the scale of the landscape. Traffic in the *English Country Scene* designs (Cats. 359 and 360) rushes past oblivious of its surroundings as if part of an endless continuum; there is a compulsive quality about the drivers' pursuit of their goals that recalls in contemporary form the theme explored by the Symbolists of an all-powerful force drawing victims involuntarily into some hell mouth. Such ideas were not part of Burra's conscious intention, which was more straightforward and connected with his dislike of the juggernaut and interest in conservation. Back in 1947 he had spoken with approval of a cut in the petrol ration, he was opposed to railway closures in the sixties, and his letters are full of criticism of developments and 'improvements', such as Manchester's scheme to 'tidy up' the verges of Ullswater as part of a plan to turn it into a reservoir[10]. Burra's dislike of heavy transport on the roads can be compared with Cruikshank's representation (Fig. 24) of popular fear of the railways a century earlier.

Burra increasingly preferred large-scale, empty places. When cultivation and the human imprint showed at all, it was often as a pattern of ploughing or arrangement of dry-stone walls whose geometry gave a certain effect of anonymity. He avoided scenes marked by the kinds of variety or complexity that might bring them within the eighteenth-century definition of the picturesque, but his interest in grandeur of scale and apparent limitlessness has much in common with contemporary concept of the sublime. Burra had the sublime landscapist's ability to show nature as overwhelming and awe inspiring, and in such pictures as *In the Lake District No. 2* (Cat. 392) and *Sussex Landscape No. 2* (Cat. 412) Burra's isolation of houses and farmsteads as tiny white spots on a hillside or flat plain defined in effect the cultivated, civilized world as a series of enclaves in the midst of boundless nature. Even if the lonely farmhouse can be seen as a metaphor for the condition of the individual in an unfriendly world, it does not imply that Burra necessarily sympathized with the Romantics' sense of nature as a divine manifestation, and landscape therefore as a bridge between man and the cosmos. Burra clung to reality, painful though it was, rather than engage in building cosmologies he did not believe in, and landscape remained for him what it had been in *Landscape with Wheels* (Cat. 142), a place of last resort for the disenchanted.

Notes

Chapter Two

1. 'In Praise of Cosmetics', from *The Painter of Modern Life* (1863), translation by Jonathan Mayne, Phaidon Press, 1964, pp. 31 and 32.

Chapter Three

1. Nash's comment is reported by his wife Margaret Nash in an unpublished memoir in the Victoria and Albert Museum Library.
2. Metzinger's *Bal Masqué* was reproduced in *Artwork*, January–March 1926, when it belonged to the Mayor Gallery.
3. Burra's letter is unfortunately impossible to date at all precisely.
4. From 'Order considered as Anarchy', an address given at the Collège de France, 3 May 1923, quoted from *A Call to Order*, Faber and Gwyer, 1926, p. 187.
5. *London People Sketched from the Life*, Smith Elder, 1863, p. 59.
6. See Jeffrey Myers, *The Enemy. A Biography of Wyndham Lewis*, Routledge and Kegan Paul, 1980, p. 159, and *Satire and Fiction*, Arthur Press, 1930, p. 43.
7. *Blasting and Bombadiering* (1937), 1967 edition, Calder and Boyars, p. 35.

Chapter Five

1. Reproduced in Nos 1–2, 1938.
2. No. 5, 1930.
3. No. 7, 1930.

Chapter Six

1. Alfred Kreymborg, quoted by Houston Peterson in *The Melody of Chaos*, Longmans Green, 1931, p. 28.
2. Peterson, op cit., p. 28.
3. Letter to Grayson McCouch, 13 March 1913, in *Selected Letters of Conrad Aiken*, ed. Joseph Killorin, Yale University Press, 1978, p. 32.
4. *Ushant. An Essay*, Duell, Sloan and Pearce, 1952, p. 278.
5. Nos. 3 and 7, 1929.

6. See Peterson, op. cit. pp. 73, 160 and 215.
7. For the photographs of lynched negroes, see for example, *The Listener*, 20 January 1932, illustrating a discussion on cruelty between Gerald Heard and Aldous Huxley.
8. *Architectural Review*, June 1934.

Chapter Seven

1. Introduction to *Edward Burra*, Tate Gallery exhibition catalogue, 1973.
2. 4 November 1931.
3. Editorial, *American Mercury*, October 1927, quoted in Jervis Anderson, *Harlem. The Great Black Way*, Orbis, 1982, p. 180.
4. *New York Times*, 17 April 1927, quoted in Jervis Anderson, op. cit. p. 141.
5. From *Notes without Music* (1935), quoted in Jervis Anderson, op. cit. p. 179.

Chapter Nine

1. In a letter to Jonathan Cape, 2 January 1946, in Harvey Breit and Margerie Bonner Lowry, *Selected Letters of Malcolm Lowry*, Jonathan Cape 1967, p. 66.
2. Undated 1947.
3. Letter to Jonathan Cape, 2 January 1946, in *Selected Letters*, op. cit. p. 67.
4. See John Rothenstein, "Edward Burra", introduction to Tate Gallery exhibition catalogue, 1973, p. 29.
5. *The Listener*, 9 June 1949.
6. The picture was previously ascribed to Callot. Monsù Desiderio was the Neapolitan title known to Burra of the artist whose proper name is François de Nomé.

Chapter Ten

1. Letter to Conrad Aiken, 9 January 1942.
2. Undatable letter from Aiken to Burra.
3. Letter to Conrad Aiken, 9 January 1942.
4. Paul Nash, "The Life of the Inanimate Object", *Country Life*, 7 May 1937.
 Herbert Read, introduction to *Surrealism*, 1936, pp 58–59.
 Grigson's first article on Palmer was in *Signature*, November

1937, while a major essay by the poet Thomas Sturge Moore had appeared in *Apollo*, December 1936.

5. Undated letter of July 1938.
6. Undated letter to Conrad Aiken of 1948.
7. Undated letter to William Chappell from Galway, September 1947.
8. Letter to Conrad Aiken, 14 June 1962.
9. Undated letter to Conrad Aiken.

Chapter Eleven

1. Letter to Conrad Aiken, 14 February 1957.
2. Letter to Conrad Aiken, 20 June 1957.

3. *New Statesman*, 25 May 1957.
4. *The Times*, 8 May 1957.
5. Some uncertainty surrounds the dates of Burra's post-war visits to America. These are the only trips documented in the correspondence between Burra and Aiken which was regular and unbroken over the whole post-war period.
6. Undated letter to Clover de Pertinez, May 1963.
7. Letter to Conrad Aiken, 19 May 1966.
8. Undated letter to Conrad Aiken.
9. Letter to Conrad Aiken, 6 January 1954.
10. Letter to Conrad Aiken of 31 August 1947, referring to petrol rationing in the USA; and letters to him of 14 June 1962, and 9 March 1962.

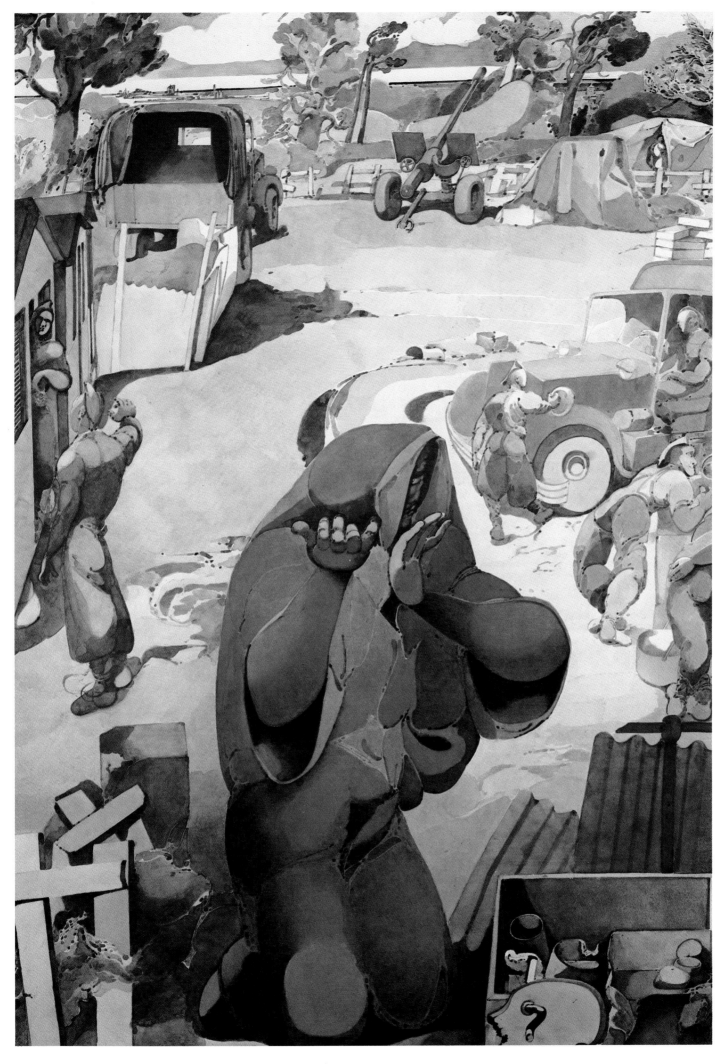

17. *Death and the Soldiers*. 1942–3. Private collection. Cat. 159.

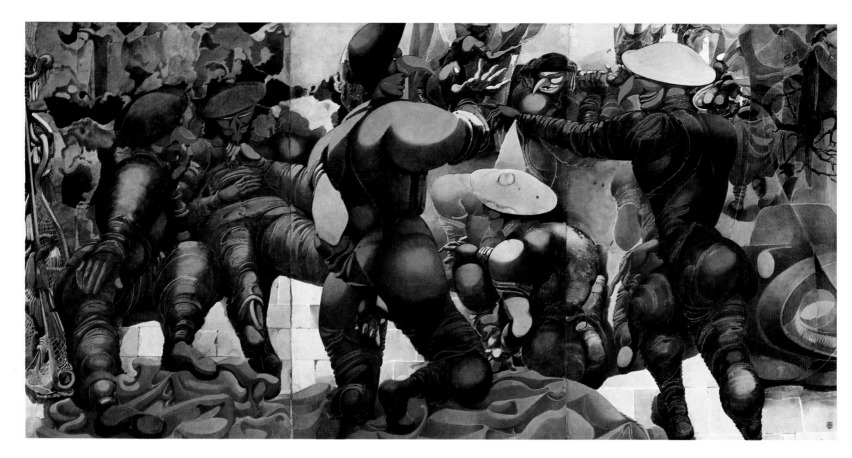

18. *Soldiers at Rye*. 1941. London, Tate Gallery. Cat. 157.

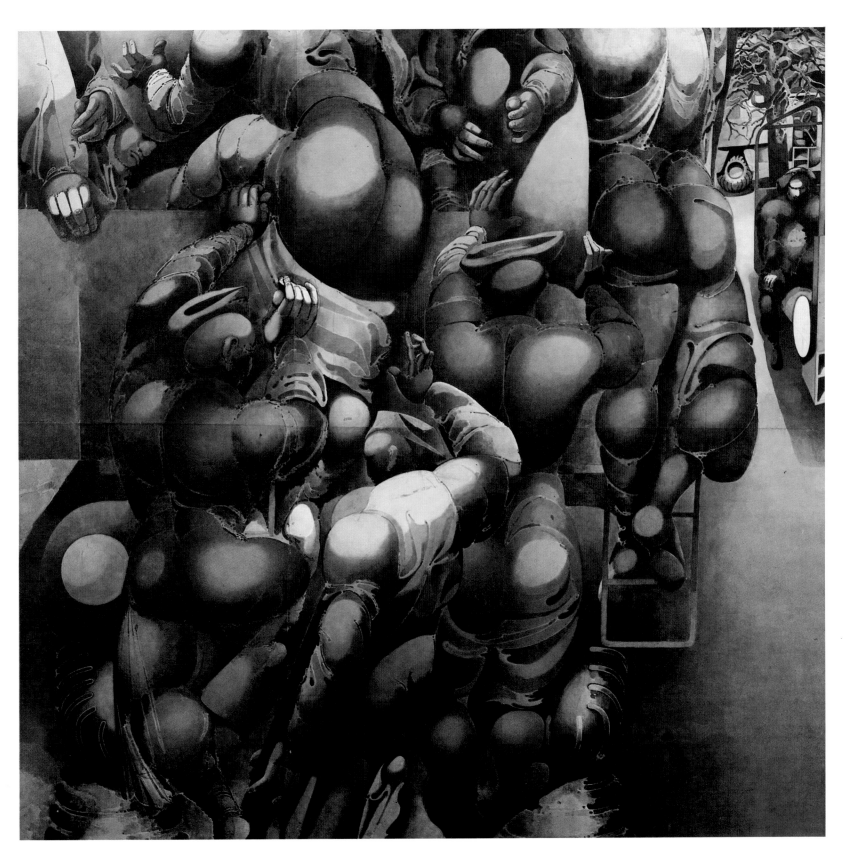

19. *Soldiers' Backs*. 1942–3. Eastbourne, Towner Art Gallery. Cat. 161.

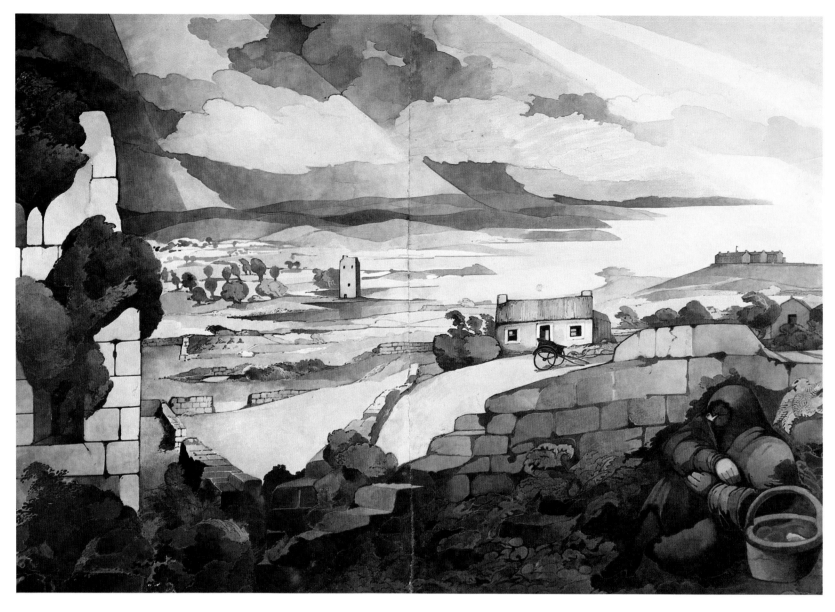

20. *The West of Ireland.* 1948. Private collection. Cat. 187.

21. *The Canal.* 1959–61.
Private collection. Cat. 268.

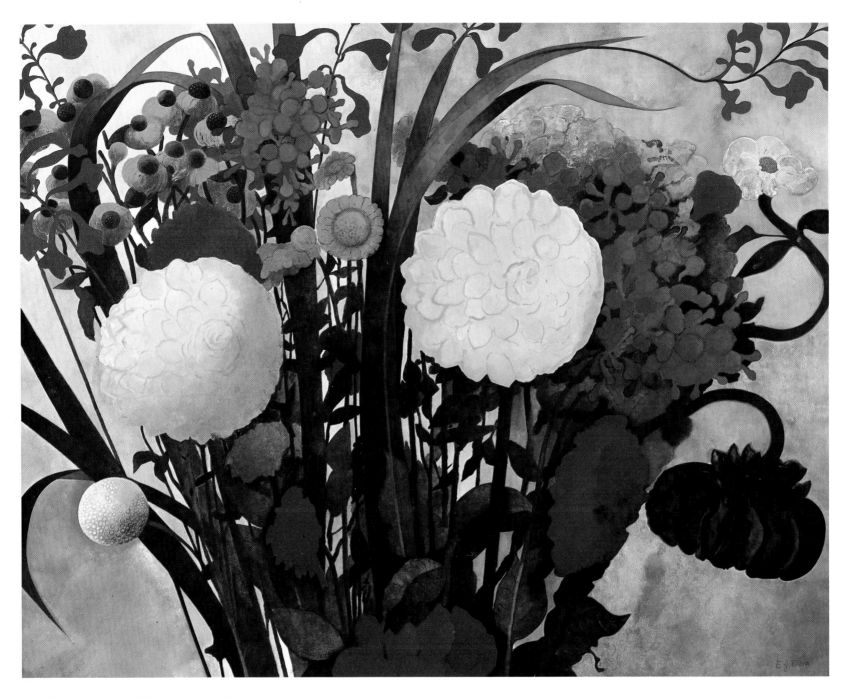

22. *Flowers*. 1964–5. Private collection. Cat. 304.

23. *Peonies and Vegetables.* 1955–7. Private collection. Cat. 241.

24. *The Hole of Horcam, Lockton Moor.* 1972. Private collection. Cat. 381.

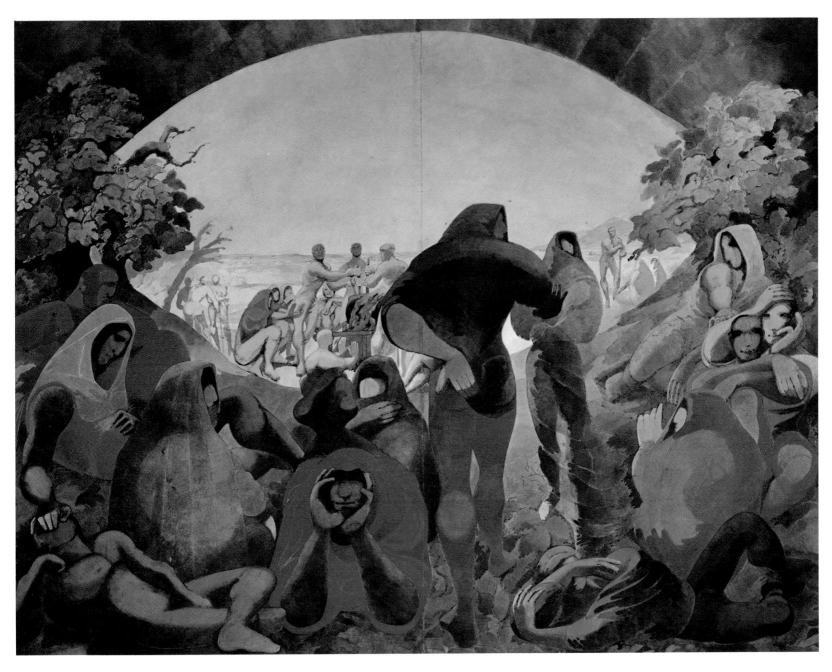

25. *The Rest in the Wilderness.* 1950–2. Private collection. Cat. 213.

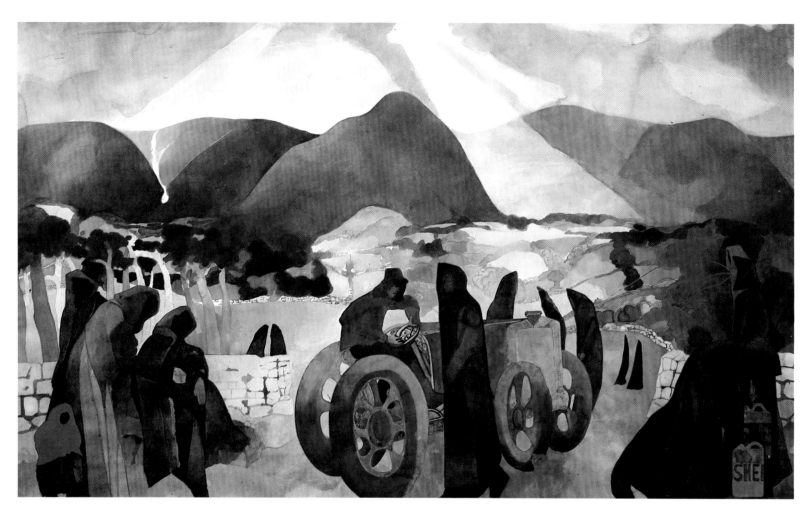

26. *Black Mountain.* 1970. Rye Art Gallery. Cat. 357.

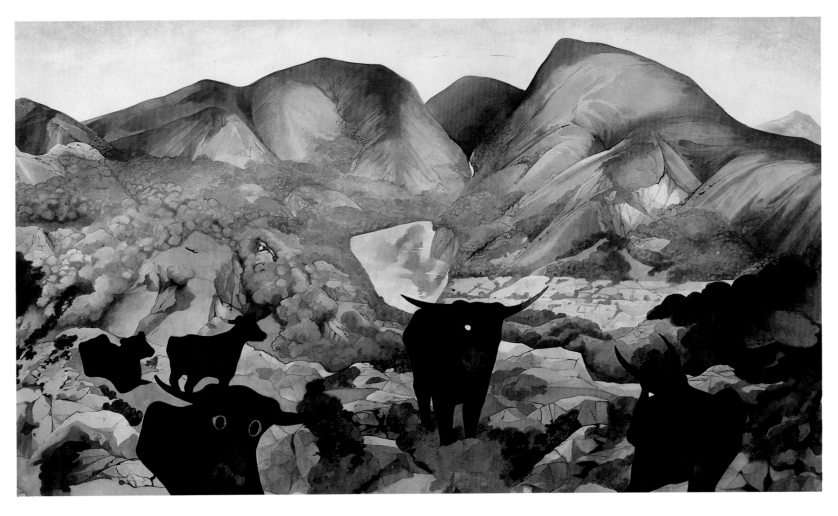

27. *Snowdonia* No. 1. 1971. Private collection. Cat. 379.

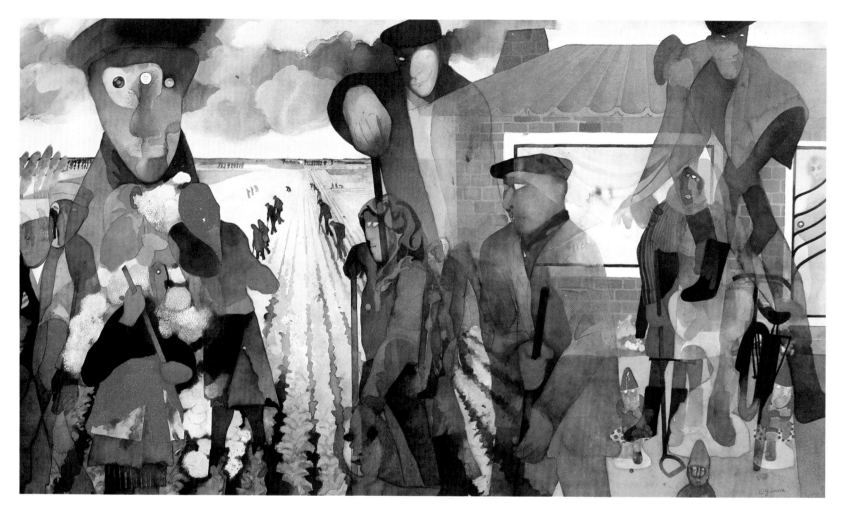

28. *Sugar Beet, East Anglia.* 1972. Private collection. Cat. 386.

29. *English Country Scene, No. 2.* 1970. Private collection. Cat. 360.

30. *Landscape, Cornwall,with Figures and Tin Mine*. 1975. Private collection. Cat. 406.

31. *View at Florence.* 1965–7. Private collection. Cat. 337.

32. *Figure Composition*, No. 2. 1944–5. Private collection. Cat. 399.

Catalogue

Burra did not keep records of his pictures, which exist only since 1952 when the Lefevre Gallery started the regular exhibitions that they have continued to the present. The gallery's invaluable photographic record forms the basis of much of this list.

All Burra's known paintings are recorded here, including those referred to in exhibition catalogues, which can be dated with reasonable certainty but have not been traced. The drawings are a detailed representation of his work, but are not intended to form an exhaustive catalogue. Theatre, opera and ballet designs are excluded except when referred to in the text; the same applies to Burra's book illustration and design work.

The infrequency of Burra's early one-man shows (there was none in England between 1932 and 1942), means that reviews and reproductions to help identify and date his work are scarce. His lack of interest in the history of his work contributed to the erratic dating in the Burra volume in the Penguin Modern Painters series (1945), which is the only major publication before the catalogue of the Tate retrospective in 1973. A few pictures are dated, but the evidence of style has been important in forming the chronology up to 1950, especially for the 1930s.

Sizes are in centimetres, height before width. Only public owners are listed by name.

Paintings

1. *Back Garden*. 1922.
Watercolour, 48.9 × 34.
London, Victoria and
Albert Museum.

2. *Balloon and Bouquets*.
1922. Ink and watercolour,
26 × 18.1. Initialled and
dated.

3. *The Beehive*. 1922.
Indian ink and green wash,
38.7 × 29.2. Signed. Not
illustrated.

4. *Market Stall*. 1922. Ink
and wash, 14 × 21.6.

5. *Out for a Walk*. 1922.
Watercolour, 34.5 × 27.
Signed.

6. Picking Flowers. 1922.
Ink and watercolour,
38.1 × 27.9. Signed.

7. *Spring*. 1922. Indian ink
and wash, 14 × 21.6.

8. *Theatre Scene*. 1922.
Indian ink and wash,
21.6 × 14.

9. *The Thief*. 1922. Ink and
wash, 14 × 21.6.

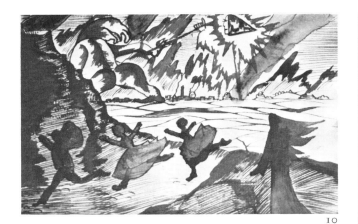

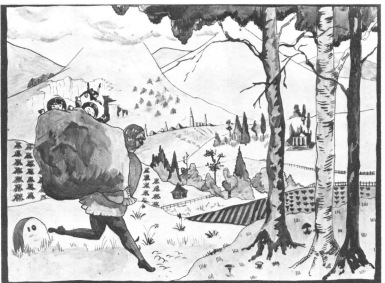

10. *The Thief.* 1922. Ink
and wash, 14 × 21.6.

11. *The Thief.* 1922. Ink
and wash, 28.6 × 38.7.

12. *Walkers.* 1922. Ink and
wash over pencil,
21.6 × 14.

13. *The Window.* 1922.
Watercolour, 34.5 × 27.5.
Signed.

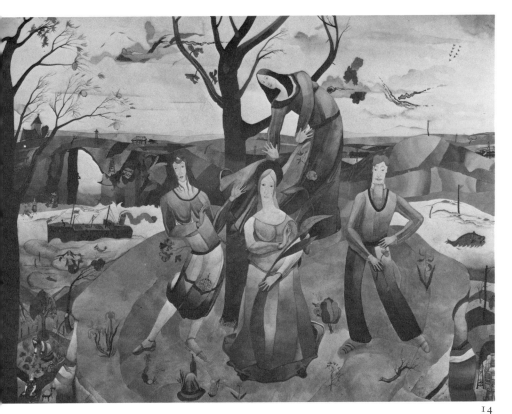

14. *The Annunciation* or
*St Anne, St Agnes and St
John Zachary.* 1922.
Watercolour, 47 × 62.2.
Signed (bottom) and
initialled and dated (centre).

15. *The Family Council.*
c. 1923–4. Watercolour,
heightened with bodycolour
and metallic paint,
23.5 × 33. Signed and dated
(later?) '25 or 26'.

16. *Girl in a Windy
Landscape. c.* 1923–4.
Pencil, ink and watercolour,
22.9 × 32.4. Signed on
reverse.

17. *Scene in a Wood.*
c. 1923–4. Watercolour,
33 × 22.9. Not illustrated.

18. *Spanish Gardeners.*
c. 1923–4. Sepia and red ink
and wash, 35.3 × 39.3. Not
illustrated.

19. *The Three Graces.*
c. 1923–4. Pencil and
watercolour, 48.8 × 22.9.
Signed.

20. *The Taverna.* 1924.
Pencil and watercolour,
39.1 × 43.8. Signed and
dated.

21. *French Scene.* 1925–6.
Watercolour, 49.5 × 39.4.
Signed and dated.

22. *Fiesta.* 1926. Pencil and
watercolour, 43.2 × 38.1.
Signed.

23. *Market Day.* 1926.
Watercolour, 55.2 × 37.5.
Signed and dated. Colour
plate 3.

24. *Le Café.* 1927.
Watercolour, 55.9 × 38.1.
Signed and dated.

21

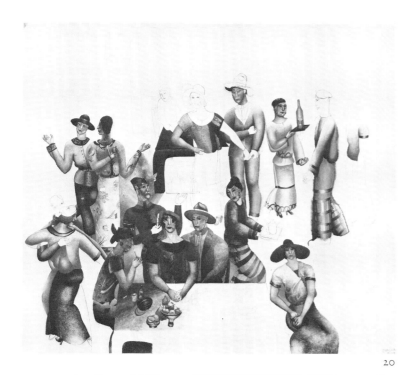

20

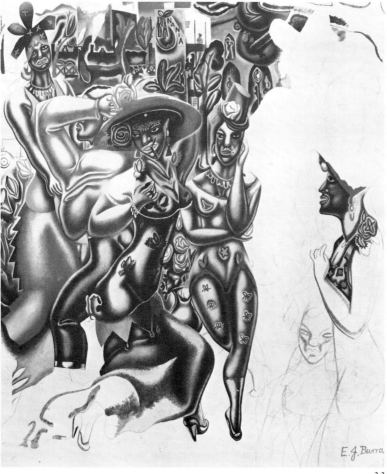

22

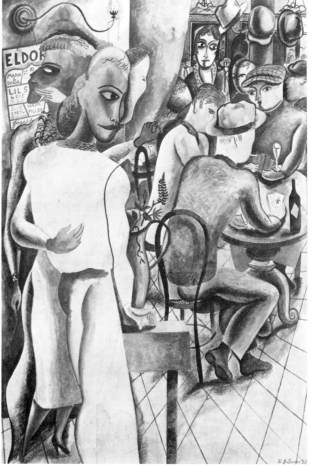

24

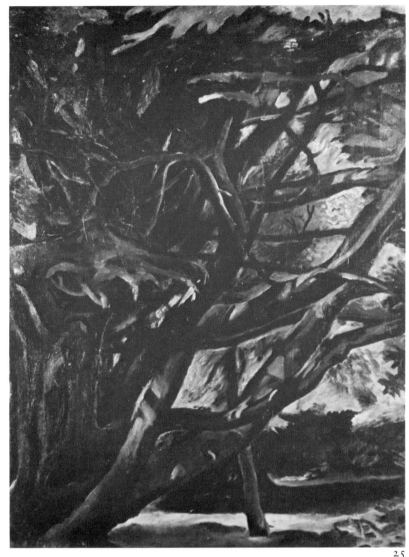

25

26

27

28

25. *Cedar at Springfield.*
1927. Oil, 63.5 × 50.8.

26. *Drawing Room at
Springfield.* 1927.
Watercolour, 56.5 × 39.4.
Signed and dated.

27. *The Drive.* 1927.
Watercolour, 56.5 × 39.4.
Signed and dated.

28. *The Garden.* 1927.
Watercolour, 55.9 × 38.1.

29. *The Greenhouse*. 1927.
Watercolour, 54.5 × 36.5.
Signed.

30. *Landscape at
Springfield*. 1927.
Watercolour, 56.5 × 39.5.

29

30

31. *The Orchard,
Springfield*. 1927.
Watercolour, 54 × 36.2.
Signed and dated.

32. *Springfield Gardens*.
1927. Watercolour,
58.4 × 43.2. Signed and
dated.

31

32

33

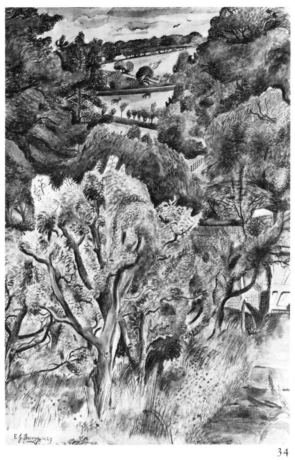

34

33. *Toulon*. 1927.
Watercolour, 56.5 × 39.5.
Signed and dated.

34. *The View*. 1927.
Watercolour, 56.5 × 39.5.
Signed and dated.

35. *Le Bal*. 1928.
Watercolour heightened
with bodycolour,
65.4 × 47. Signed and dated
'Nov 1928'.

36. *Les Folies de Belleville*.
1928. Gouache, 63.5 × 51.
Signed and dated 'May
1928'.

37. *Portrait of William
Chappell*. 1928. Oil,
76.2 × 50.8.

35

36

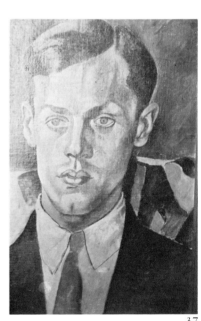

37

38. *Arcadia.* 1928–9. Watercolour heightened with body colour, 67.3 × 47.6. Signed and dated.

38a. *The Cafe. c.* 1928–9. Watercolour, 59.7 × 48.3. Illustrated page 201.

39. *The Eavesdropper.* 1928–9. Watercolour heightened with bodycolour, 61 × 48.9

40. *The Lute Players.* 1928–9. Watercolour heightened with bodycolour, 45.5 × 36.3. Signed.

41. *Marriage à la Mode.* 1928–9. Gouache, 62.2 × 50.8.

42. *The Tram.* 1927–9. Watercolour heightened with bodycolour, 59.1 × 38.7. Signed and dated.

43. *Balcony, Toulon.* 1929. Oil, 50.8 × 40.6. Signed and dated.

44. *The Common Stair.* 1929. Oil, 45.7 × 38.1. Signed and dated. Not illustrated.

45. *Composition collage.* 1929. Collage and ink, 47.6 × 39.4. Signed. Colour plate 1.

46. *Dancing Cows.* 1929. Gouache, 59.5 × 47.5.

47. *Dessert.* 1929. Gouache, 58.5 × 47.5. Signed. Colour plate 2.

48. *Grog.* 1929. Oil, size unknown. Not illustrated.

49. *The Kite.* 1929. Gouache, 76.2 × 55.2. Colour plate 4.

50. *On the Shore.* 1929. Gouache, 51.0 × 62.7.

50a. *Show Girls.* 1929. Gouache, 70 × 35. Illustrated page 201.

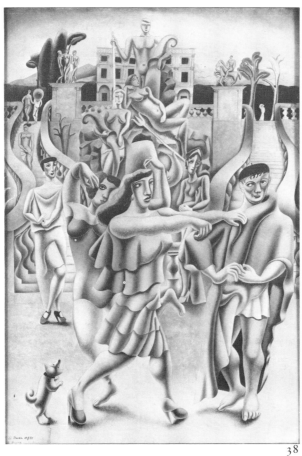

38

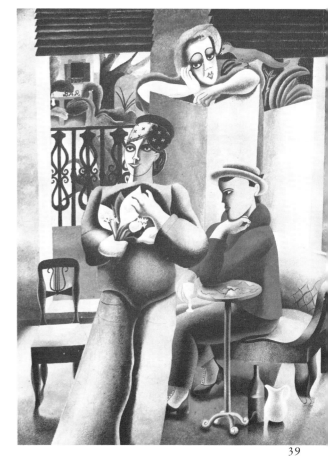

39

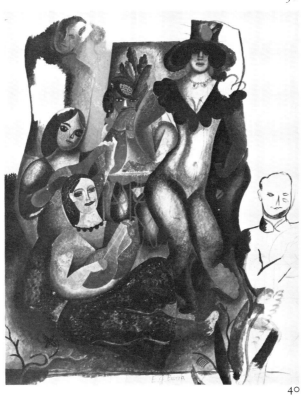

40

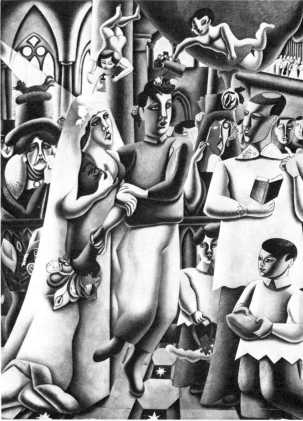

41

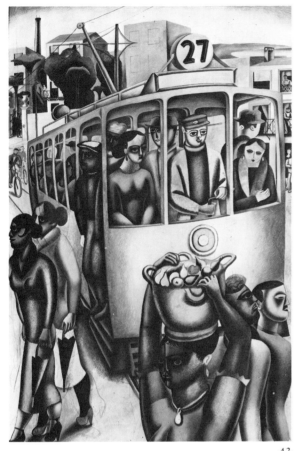

42

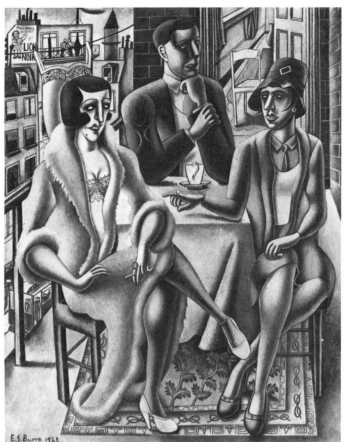

43

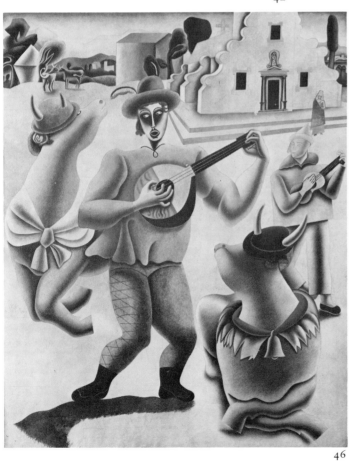

46

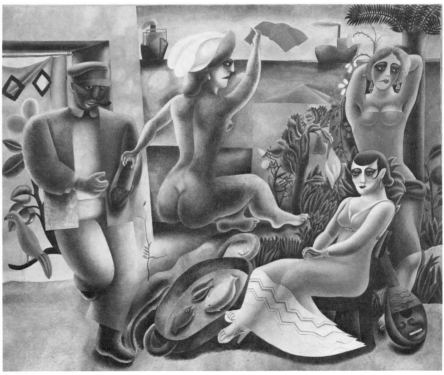

50

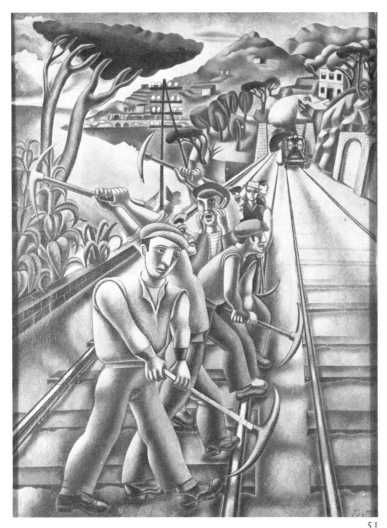

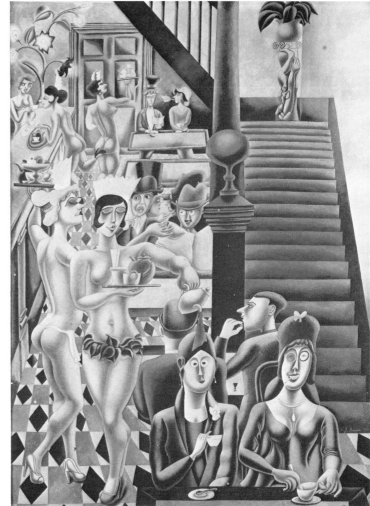

51

52

51. *The Railway Gang.*
1929. Oil, 68.6 × 50.8.
Signed and dated.

52. *The Tea-Shop.* 1929.
Gouache, 66 × 47.6. Signed
and dated.

53. *The Terrace.* 1929.
Gouache, 60.3 × 47.6.
Signed. Colour plate 5.

54. *The Two Sisters.* 1929.
Oil, 59.7 × 49.5. Signed
and dated.

Note: Additional titles,
other than drawings, which
are listed in the catalogue of
Burra's first one-man show
at the Leicester Galleries in
April 1929, are: *Aux Mals
Assis, The Bar, The
Barmaid, Chinese Lantern,
Coffee, The Dance, Evening
Promenade, Nacktkultur,
Promenade, Still Life* and
Vintage.

55. *In Training. The Skater.*
1927–9. Watercolour
heightened with body-
colour, 55.2 × 38.7. Signed
and dated.

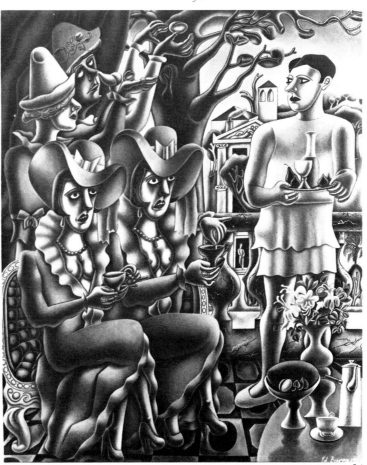

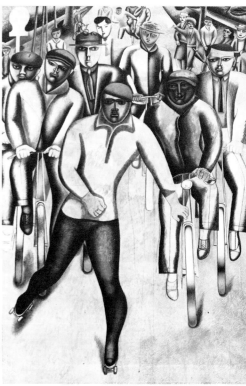

54

55

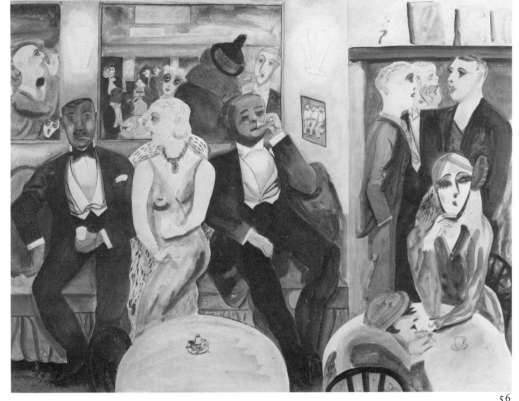

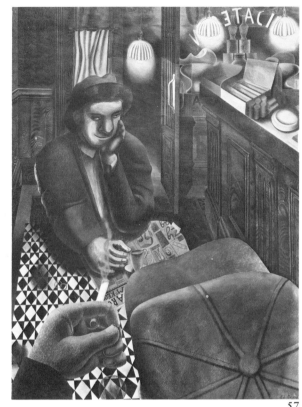

56

57

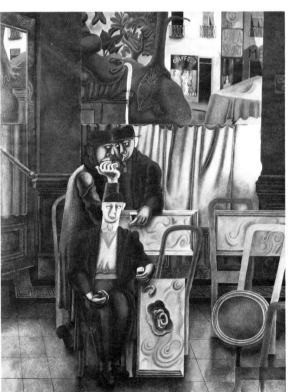

58

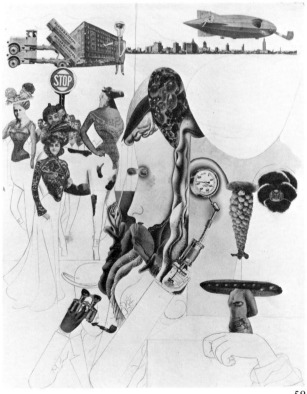

59

56. *Le Boeuf sur le Toit.*
1930. Pencil and
watercolour, heightened
with bodycolour,
38.8 × 51.4.

57. *The Café.* 1930.
Gouache, 66 × 50.5. Signed
and dated. Southampton
Art Gallery.

58. *Café Bar.* 1930.
Gouache, 64.8 × 49.5.
Dated.

59. *Collage.* 1930. Collage
and pencil, size unknown.

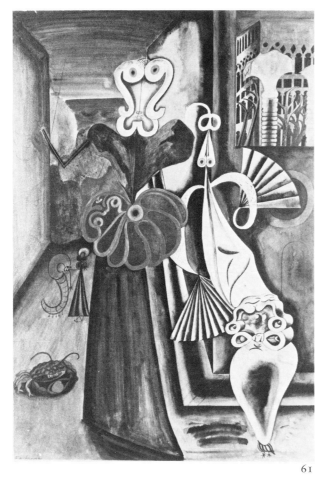

61

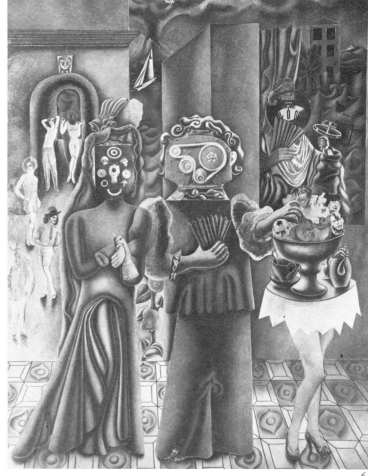

62

64

60. *Dockside Café.* 1929.
Watercolour, 67.3 × 48.2.
Signed. Illustrated page 201.

61. *The Duenna.* 1930.
Watercolour, 55.4 × 37.5.
Signed and dated.

62. *Eruption of Vesuvius.*
1930. Collage and
watercolour, 50.8 × 39.4.

63. *Keep your Head.* 1930.
Collage and pencil,
59.7 × 54.4. London, Tate
Gallery.

64. *Montage.* 1930. Size
unknown.

63

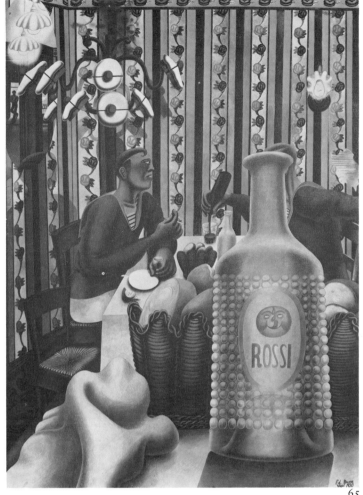

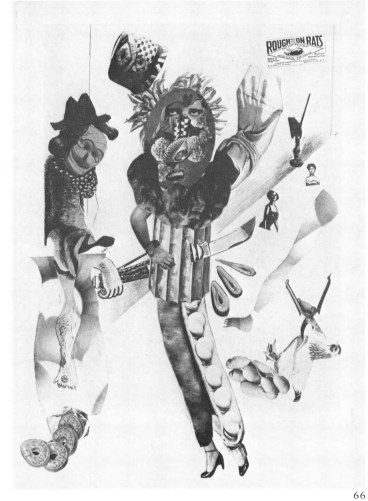

65

66

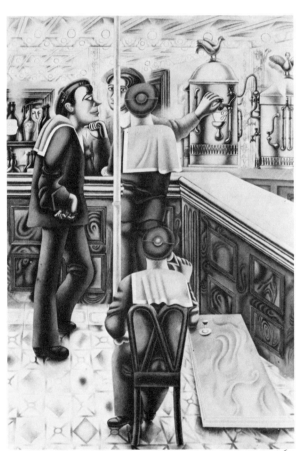

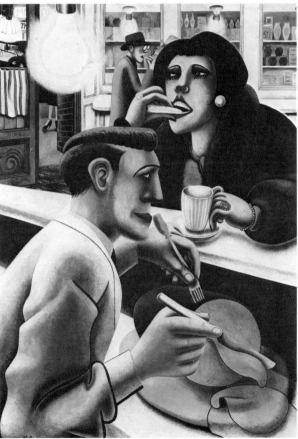

65. *Rossi*. 1930. Tempera, 66.7 × 49.5. Signed and dated 'Sept 1930'. Ottawa, National Gallery of Canada.

66. (with Paul Nash) *Rough on Rats*. 1930. Collage and pencil, 48.9 × 36.9.

67. *Sailors at a Bar*. 1930. Watercolour, 67.3 × 48.2. Signed and dated.

68. *The Snack Bar* (previously known as *Delicatessen*). 1930. Oil, 76 × 55. Signed and dated. London, Tate Gallery.

67

68

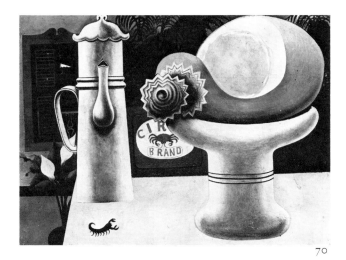

70

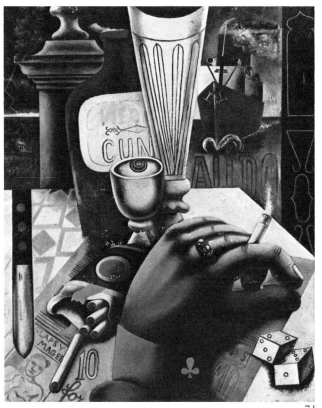

71

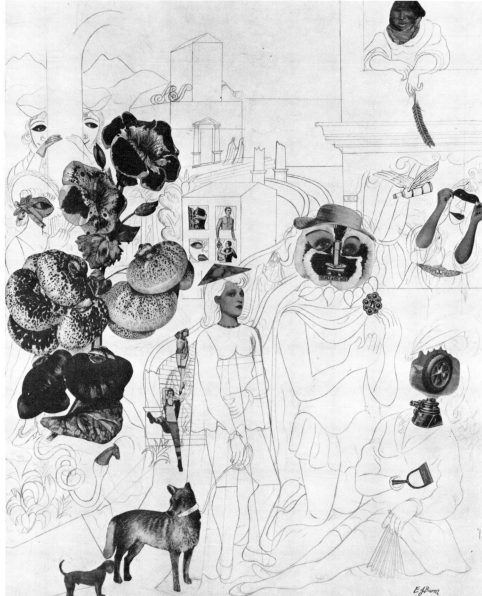

69

69. *Venez avec moi.* 1930.
Collage and pencil,
61.0 × 48.3. Signed. Leeds
City Art Gallery.

70. *The Ham.* 1931. Oil,
50.8 × 68.6. Signed.

71. *The Hand.* 1931. Oil,
68.6 × 50.8. Signed and
dated.

72. *John Deth.* 1931.
Watercolour heightened
with bodycolour,
55.9 × 76.2. University of
Manchester, Whitworth Art
Gallery.

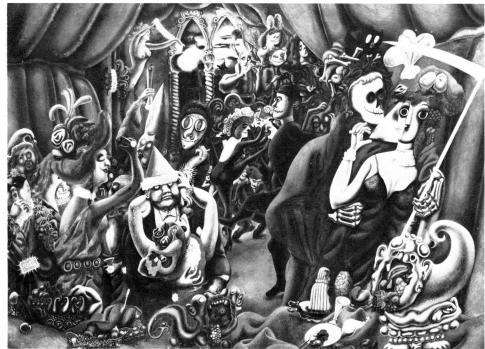

72

73

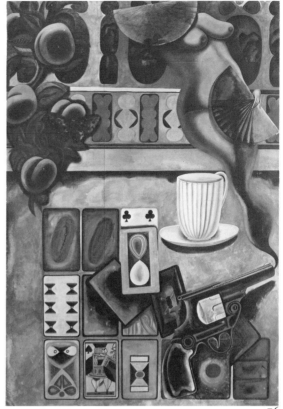

76

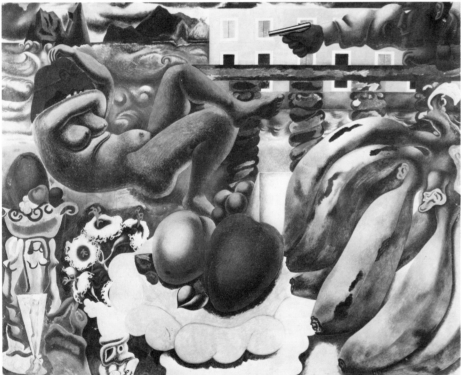

74

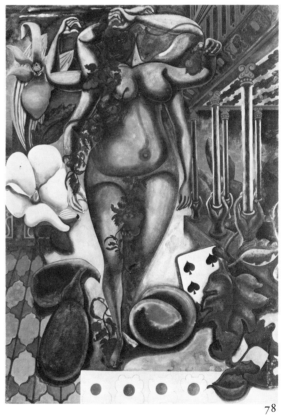

78

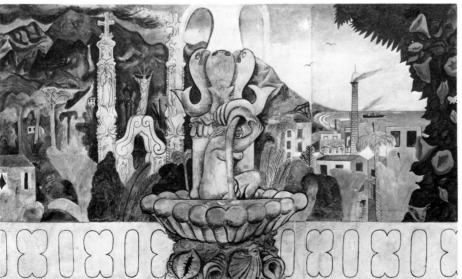

75

73. *Minuit Chanson.* 1931.
Watercolour heightened
with bodycolour,
54 × 73.3. Signed.

74. *Revolver Dream.* 1931.
Watercolour heightened
with bodycolour,
43.2 × 53.3. Signed and
dated.

75. *Rio Grande* (design for
a backcloth for the ballet).
1931. Watercolour,
44.5 × 73.7. Signed.

76. *Still Life with a Pistol.*
1931. Watercolour,
76.2 × 55.9.

77. *Storm in the Jungle.*
1931. Gouache,
55.9 × 67.3. Signed and
dated. Nottingham, Castle
Museum. Colour plate 9.

78. *Tomato Lady.* 1931.
Watercolour heightened
with bodycolour,
77.5 × 55.9.

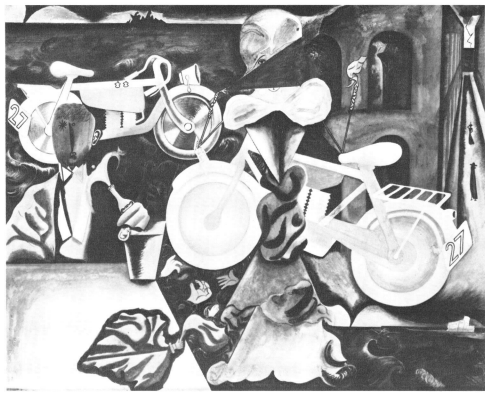

79

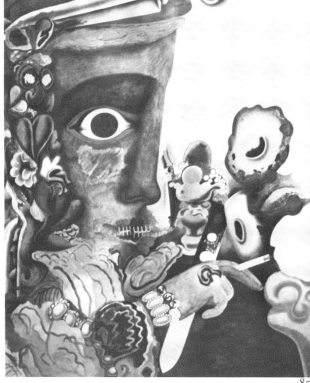

80

81

82

79. *Composition. Motor
Cycle.* 1931. Watercolour,
57.2 × 78.7. Signed and
dated.

80. *Dr Fu Manchu* (?).
1931. Watercolour,
76.2 × 55.9. Signed.

81. *Flamenco Dancer.*
1931. Watercolour
heightened with
bodycolour, 64.6 × 73.0.
Signed and dated.

82. *Fortune Tellers.* 1931.
Watercolour, 57.2 × 78.7.

83. *Madame Butterfly.*
1931. Watercolour,
55.9 × 75.6. Not
illustrated.

84

86

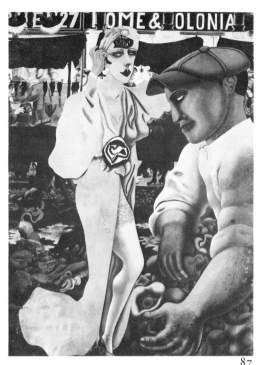

87

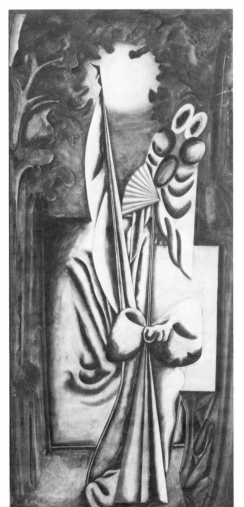

88

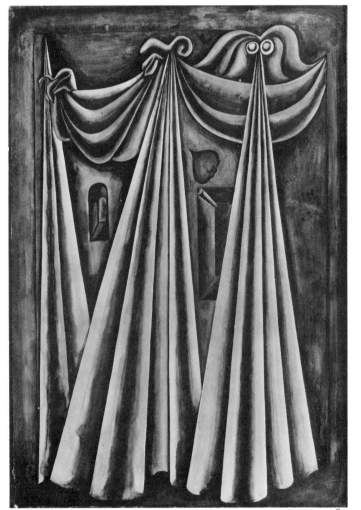

89

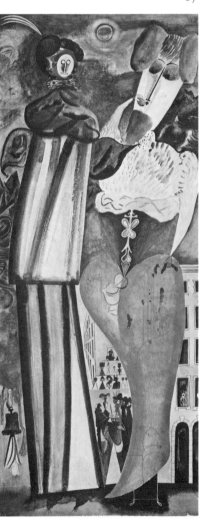

90

84. *The Duennas.* 1932.
Watercolour, 55.2 × 43.2.
Signed and dated.

85. *Harbour Scene.* 1932.
Watercolour and gouache,
55.9 × 76.2. Signed and
dated 1932. Not illustrated.

86. *The Hostesses.* 1932.
Watercolour, 60.3 × 47.6.
Leeds City Art Gallery.

87. *Saturday Market.* 1932.
Gouache, 73.7 × 53.3.
Signed and dated.

88. *Spanish Dance.* 1932.
Gouache, 78 × 34.9.

89. *The Three.* 1932.
Watercolour heightened
with bodycolour,
38.1 × 27.9.

90. *The Two Giantesses.*
1932. Watercolour, size
unknown. Signed and
dated.

90a. *The Nit Pickers.* 1932.
Watercolour, 71 × 40·6.
Signed and dated. Not
illustrated.

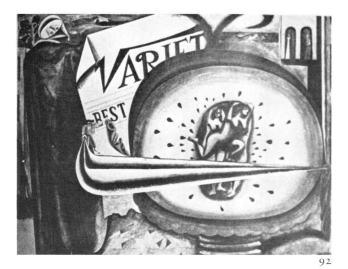

92

91

90b. *Market Day.* 1932. Oil over black chalk, 76·2 × 50·8. Signed and dated. Illustrated page 201.

90c. *Bird Women.* 1932. Pencil, ink, watercolour and gouache, 55·5 × 76·2. Signed and dated. Illustrated page 201.

91. *South West Wind.* 1932. Gouache, 55.2 × 73.7. Portsmouth Art Gallery.

92. *Variety.* Watercolour, size unknown.

Note: Additional titles, other than drawings, which are listed in the catalogue of Burra's one-man show at the Leicester Galleries in May 1932 are: *The Breath of Scandal, The Caribbees, Coffee on the Terrace, Dr Fu Manchu* (if it is not no. 80), *Home Again, Indiscretions, L'Inquiétude, Midi, Parade, Spectres, Still Life, Tea Leaves Overboard* (possibly no. 85).

93. *Bullfight.* 1933. Watercolour, 54.6 × 75.6.

94. *Composition with Figure.* 1933. Watercolour, 55.9 × 78.8.

95. *Group of Figures.* 1933. Watercolour, size unknown. Signed and dated 'La Burra 33 June'.

96. *The Pointing Finger.* 1933. Watercolour, 68.5 × 38.1.

97. *Spanish Music Hall.* 1933. Watercolour, 53.3 × 72.4.

98. *Still Life with Figures in a Glass.* 1933. Watercolour, 77.5 × 110.5. Colour plate 6.

99. *The Green Fig. c.* 1933. Watercolour, 57 × 79. Signed. British Council.

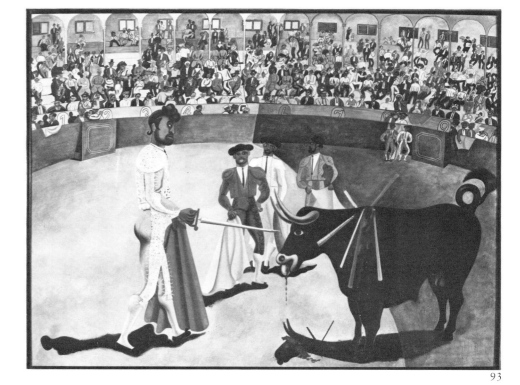

93

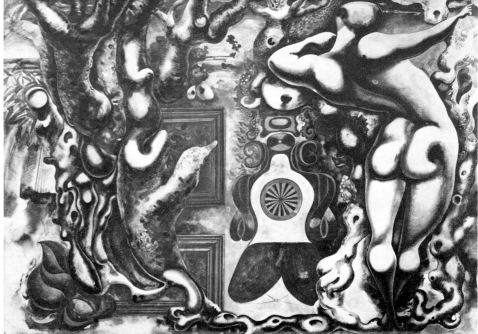

94

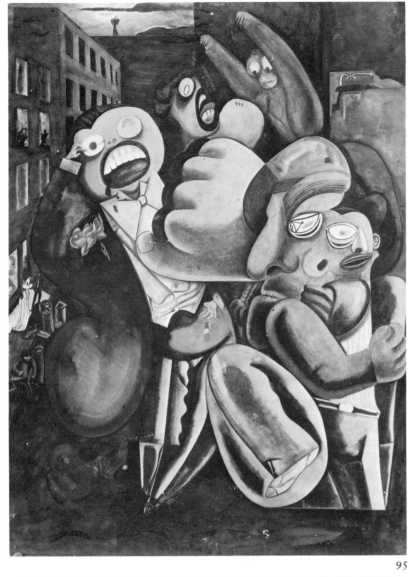

95

96

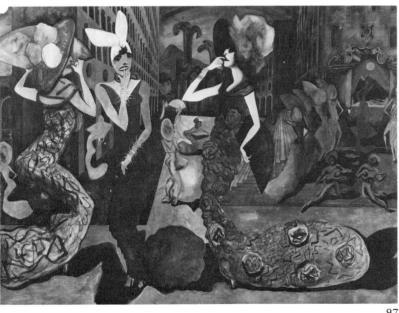

97

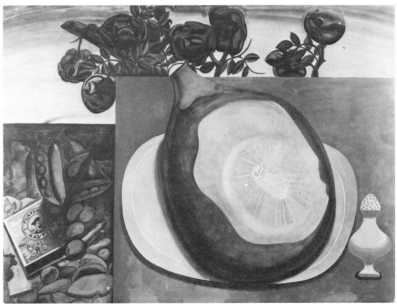

98

100

101

100. *Composition.* 1933–4.
Watercolour, 76.2 × 55.9.
London, Victoria and
Albert Museum.

101. *Composition.* 1933–4.
Watercolour, 50.8 × 85.1.

102. *News of the World.*
1933–4. Gouache,
78.6 × 54.6. Signed and
dated '33.34'. Bury Art
Gallery.

103. *Wheels.* 1933–4.
Watercolour, size
unknown.

102

103

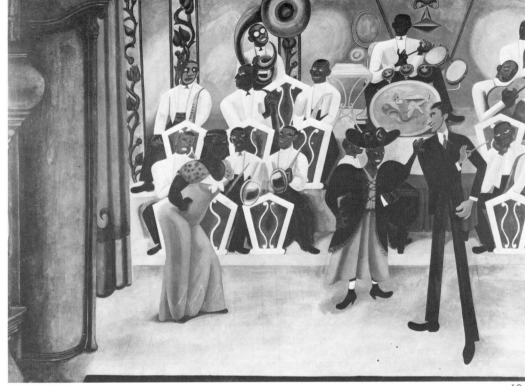

104

105

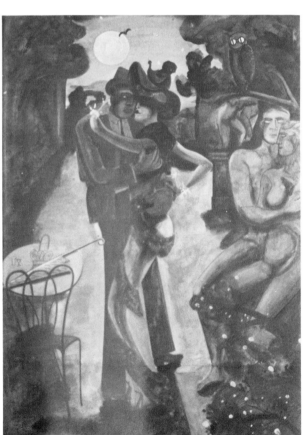

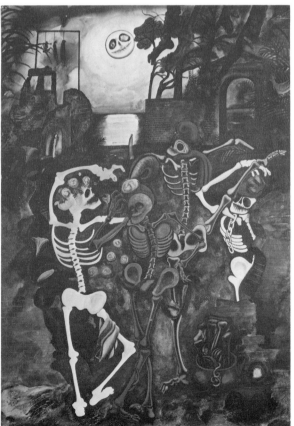

104. *The Band*. 1934.
Watercolour, 55.6 × 76.
Inscribed: 'Burrito '34'.
London, British Council.

105. *Bazaar*. 1934.
Watercolour, 55.9 × 38.1.

106. *Couple Dancing*.
1934. Watercolour,
54.6 × 36.9.

107. *Dancing Skeletons*.
1934. Gouache,
78.7 × 55.9. Signed and
dated. London, Tate
Gallery.

106

107

108. *Harlem*. 1934.
Gouache, 79.4 × 57.2.
Signed and dated. London,
Tate Gallery.

109. *Harlem*. 1934.
Gouache, 78.6 × 56. Signed
and dated. Bedford, Cecil
Higgins Art Gallery.

110. *Music Hall*. 1934.
Watercolour heightened
with bodycolour,
57.2 × 78.7. Signed and
dated.

111. *Serpent's Eggs*. 1934.
Gouache, 78.7 × 55.9.
Signed and dated.
Gloucester Art Gallery.

112. *Striptease*. 1934,
Gouache, 77.5 × 55.
Colour plate 7.

112a. *Blues for Ruby
Matrix. c.* 1934.
Watercolour, 54.6 × 56.
Not illustrated.

113. *Cuban Band*. 1934–5.
Gouache, 124.5 × 55.9.
Colour plate 8.

114. *Harlem Scene*.
1934–5. Watercolour,
78.7 × 55.9. Verso: *Piece of
Tail*, pencil and
watercolour.

115. *Madame Pastoria*.
1934–5. Watercolour,
64.8 × 45.1.

116. *Mae West*. 1934–5.
Watercolour, 76.2 × 55.

117. *Nellie Wallace*.
1934–5. Pencil and
watercolour, 49.4 × 38.1.

118. *Oyster Bar, Harlem*.
1934–5. Watercolour,
76.2 × 55.9.

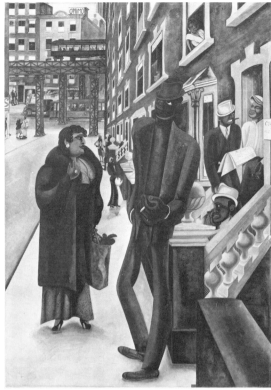

108

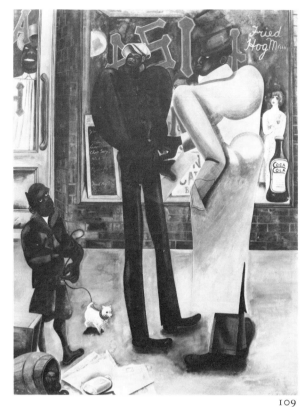

109

110

111

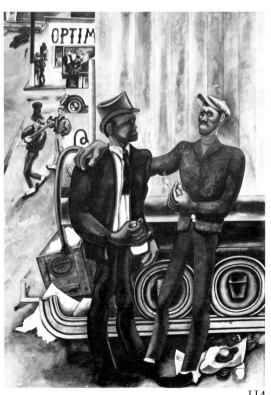

114

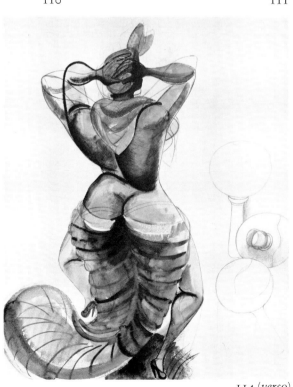

114 (*verso*)

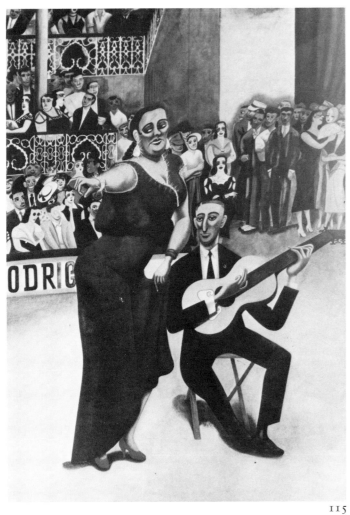

115

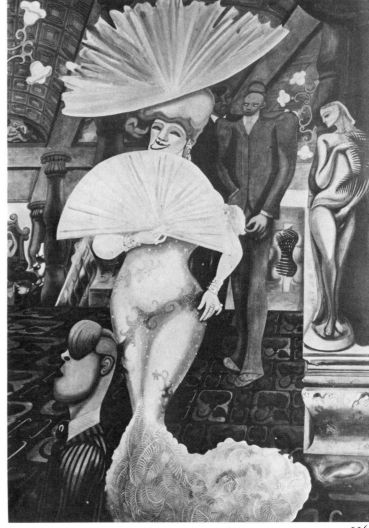

116

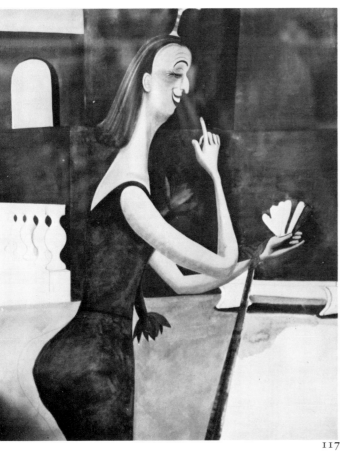

117

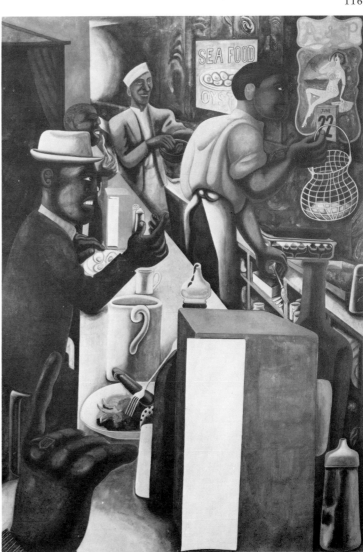

118

119. *Red Peppers*. 1934–5.
Tempera, 77.5 × 55.2.
Dundee Art Gallery.

120. *Savoy Ballroom*.
1934–5. Watercolour,
60.3 × 47.0.

121. *Spanish Dancer in a
White Dress*. 1934–5.
Watercolour heightened
with bodycolour,
76.2 × 56.5. Signed.

122. *The Churchyard*.
1935. Watercolour, size
unknown. Not illustrated.

123. *El Paso*. 1935.
Watercolour,
133.3 × 111.8.

124. *Harbour with Boats*.
1935. Watercolour, 74.9
× 143.8. Signed and dated.

124a. *Liverpool Pub Scene*.
1935. Watercolour, 76.2 ×
56. Not illustrated.

125. *Public Bar. c.* 1935.
Watercolour, 75.5 × 54.5.

126. *The Torturers*.
c. 1935. Watercolour,
75.5 × 54.5. Initialled.
Colour plate 11.

127. *Figure in a Café*. 1936.
Watercolour, 132.1 × 45.7.

128. *Red-cloaked Figure*.
1936. Watercolour,
110.5 × 55.9. Not
illustrated.

129. *Silence. c.* 1936.
Watercolour, 116.8 × 78.7.
Adelaide, Art Gallery of
South Australia.

130. *Chile con Carne*.
1937. Watercolour,
86.4 × 101.6. Signed and
dated. Colour plate 16.

130a. *Mexican Drawing*.
1937. Ink, 188 × 122. Not
illustrated.

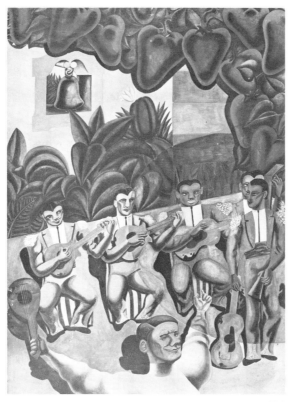

119

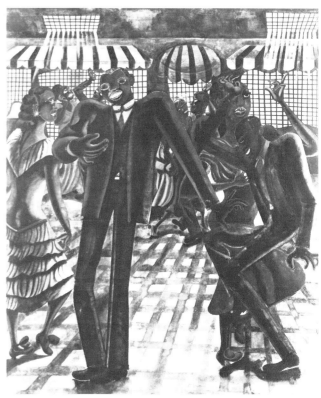

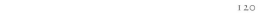

120

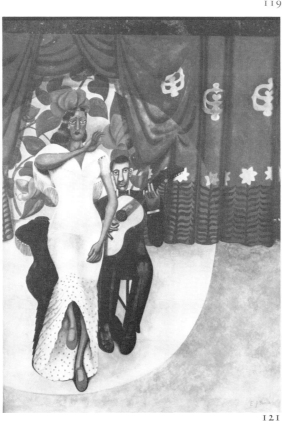

121

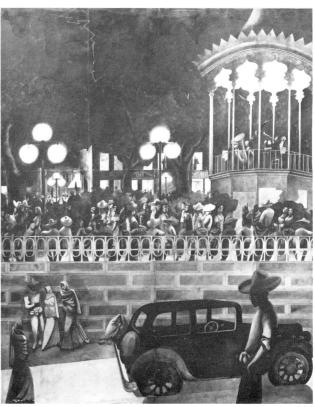

123

124

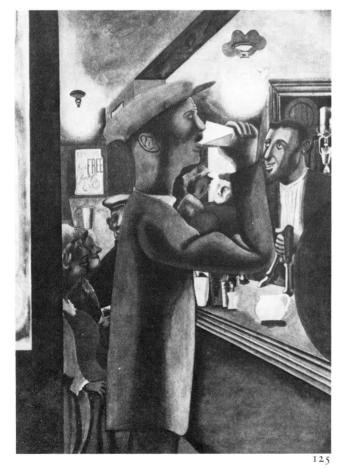

125

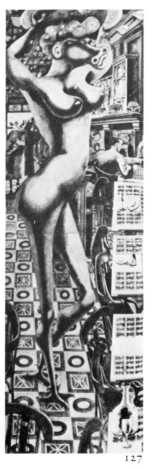

127

129

131. *Destiny.* 1937.
Watercolour,
146.1 × 105.4.

132. *Bal des Pendus.*
c. 1937. Watercolour,
157.5 × 109.2. New York,
Museum of Modern Art.

133. *The Mendicant.*
c. 1937. Watercolour, size
unknown. This title belongs
to a recorded work, but has
previously been wrongly
given to no. 131. Not
illustrated.

134. *The Puppet. c.* 1937.
Watercolour, 101.6 × 76.2.

135. *Spanish Civil War
Scene. c.* 1937.
Watercolour, 101 × 67.9.
Signed.

136. *The Three Fates.*
c. 1937. Watercolour,
132.1 × 111.8. Colour
plate 10.

137. *The Watcher. c.* 1937.
Watercolour, 96.5 × 61.
Edinburgh, Scottish
National Gallery of
Modern Art.

137a. *Pot of Gold. c.* 1937.
Watercolour, 157·4 ×
111·8. Signed. Not
illustrated.

137b. *Spectre. c.* 1937.
Watercolour, 68·6 × 101·6.
Not illustrated.

138. *Beelzebub.* 1937–8.
Watercolour,
154.9 × 111.8.

139. *Prisoner of Fate.*
1937–8. Watercolour,
109.2 × 78.7.

140. *Blue-robed Figure
under a Tree.* 1937–9.
Watercolour, 118.1 × 85.1.
Illustrated page 201.

141. *Landscape with Red
Wheels.* 1937–9.
Watercolour, 48.2 × 62.1.

142. *Landscape with
Wheels.* 1937–9.
Watercolour, 49.5 × 62.2.

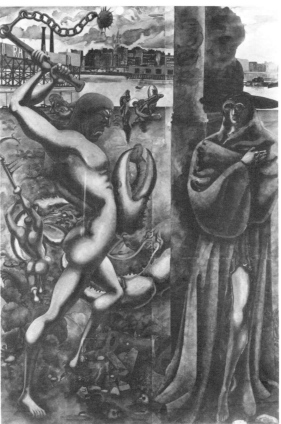

131

132

134

135

137

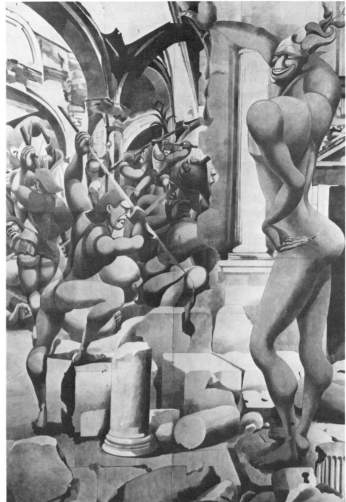

138

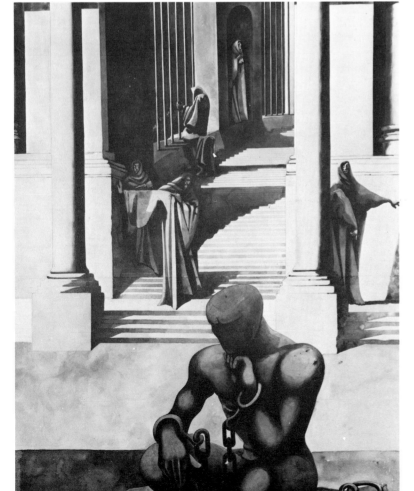

139

141

142

143. *Trees.* 1937–9.
Watercolour, 165.1 × 78.7.

144. *Camouflage.* c. 1938.
Watercolour,
101.6 × 205.7, as originally
exhibited at the Redfern
Gallery in 1942. Colour
plate 12 is the right-hand
two-thirds after Burra had
detached the left-hand of
the three original joined
sheets, which is illustrated
here.

145. *Medusa.* c. 1938.
Watercolour,
154.9 × 111.8. Colour
plate 13.

146. *Mexican Church.*
c. 1938. Gouache and
watercolour,
132.1 × 103.5. London,
Tate Gallery.

147. *Old Iron.* c. 1938.
Watercolour, 97.8 × 130.8.
Monogram and signature.
Colour plate 15.

148. *Saint and Candles.*
c. 1938. Watercolour,
76.2 × 121.9. Not
illustrated.

149. *War in the Sun.*
c. 1938. Watercolour,
106.5 × 157.5.
Not illustrated.

143

144

146

150

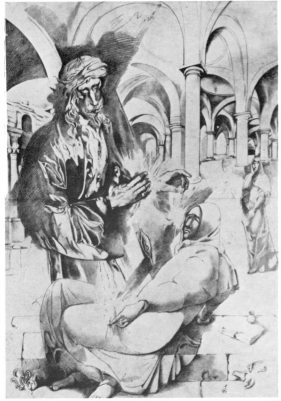

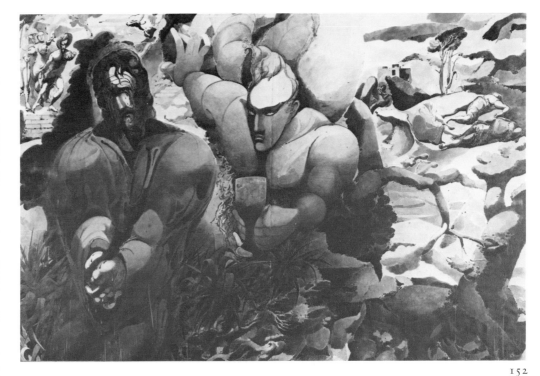

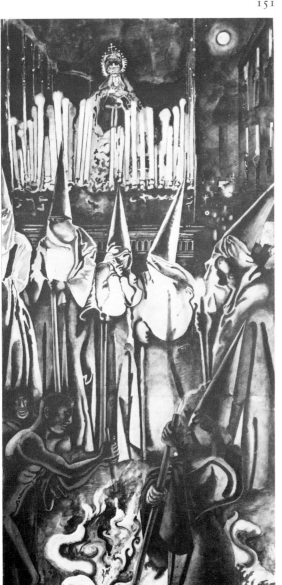

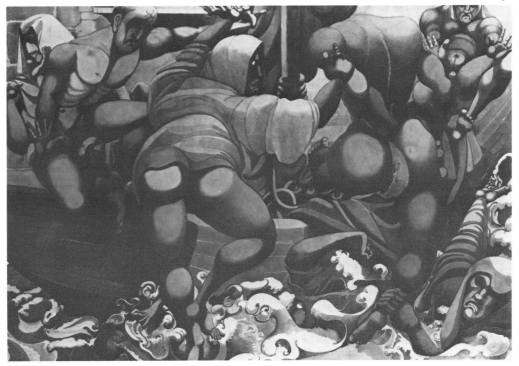

151

152

153

154

150. *Santa Maria in Aracoeli*. 1938–9. Watercolour heightened with bodycolour, 153.5 × 110.5.

151. *The Vision of St Theresa*. 1938–9. Pencil and wash, 101.6 × 76.2.

152. *Agony in the Garden*. 1939. Watercolour, 71.5 × 107.5.

153. *Crossing the Styx*. 1939. Watercolour, 68.6 × 101.6. Signed.

154. *Holy Week, Seville*. 1939. Watercolour, 159 × 77. Signed and dated. Sydney, Art Gallery of New South Wales.

155. *The Riot.* 1939.
Watercolour, 77.5 × 111.8.
Signed and dated.

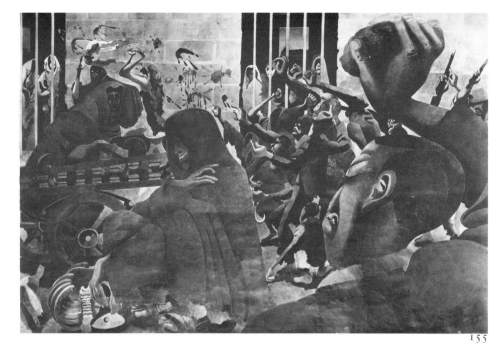

155

156. *The Wake.* 1939. A
pair, each gouache and
watercolour, 102.2 × 69.9.
Both signed and dated.
London, Tate Gallery.

157. *Soldiers at Rye.* 1941.
Gouache and watercolour,
105.4 × 207.6. Initialled
and dated. London, Tate
Gallery. Colour plate 18.

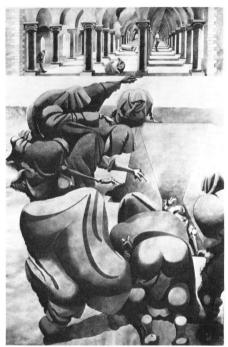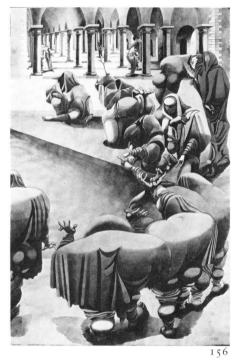

156

158. *Blasted Oak.* 1942.
Watercolour, 63.5 × 73.7.
London, Arts Council of
Great Britain.

159. *Death and the
Soldiers.* 1942–3.
Watercolour, 100.3 × 67.3.
Colour plate 17.

158

160

162

164

165

160. *Ropes and Lorries.*
1942–3. Watercolour,
109.9 × 76.8.

161. *Soldiers' Backs.*
1942–3. Watercolour,
110.5 × 114.3. Eastbourne,
Towner Art Gallery. Colour
plate 19.

162. *Soldiers in a Lorry.*
1942–3. Watercolour,
78.8 × 112. Melbourne,
National Gallery of
Victoria. (Felton Bequest,
1949).

163. *Soldiers with Spears.*
1942–3. Watercolour, size
unknown. Not illustrated.

164. *Landscape near Rye.*
1943–5. Watercolour,
50.8 × 78.7.

165. *The Road.* 1943–5.
Watercolour, 101.6 × 68.6.

166

167

166. *Gorbals Landscape.*
1944. Watercolour, size
unknown. Signed and (?)
dated.

167. *The Cabbage Harvest.*
c. 1945. Watercolour,
55.9 × 76.2.

167a. *Figures in a*
Landscape. c. 1945–6.
Watercolour, size
unknown. Colour Plate 14.

168. *The Bird.* 1946.
Watercolour, size
unknown. Not illustrated.

169. *Birdman and Pots in a*
Landscape. 1946.
Watercolour, 55.9 × 77.5.

170. *Birdmen and Pots.*
1946. Watercolour,
75.5 × 56. Signed.
Hove Art Gallery.

171. *Landscape with*
Birdman Piper and
Fisherwoman. 1946.
Watercolour, size
unknown.

169

170

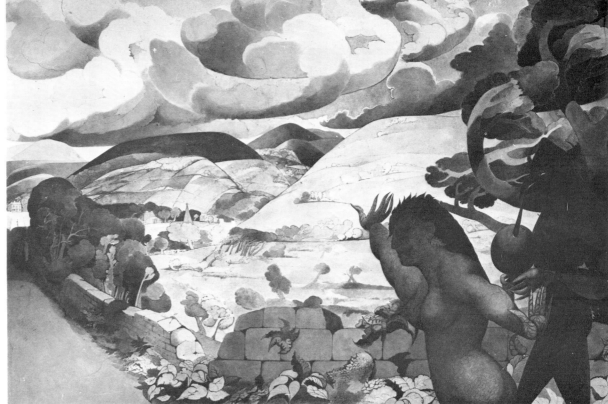

171

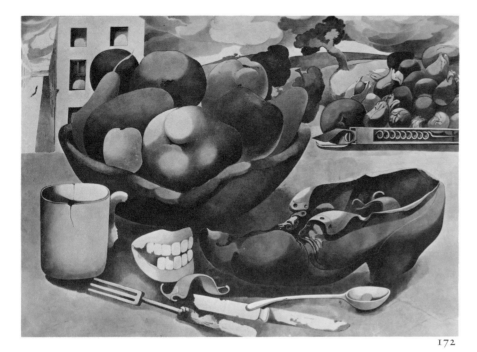

172

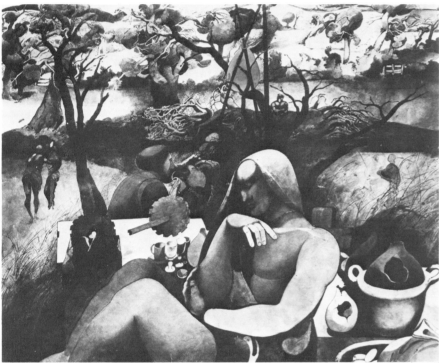

173 (recto)

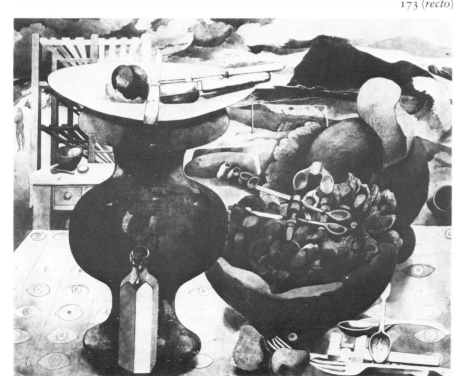

173 (verso)

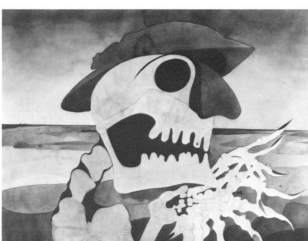

174

172. *Still Life in a Landscape.* 1946. Watercolour, 57.2 × 89.

173. *Figure in a Landscape* (recto). *c.* 1946. Watercolour, 66 × 81.3. *Still Life in a Landscape* (verso). *c.* 1946. Watercolour.

174. *Skull in a Landscape.* *c.* 1946. Watercolour heightened with bodycolour, 55.2 × 76.2. London, Imperial War Museum.

175

176

175. *The Harbour*. 1947.
Watercolour, size
unknown.

176. *Landscape with
Figures*. 1947.
Watercolour, size
unknown.

177

177. *The Railway Viaduct*.
1947. Watercolour,
78.8 × 111.8.

178. *The River*. 1947.
Watercolour, 78.7 × 111.8.

179. *Romney Marsh*. 1947.
Watercolour, 66 × 99.7.
Not illustrated.

178

180

183

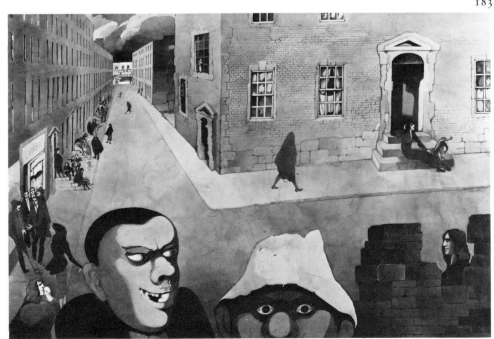

184

182

180. *Rye Landscape with Figure*. 1947. Watercolour, 68.6 × 101.6. Bedford, Cecil Higgins Art Gallery.

181. *Ladies Walking*. *c.* 1947. Watercolour, 78.1 × 56.6. London, Victoria and Albert Museum. Not illustrated.

182. *The Alley, Ireland*. 1948. Watercolour, 101.6 × 68.6.

183. *Dublin Street Scene*. 1948. Watercolour, 66 × 101.6. Belfast, Ulster Museum.

184. *Irish Street Scene*. 1948. Watercolour, 66 × 101.6.

185. *It's all Boiling up.* 1948. Watercolour, 55.9 × 78.7.

186. *Procession.* 1948. Watercolour, 101.6 × 78.7.

187. *West of Ireland.* 1948. Watercolour, 78.7 × 111.8. Colour plate 20.

188. *Zoot Suits.* 1948. Watercolour, size unknown. Not illustrated.

189. *Limbo.* 1948–50. Watercolour, 67.2 × 102.2. University of Manchester, Whitworth Art Gallery.

190. *Resting Angel.* 1948–50. Watercolour, 73 × 104.1.

191. *Resurrection.* 1948–50. Watercolour, 101.6 × 67.3.

192. *Riot.* 1948–50. Watercolour, 78.7 × 110.5.

193. *Salome.* 1948–50. Watercolour, 77.7 × 55.9.

194. *Trees.* 1948–50. Watercolour, 48.3 × 61.

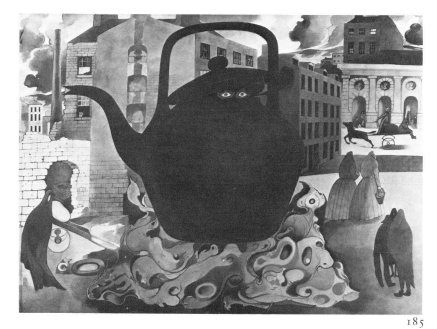

185

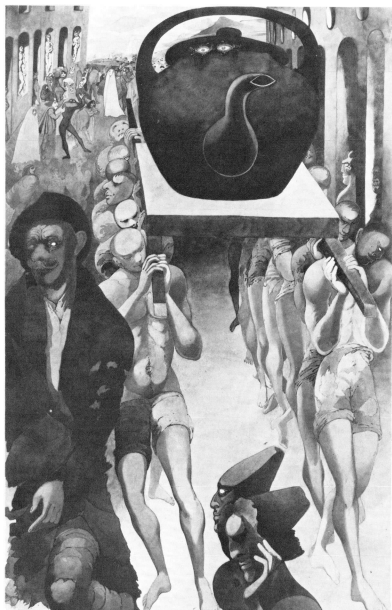

186

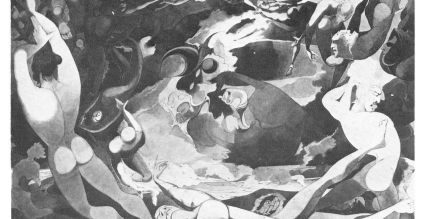

189

190

191

192

193

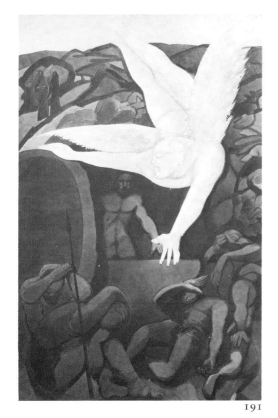

194

195. *Fish Stall, Glasgow.*
1949. Watercolour,
50.2 × 62.2. Signed.

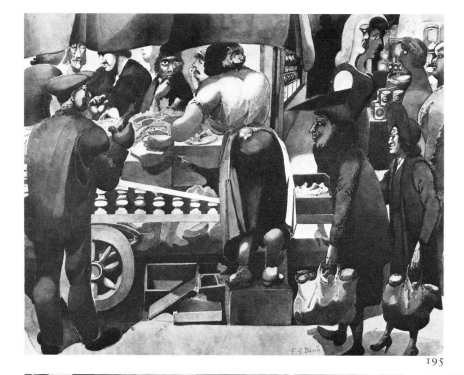

196. *Glasgow Pub.* 1949.
Watercolour, 57.2 × 78.7.
Signed.

197. *The Market.* 1949.
Watercolour, 68.6 × 101.6.
Not illustrated.

198. *Scarecrows.* 1949.
Watercolour, 78.7 × 55.9.
Huddersfield Art Gallery.

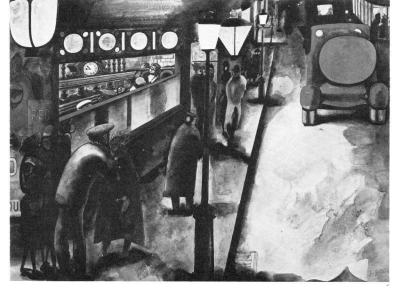

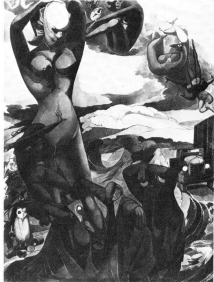

199. *Sussex Landscape.*
1949. Watercolour, size
unknown.

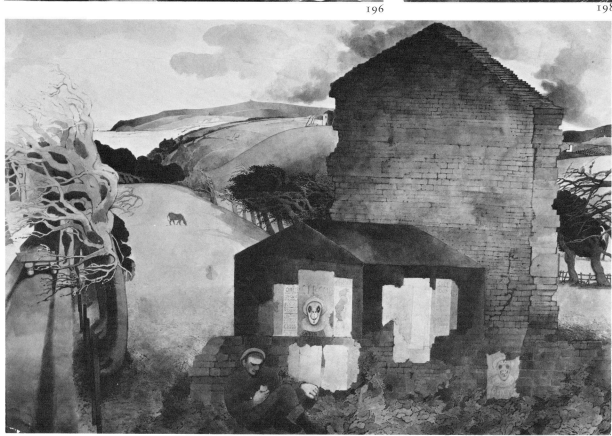

195

196

198

199

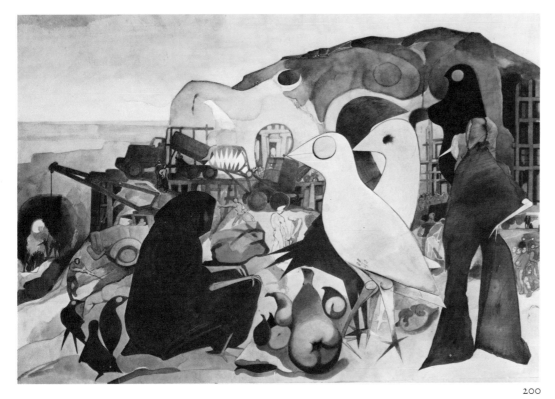

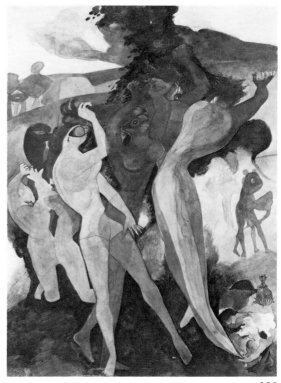

200

201

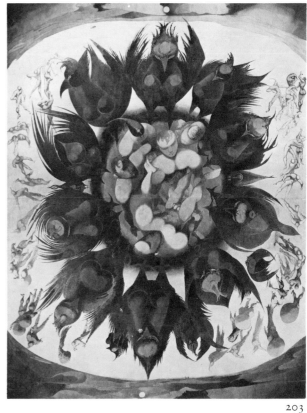

202

203

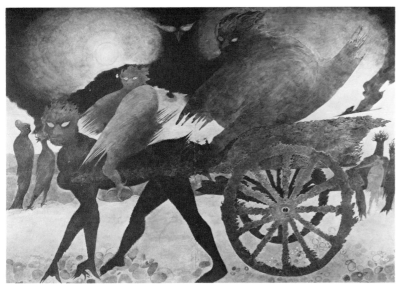

200. *Construction. c.* 1950
Watercolour, 74.0 × 104.
Signed.

201. *Green Figures in a
Landscape. c.* 1950.
Watercolour, 75.5 × 55.2.

202. *Judith and Holofernes.*
1950–1. Watercolour,
102.5 × 132.1.

203. *The Birds.* 1950–2.
Watercolour,
133.3 × 102.8, Adelaide,
National Gallery of South
Australia.

204. *Birds.* 1950–2.
Watercolour, 76.2 × 109.2.

205. *Birds.* 1950–2.
Watercolour, size
unknown. Not illustrated.

204

206

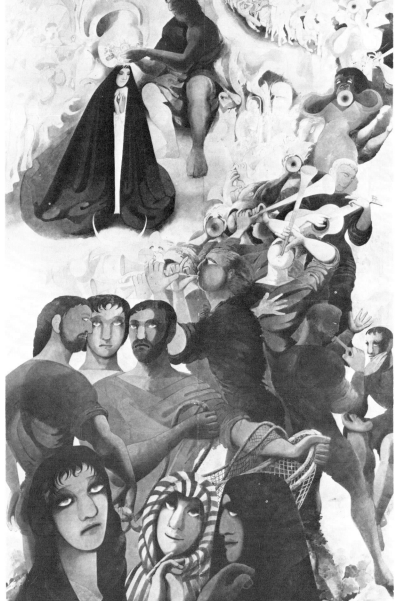

207

208

206. *Christ Mocked.*
1950–2. Watercolour,
136.5 × 132.1. University
of Dundee.

207. *The Coronation of the
Virgin.* 1950–2.
Watercolour, 203 × 132.

208. *The Entry into
Jerusalem.* 1950–2.
Watercolour,
204.5 × 102.9. Fredericton,
New Brunswick,
Beaverbrook Art Gallery.

209

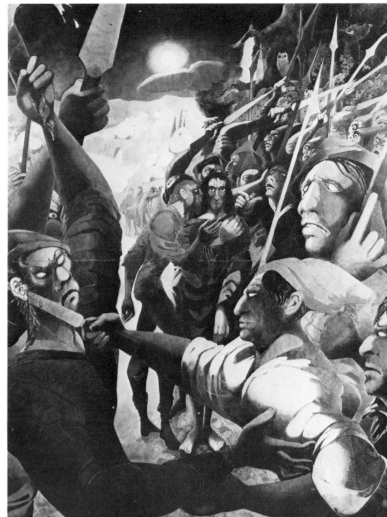

211

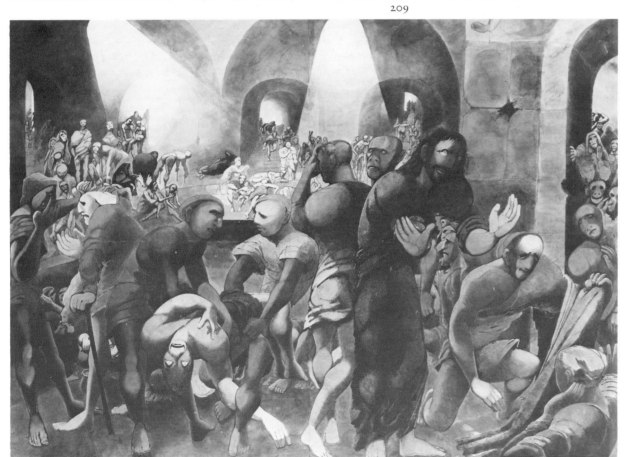

212

209. *The Expulsion of the Moneychangers*. 1950–2. Watercolour heightened with bodycolour, 133.4 × 104.1.

210. *Joseph of Arimathea*. 1950–2. Watercolour, 132.1 × 100.3. Not illustrated.

211. *Peter and the High Priest's Servant*. 1950–2. Watercolour, 133.4 × 102.8.

212. *The Pool of Bethesda*. 1950–2. Watercolour, 111.1 × 154.9.

213. *The Rest in the Wilderness*. 1950–2. Watercolour, 102 × 132. Colour plate 25.

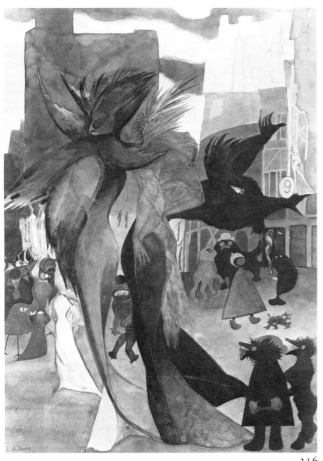

216

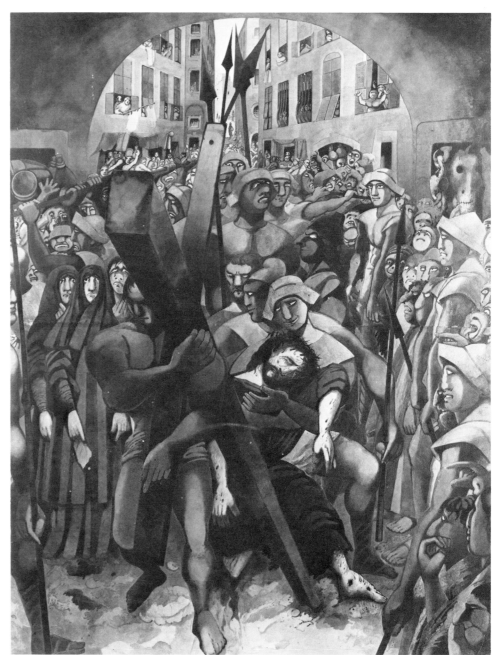

214

214. *Simon of Cyrene.*
1950–2. Watercolour,
133.4 × 100.3.

215. *The Argument.*
1952–4. Watercolour,
52.1 × 73.7. Not
illustrated.

216. *Bird Women.* 1952–4.
Watercolour, 75.6 × 55.9.
Signed.

216a. *Boats and Rocks.*
1952–4. Watercolour,
55.9 × 75.6.

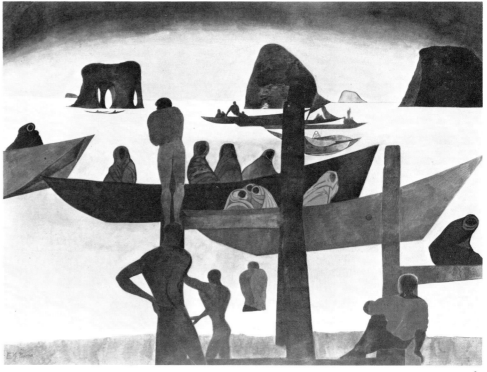

216a

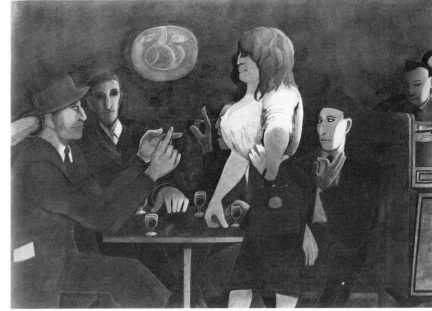

218

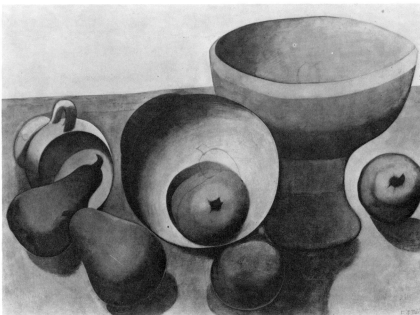

217

219

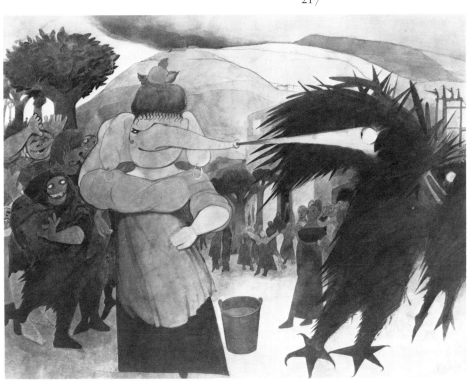

217. *Bottles in a Landscape.* 1952–4. Watercolour, 69 × 50.7. Signed. London, British Museum.

218. *Café Bar.* 1952–4. Watercolour, 55.9 × 75.6.

219. *Dishes and Pears.* 1952–4. Watercolour, 55.9 × 75.6. Signed.

220. *Elephant Lady.* 1952–4. Watercolour, 58.4 × 77.5. Signed.

220

221. *Esso.* 1952–4.
Watercolour, 73.7 × 104.1.
Signed.

222. *Excavation.* 1952–4.
Watercolour, 55.9 × 75.6.

223. *Fish Women.* 1952–4.
Watercolour, 55.9 × 75.5.
Not illustrated.

224. *Flowering Heads.*
1952–4. Watercolour, size
55.9 × 76.2.

225. *Flowers in a Bar.*
1952–4. Watercolour,
55.9 × 75.6. Signed.

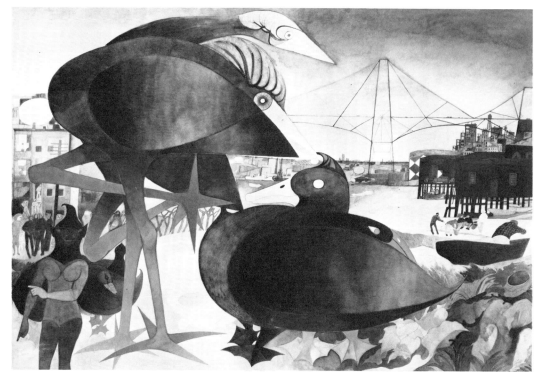

221

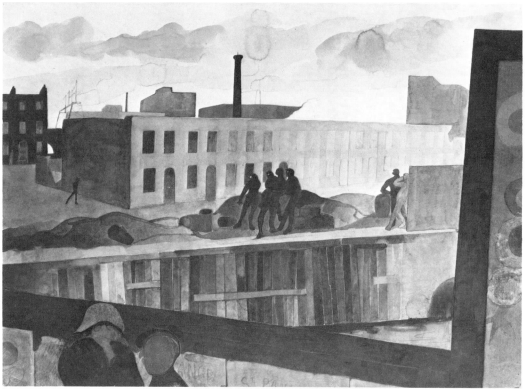

222

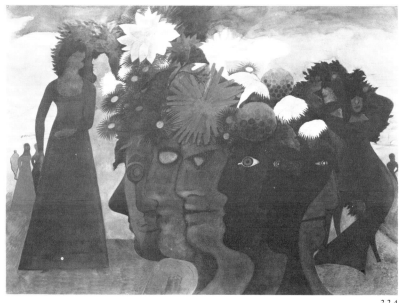

224

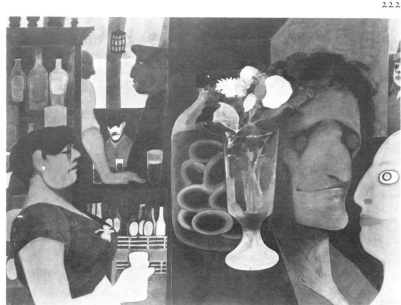

225

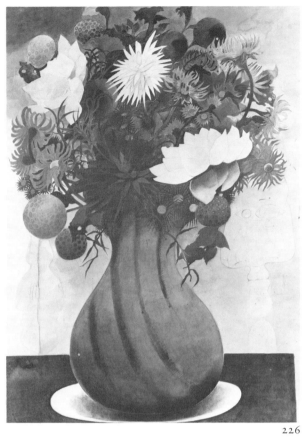

226

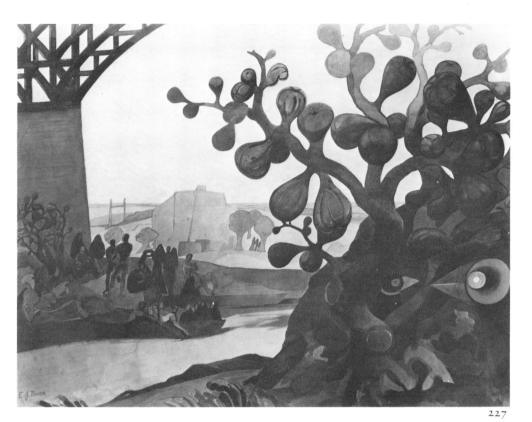

227

226. *Flowers in a Vase.*
1952–4. Watercolour,
75.6 × 55.9.

227. *Landscape with a Fig
Tree.* 1952–4. Watercolour,
58.4 × 77.5. Signed.

228. *The Opening of the
Hunting Season.* 1952–4.
Watercolour, 73.7 × 105.4.

229. *Pears and Cabbage.*
1952–4. Watercolour,
55.9 × 75.6. Signed.

230. *Pot Women.* 1952–4.
Watercolour, 55.9 × 75.5.

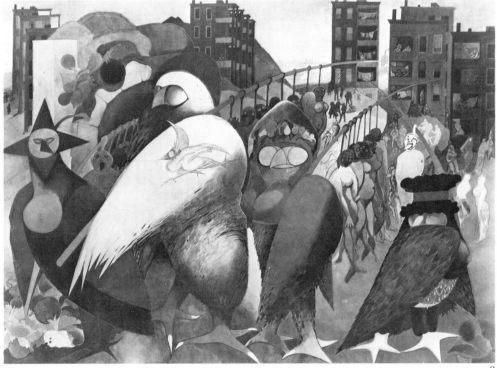

228

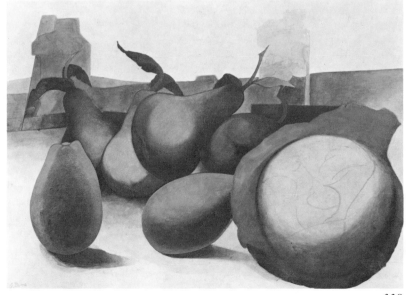

229

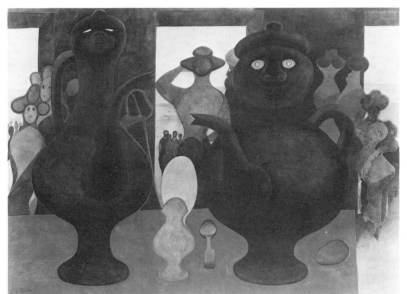

230

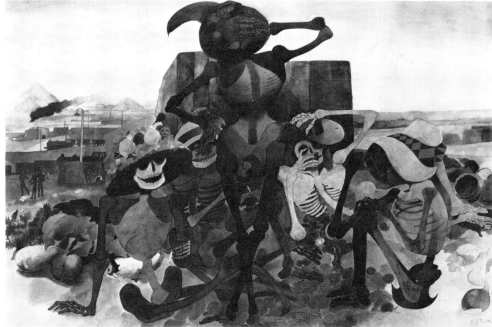

231. *Skeleton Party*. 1953.
Watercolour, 69.8 × 102.2.
Signed. London, Tate
Gallery.

231

232. *Still Life with Figures*.
1953. Watercolour,
54.6 × 74.3. Signed.

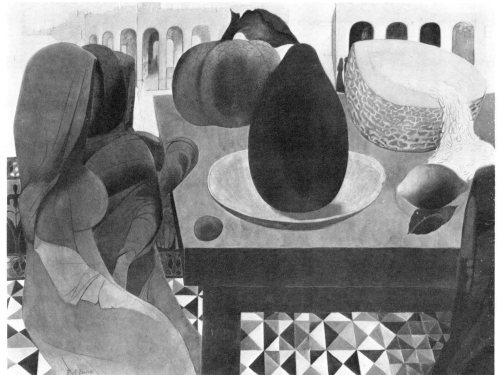

232

233. *Café Scene*. 1954.
Watercolour, 52.1 × 73.6.
Signed and dated.

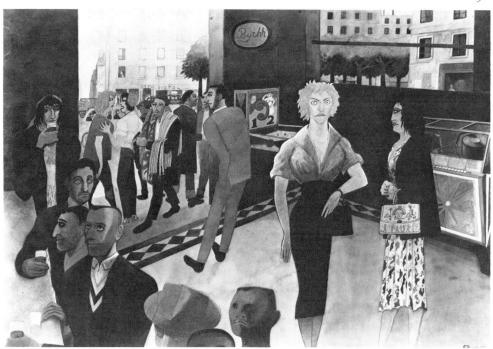

233

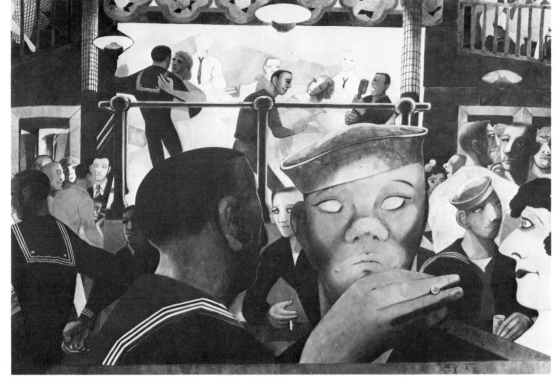

234

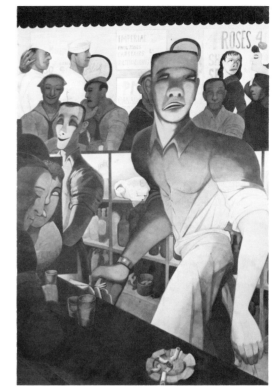

235

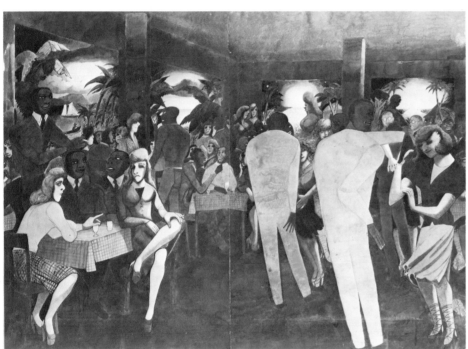

236

234. *Izzy Ort's*. 1955.
Watercolour, 74 × 104.
Edinburgh, Scottish
National Gallery of
Modern Art.

235. *Silver Dollar Bar*.
1955. Watercolour,
110 × 72. York City Art
Gallery.

236. *Tropical Bar Scene*.
1955. Watercolour,
77 × 110.

237. *Dahlias and Daisies*.
1955–7. Watercolour,
71.1 × 106.7. Signed.

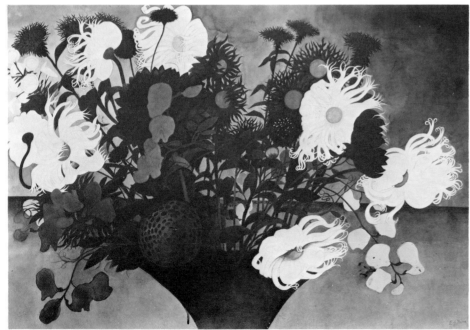

237

238. *Mallows.* 1955–7.
Watercolour, 135.3 × 78.1.
Signed.

239. *Owl and Quinces.*
1955–7. Watercolour,
135.3 × 78.1. Signed.

238

239

240

240. *Peonies.* 1955–7.
Watercolour, 71.1 × 106.7.
Signed.

241. *Peonies and
Vegetables.* 1955–7.
Watercolour, 101 × 71.
Colour plate 23.

242. *Shrubs and Lilies and
Iris.* 1955–7. Watercolour,
106.7 × 71.1.

242

243

245

244

246

243. *Still Life and Basket.*
1955–7. Watercolour,
72 × 104. Signed.

244. *Still Life and Basket.*
1955–7. Watercolour,
72 × 104. Signed.

245. *Still Life, Bottles and
Basket.* 1955–7.
Watercolour, 72 × 104.
Signed.

246. *Still Life, Dishes and
Bottles.* 1955–7.
Watercolour, 72 × 104.
Signed.

247. *Tulips in a Yellow Pot.*
1955–7. Watercolour,
104 × 72. Signed.

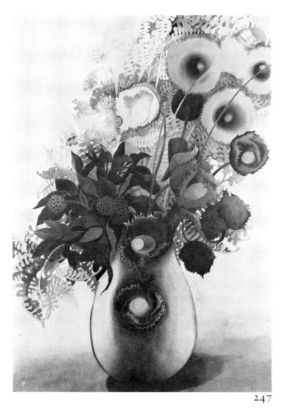

247

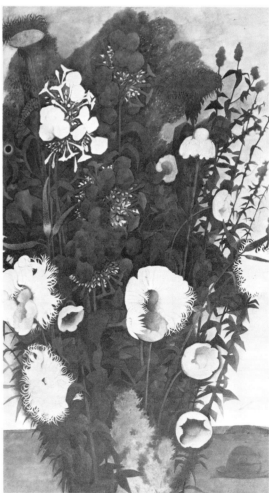

248

248. *Cyclamen. c.* 1957.
Watercolour, 76.2 × 57.1.
Signed.

249. *Flowers in a Pot.*
c. 1957. Watercolour,
137.1 × 83.8.

250. *Mixed Flowers.*
c. 1957. Watercolour,
134.6 × 77.8. Fredericton,
New Brunswick,
Beaverbrook Art Gallery.

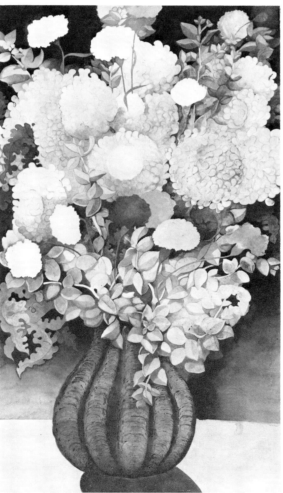

249

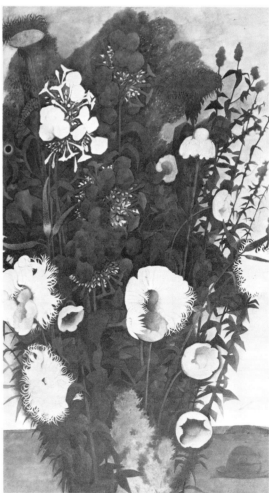

250

251

251. *Apples*. 1957–9.
Watercolour, 76.8 × 134.6.
Signed.

252

252. *Bouquet*. 1957–9.
Watercolour, 104.1 × 73.7.

253. *Cabbages*. 1957–9.
Watercolour, 134.6 × 76.2.
Signed.

254. *Chrysanthemums and Asters*. 1957–9.
Watercolour, 134.6 × 76.2.
Not illustrated.

255. *Flowering Vegetables*.
1957–9. Watercolour,
134.6 × 76.2.

253

255

256

257

256. *Gourds*. 1957–9.
Watercolour, 76.2 × 134.6.
Signed.

257. *Lupins and Peonies*.
1957–9. Watercolour,
76.2 × 134.6.

258. *Landscape with Beans*.
1957–9. Watercolour,
76.2 × 134.6. Signed.

258

259. *May Blossom*. 1957–
9. Watercolour,
76.2 × 134.6.

260. *Still Life*. 1957–9.
Watercolour, 104.1 × 73.7.
Not illustrated.

259

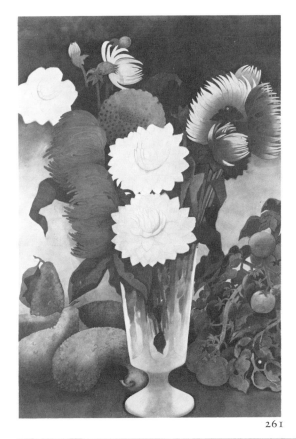

261. *Still Life with Dahlias.*
1957–9. Watercolour,
115.6 × 76.2.

262. *Vase of Leaves.* 1957–
9. Watercolour,
104.1 × 73.7.

261

262

263. *Scene in Harlem
(Simply Heavenly).* 1958.
Watercolour, 72.4 × 106.7.
Signed.

263

264. *Apple and Pear
Blossom.* 1959–61.
Watercolour, 66.0 × 101.6.

264

265. *Bean Poles*. 1959–61.
Watercolour, 132.1 × 76.2.

266. *The Burning House*.
1959–61. Watercolour,
101.6 × 66.

265

266

267. *Burning Torch*.
1959–61. Watercolour,
100.3 × 68.6. Signed.

268. *The Canal*. 1959–61.
Watercolour, 133.4 × 76.2.
Colour plate 21.

269. *The Churchyard*.
1959–61. Watercolour,
133.4 × 77.5.

267

269

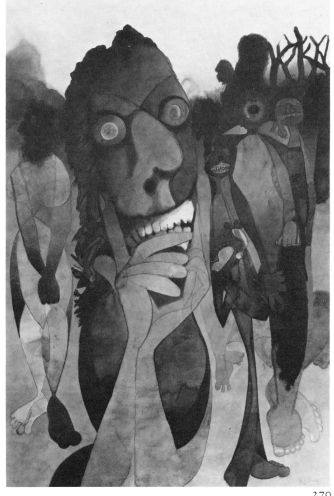

270

272

270. *Miss Eager.* 1959–61. Watercolour, 100.3 × 68.6. Signed.

271. *Early Morning Fog.* 1959–61. Watercolour, 76.2 × 132.1. Not illustrated.

272. *The Fire.* 1959–61. Watercolour, 77.5 × 134.6.

273. *Frogmen.* 1959–61. Watercolour, 77.5 × 55.9. Signed.

274. *The Mulberry Tree.* 1959–61. Watercolour, 77.5 × 133.4. Not illustrated.

275. *Pear Trees, Autumn.* 1959–61. Watercolour, 106.7 × 71.1.

276. *Punch and Judy.* 1959–61. Watercolour, 54.6 × 74.9. Signed.

273

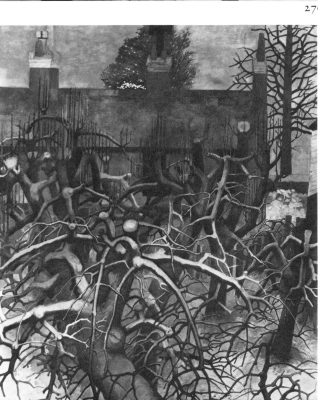

275

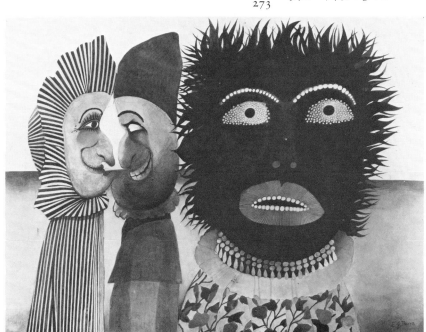

276

277. *The Ramparts.*
1959–61. Watercolour,
76.2 × 133.4. Signed.

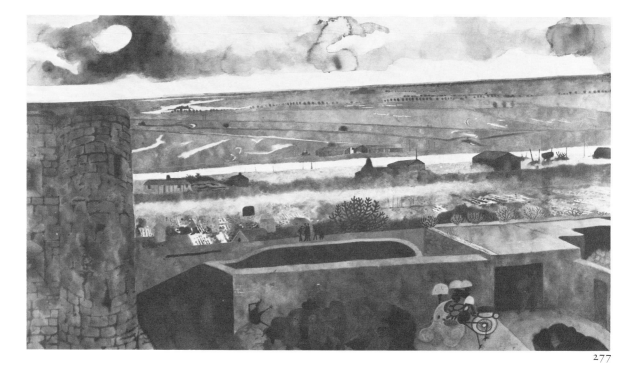

277

278. *Susanna and the
Elders.* 1959–61.
Watercolour, 77.5 × 134.6.

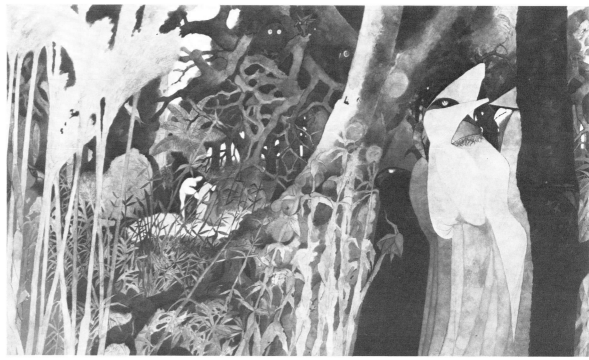

278

279. *The Tree.* 1959–61.
Watercolour, 77.7 × 133.4.
Signed.

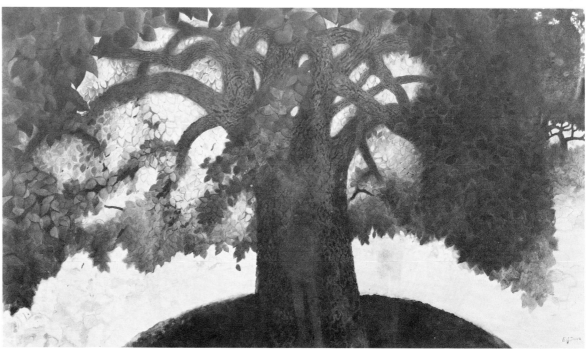

279

280

280. *The Valley.* 1959–61.
Watercolour, 76.2 × 133.4.

281

281. *The White Peacock.*
1959–61. Watercolour,
77.5 × 134.6. Sydney, Art
Gallery of New South
Wales.

282. *A Fair Moving On.*
1961. Watercolour,
76.2 × 133.4. Signed and
dated.

282

283. *The Allotments.*
1962–3. Watercolour,
76.2 × 133.4. Signed.

283

284. *Cherry Trees, Winter.*
1962–3. Watercolour,
78.7 × 133.4.

284

285. *Connemara.* 1962–3.
Watercolour, 73.7 × 134.6.
Signed.

285

286. *The Fountain.* 1962–3.
Watercolour, 78.7 × 133.4.
Signed.

287. *The Gateway.* 1962–3.
Watercolour, 133.4 × 78.7.

288. *The Gossips.* 1962–3.
Watercolour, 76.8 × 66.6.

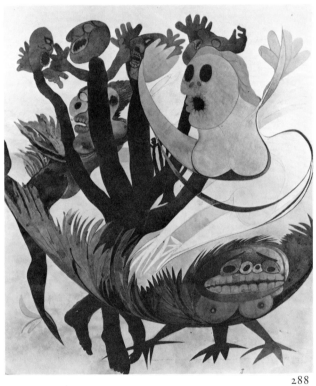

286

287

288

289. *Low Tide near Rye.*
1962–3. Watercolour,
75.5 × 133.3. Signed.

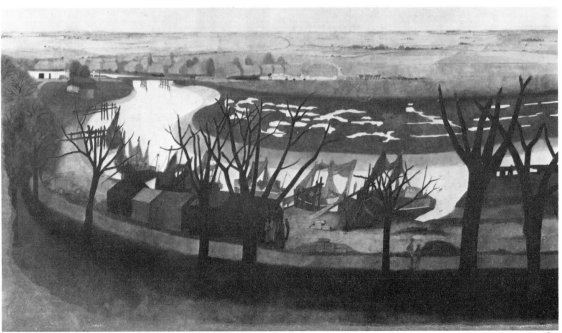

289

290. *Near Winchelsea.*
1962–3. Watercolour,
76.2 × 133.4. Signed.

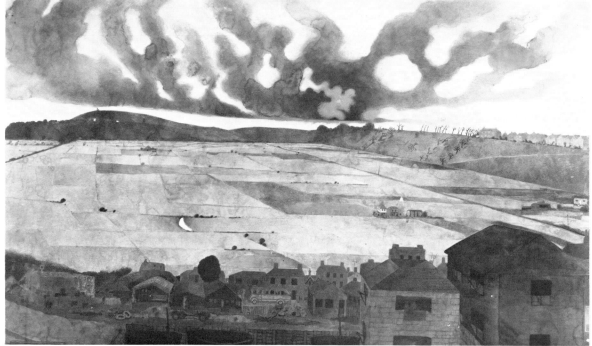

290

291. *River Rother, Early Morning.* 1962–3.
Watercolour heightened with bodycolour,
76.2 × 133.4. Signed.

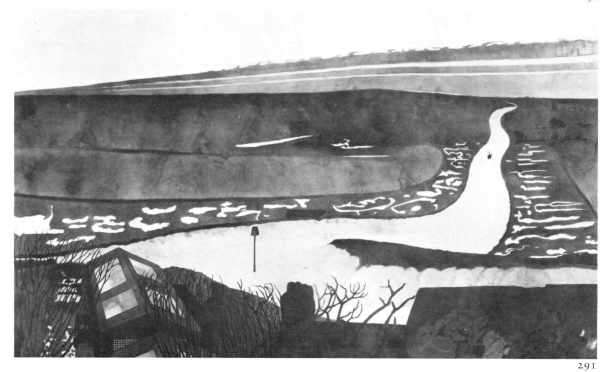

291

292. *Rocks and Seaweed, Galway.* 1962–3.
Watercolour, 76.2 × 133.3.
Signed.

292

293. *The Sphinx*. 1962–3.
Watercolour, 76.2 × 66.
Signed.

293

294

296

297

298

294. *The Tomb*. 1962–3.
Watercolour, 133.4 × 78.7.
Signed.

295. *The Visitors*. 1962–3.
Watercolour, 73.7 × 134.6.
Not illustrated.

296. *The Washerwomen*.
1962–3. Watercolour,
134.6 × 81.3. Signed.

297. *The Yellow Cement
Mixer*. 1962–3.
Watercolour, 134.6 × 81.3.

298. *The Straw Man*. 1963.
Watercolour, 78.8 × 111.8.
Signed and dated.

299

303

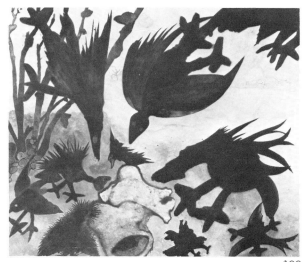

300

299. *The Bar.* 1964–5.
Watercolour, 134.6 × 54.
Signed.

300. *The Birds.* 1964–5.
Watercolour, 67.3 × 80.
Signed.

301. *The Boozer.* 1964–5.
Watercolour, 79.4 × 45.7.
Signed. Not illustrated.

302. *The Campers.* 1964–5.
Watercolour, 80 × 133.4.
Signed.

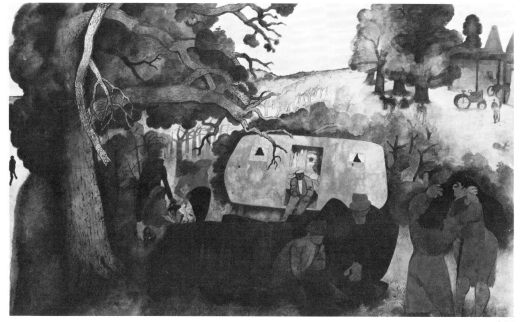

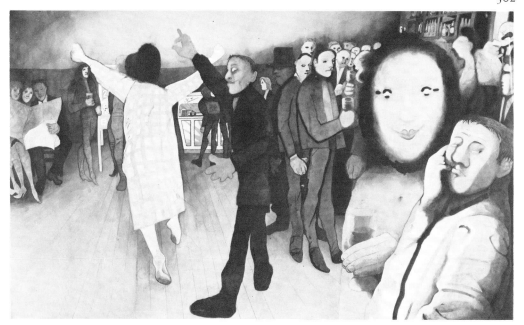

302

305

303. *Crunchy, Crunchy!*
1964–5. Watercolour,
67.3 × 80. Signed.

304. *Flowers.* 1964–5.
Watercolour, 78 × 103.
Signed. Colour plate 22.

305. *The Juke Box.* 1964–5.
Watercolour, 79.4 × 134.6.
Wellington, National Art
Gallery of New Zealand.

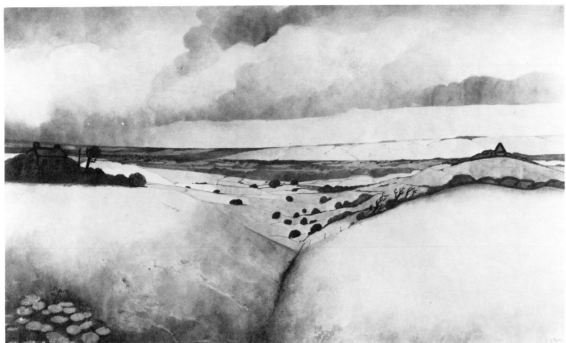

306. *Landscape near Rye.* 1964–5. Watercolour, 80 × 132.1. Signed.

306

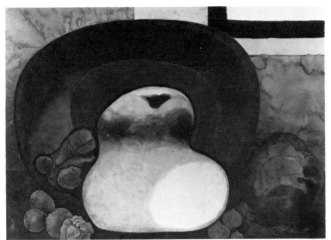

307

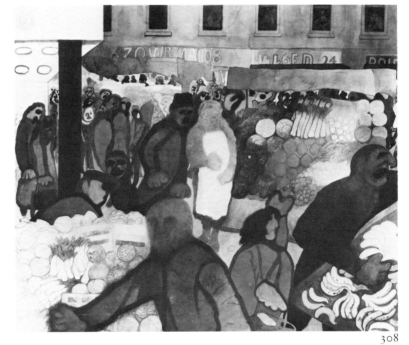

308

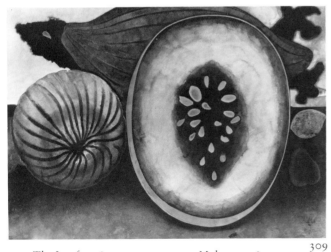

309

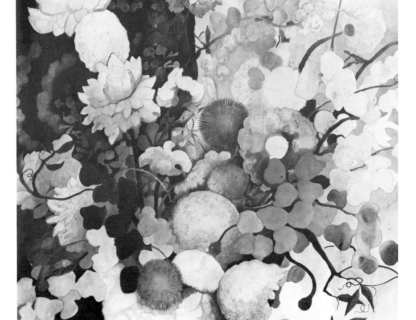

307. *The Loaf.* 1964–5. Watercolour, 57.8 × 78.7.

308. *The Market.* 1964–5. Watercolour, 80 × 95.3. Signed.

309. *Melons.* 1964–5. Watercolour, 57.8 × 78.7. Signed.

310. *Mixed Flowers.* 1964–5. Watercolour, 78.7 × 88.3. Signed.

310

311. *Mixed Flowers.*
1964–5. Watercolour,
134.6 × 80. Signed.

312. *Sea Urchins.* 1964–5.
Watercolour, 45.1 × 66.
Signed.

313. *Still Life.* 1964–5.
Watercolour, 80 × 87.6.

314. *Under the Hill.* 1964–5
Watercolour, 80.6 × 134.6.
Initialled and signed.

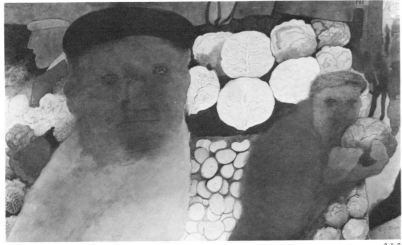

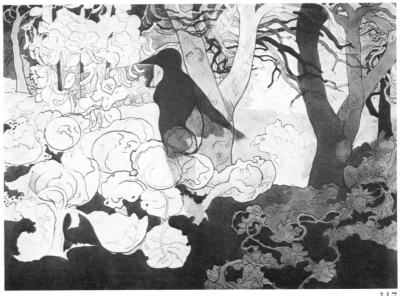

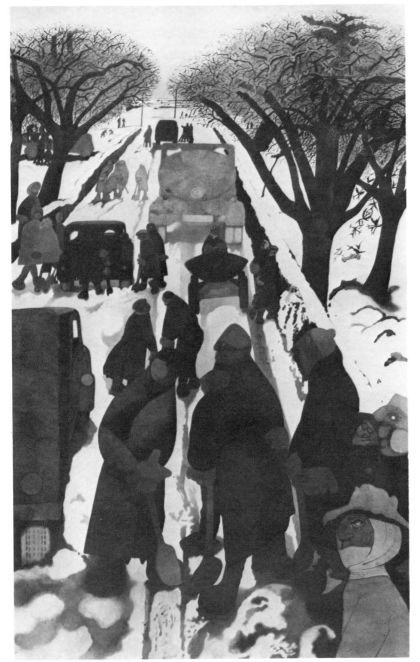

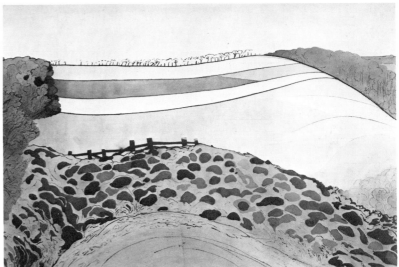

315. *Vegetable Stall*. 1964–5.
Watercolour, 47.6 × 80.
Signed.

316. *Winter*. 1964–5.
Watercolour, 137.2 × 81.2.
Signed, and title inscribed
on the back. London, Arts
Council of Great Britain.

317. *Birdwoman*. 1964. Ink
and wash, 56.5 × 78.1.
Signed and dated. Hove Art
Gallery.

318. *Kentish Fields*. 1965.
Ink and wash, 68.6 × 101.
Signed and dated.

319. *The Pylon*. 1965. Ink
and wash, 68.6 × 101.
Signed and dated.

320

321

322

320. *Romney Marsh.* 1965.
Watercolour, 79.4 × 132.1.
Signed and dated.

321. *After the Market
Closed.* 1965–7.
Watercolour, 132.1 × 78.8.
Signed.

322. *Distant View of
Florence.* 1965–7.
Watercolour, 133.4 × 78.7.

323. *East Anglia.* 1965–7. Watercolour, 79.4 × 132.1. Signed.

323

324. *English Country Lane.* 1965–7. Watercolour, 80.6 × 132.1. Signed.

324

325. *English Countryside.* 1965–7. Watercolour, 79.4 × 132.1.

325

326. *Flowers*. 1965–7.
Watercolour, 101.6 × 68.6.
Signed.

327. *Flowers in a Vase*.
1965–7. Ink and wash,
54.6 × 31.8. Signed.

328. *Fruit and Flowers*.
1965–7. Ink and wash,
45.1 × 80. Signed.

329. *The Grotto*. 1965–7.
Watercolour, 78.7 × 133.4.
Signed.

330. *Honesty*. 1965–7. Ink
and wash, 102.2 × 69.3.
Signed.

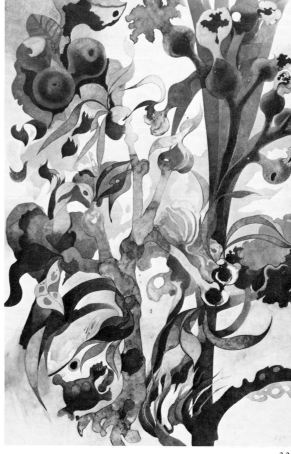

326

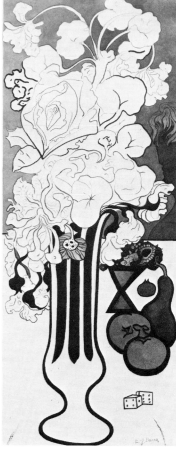

327

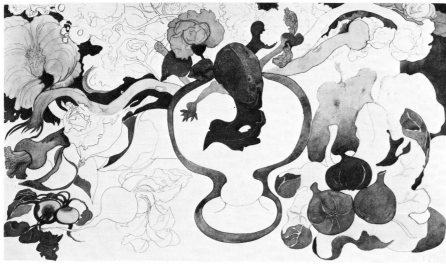

328

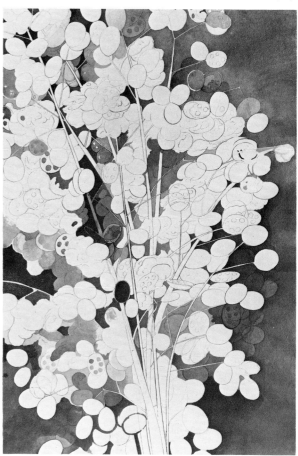

330

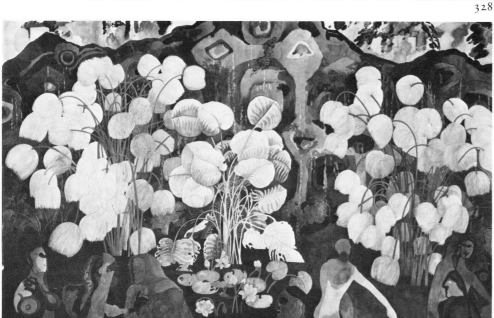

329

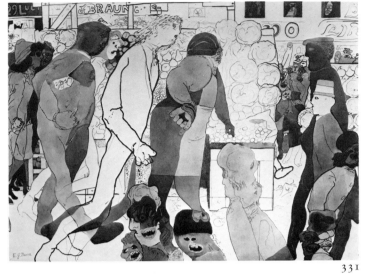

331

332

333

334

335

331. *The Market.* 1965–7.
Ink and wash, 57.8 × 78.7.
Signed.

332. *Marrows.* 1965–7. Ink
and wash, 57.2 × 76.9.
Signed.

333. *Marrows in a
Window.* 1965–7. Ink and
wash, 57.2 × 78.1.

334. *Pears.* 1965–7. Ink,
crayon and wash,
57.8 × 78.7. Signed.

335. *Peppers.* 1965–7. Ink
and wash, 68.6 × 101.6.
Signed.

336. *The Tunnel.* 1965–7.
Watercolour, 79.4 × 132.1.
Signed.

337. *View at Florence.*
1965–7. Watercolour,
79.4 × 132.1. Signed.
Colour plate 31.

338. *Wild Flowers.* 1965–7.
Watercolour, 68.6 × 101.6.
Not illustrated.

336

339. *Yorkshire Landscape.*
1965–7. Watercolour,
78.8 × 133.3. Signed.

339

340. *Zona Industriale.*
1965–7. Watercolour,
78.7 × 133.4.

340

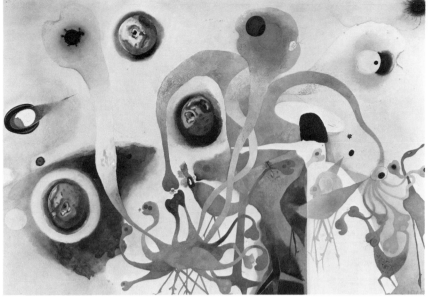

341

342

343

344

341. *Head Hunting*. 1968.
Watercolour, 78.7 × 132.1.
Signed.

342. *Approaching Storm*.
1968–9. Watercolour,
132.1 × 78.7. Signed.

343. *Eyes*. 1968–9.
Watercolour, 78.7 × 133.1.

344. *Frozen Landscape*.
1968–9. Watercolour,
78.7 × 133.3. Signed.

345. *Kent Landscape.*
1968–9. Watercolour,
78.7 × 140.

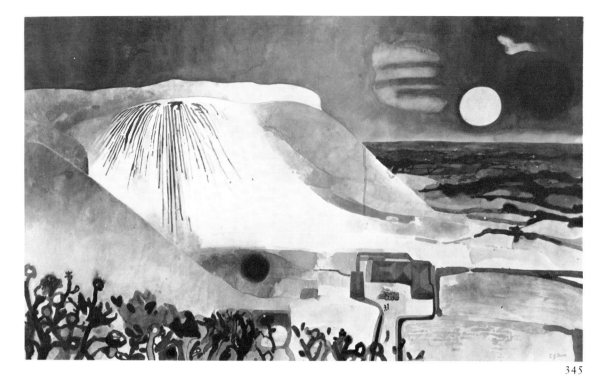

345

346. *Machines Quarrelling.*
1968–9. Watercolour,
78.7 × 133.1. Signed.

347. *Miss Tiny Feet.* 1968–9.
Watercolour heightened
with bodycolour,
133.1 × 78.7. Signed.

348. *Picking a Quarrel.*
1968–9. Watercolour,
78.7 × 133.1.

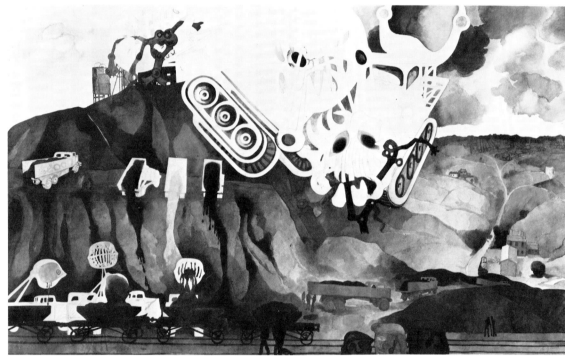

346

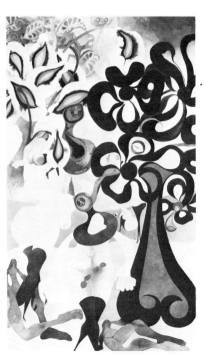

347

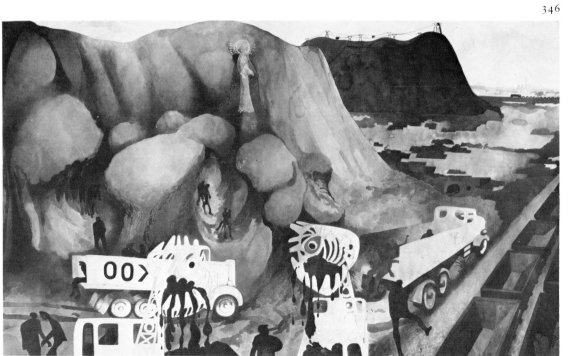

348

349

350

349. *Red Flowers*. 1968–9.
Watercolour, 102.9 × 68.6.
Signed.

350. *Salome, Herod,
Herodias and the Head of
St John the Baptist*. 1968–9.
Watercolour, 78.7 × 83.9.
Signed.

351

351. *Sheep in a Landscape*.
1968–9. Watercolour,
80 × 133.1. Signed.

352. *Storm Clouds over
Romney Marsh*. 1968–9.
Watercolour, 78.7 × 133.1.
Not illustrated.

353

353. *Weald of Kent*.
1968–9. Watercolour,
78.7 × 133.1. Signed.

354

355

356

358

354. *Wye Valley No. 1.*
1968–9. Watercolour,
79.4 × 132.7. Signed.

355. *Wye Valley No. 2.*
1968–9. Watercolour,
133.1 × 79.4. Signed.

356. *A View of Rochester.*
1969. Watercolour,
78.7 × 133.4. Signed.

357. *Black Mountain.*
1970. Watercolour,
78.7 × 132.1. Signed and
dated. Rye Art Gallery.
Colour plate 26.

358. *Cornish Clay Mines.*
1970. Watercolour,
78.7 × 133.4. Signed.

359. *An English Country Scene No. 1.* 1970. Watercolour, 78.7 × 133.4. Signed.

360. *An English Country Scene No. 2.* 1970. Watercolour, 78.7 × 133.4. Colour Plate 29.

359

361. *The Old Viaduct.* 1970. Watercolour, 78.7 × 133.4. Signed.

361

362. *A Quarry near Buxton.* 1970. Watercolour, 78.7 × 133.4. Signed.

362

363

365

366

363. *Rhododendron.* 1970.
Watercolour, 133.4 × 78.7.
Signed.

364. *A View at Cornwall.*
1970. Watercolour,
78.7 × 133.4. Signed. Not
illustrated.

365. *Cows.* 1970–1.
Watercolour, 78.7 × 133.4.
Signed.

366. *Crab Cocktail.* 1970–1.
Watercolour, 78.7 × 133.4.
Signed.

367. *Giant Cabbages.*
1970–1. Watercolour,
78.7 × 133.4. Signed.

368. *Heads.* 1970–1.
Watercolour, 77.5 × 56.5.
Signed.

367

368

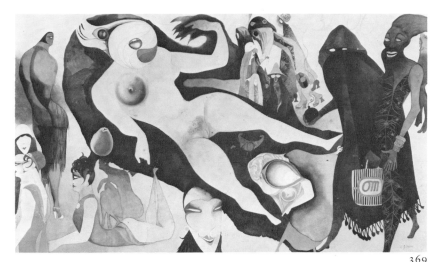

369

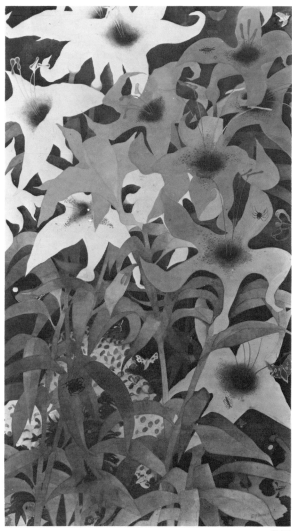

370

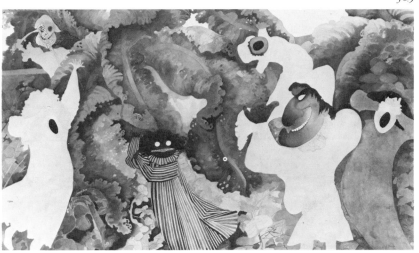

371

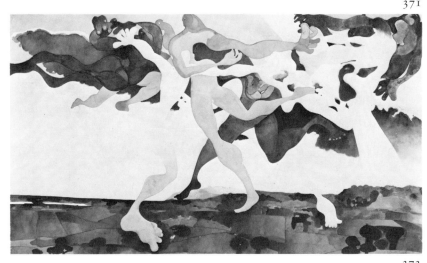

372

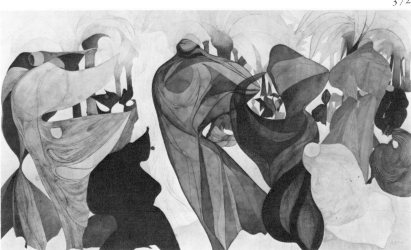

373

369. *In'cubi and Succ'ubi.*
1970–1. Watercolour,
78.7 × 133.4. Signed.

370. *Lilies.* 1970–1.
Watercolour, 133.4 × 78.7.
Signed.

371. *Punch Hitting Topsy
over the Head with a Baby.*
1970–1. Watercolour,
78.7 × 133.4. Signed.

372. *Thunderstorm.*
1970–1. Watercolour,
78.7 × 133.4. Signed.

373. *Whirling Dervishes.*
1970–1. Watercolour,
78.7 × 133.4. Signed.

374. *Ebbw Vale.* 1971.
Watercolour, 78.7 × 133.4.
Signed.

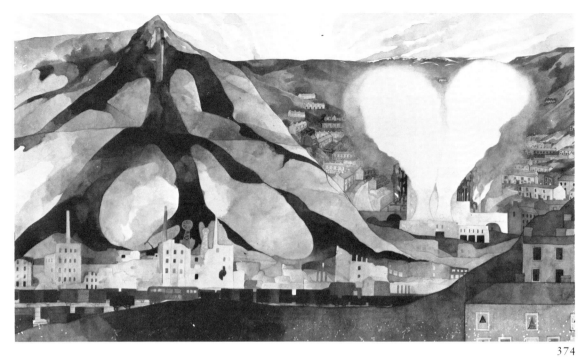

374

375. *Newport.* 1971.
Watercolour, 78.7 × 133.4.
Signed.

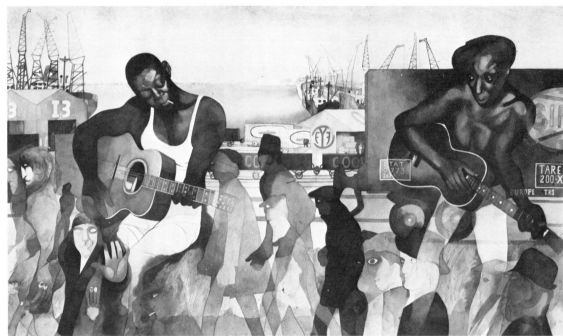

376. *Pen-y-Ghent.* 1971.
Watercolour, 63.5 × 96.5.
Signed.

377. *Pen-y-Ghent with
Black Sheep.* 1971.
Watercolour, 67.3 × 101.6.

375

376

377

378

378. *Slate Quarry, Snowdonia.* 1971. Watercolour, 78.7 × 133.4. Signed.

379. *Snowdonia No. 1.* 1971. Watercolour, 78.7 × 133.4. Signed. Colour plate 27.

380

380. *Snowdonia No. 2.* 1971. Watercolour, 79.7 × 133.4. Signed.

381. *The Hole of Harcum, Lockton Moor.* 1972. Watercolour, 63.5 × 96.5. Colour Plate 24.

382

382. *Kilnsey Crag, with Pub.* 1972. Watercolour, 63.5 × 96.5. Signed.

383. *Motorway.* 1972.
Watercolour, 78.7 × 133.4.
Signed.

383

384. *Motorway.* 1972.
Watercolour, 78.7 × 135.9.
Signed.

384

385. *Near Whitby,
Yorkshire.* 1972.
Watercolour, heightened
with bodycolour,
78.7 × 133.4. A smaller
version also exists.

386. *Sugar Beet, East
Anglia.* 1972. Watercolour,
78.7 × 133.4. Signed.
Colour plate 28.

385

388

387

387. *Valley and River,
Northumberland*. 1972.
Watercolour, 100.3 × 67.9.
Signed. London, Tate
Gallery.

388. *Valley, Yorkshire*.
1972. Watercolour,
78.7 × 133.4. Signed.

389. *Wharfedale,
Yorkshire*. 1972.
Watercolour, 67.3 × 101.6.
Signed.

390. *Industrial Landscape*.
1973. Watercolour,
67.3 × 100.3.

389

390

391. *In the Lake District
No. 1*. 1973. Watercolour,
80 × 135.9.

391

392. *In the Lake District
No. 2*. 1973. Watercolour,
80 × 135.9.

392

393. *Landscape*. 1973–4.
Watercolour, 76 × 135.9.

393

394

394. *Dartmoor*. 1974.
Watercolour, 78.1 × 135.9.

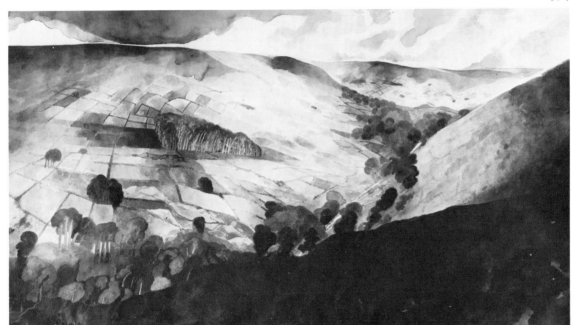

395

395. *Landscape, Dartmoor*.
1974. Watercolour,
78.1 × 135.9.

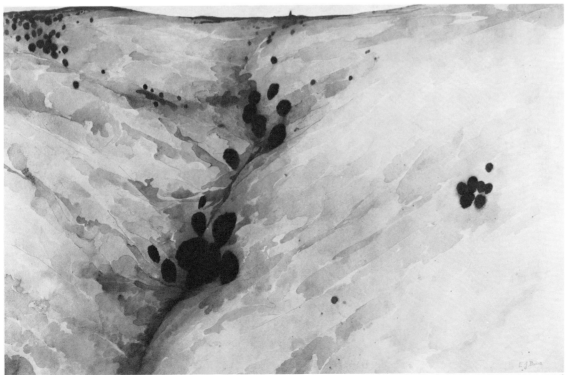

396

396. *The Valley*. 1974.
Watercolour, 67.3 × 100.3.
Signed.

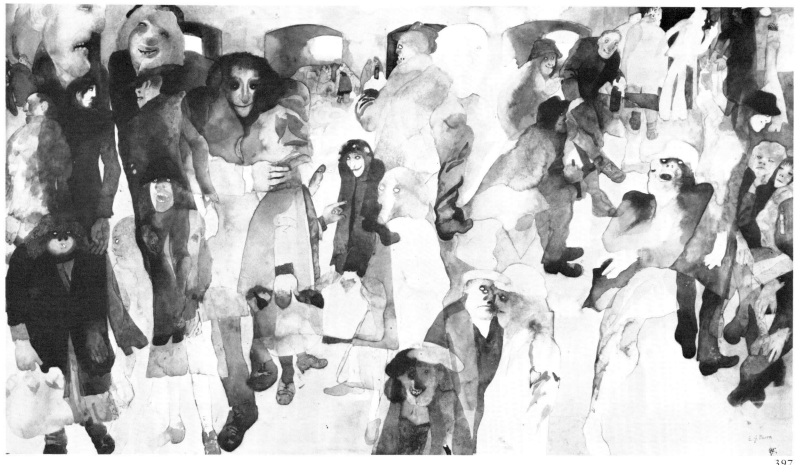

397

397. *Figure Composition
No. 1.* 1974–5.
Watercolour, 78.1 × 135.9.
Signed.

398. *Figure Composition
No. 2.* 1974–5.
Watercolour, 78.1 × 135.9.
Signed. Colour plate 32.

399. *Flowers and Trees.*
1974–5. Watercolour,
137.2 × 78.7. Signed.

400. *The Forth Bridge.*
1974–5. Watercolour,
137.2 × 78.7. Signed.

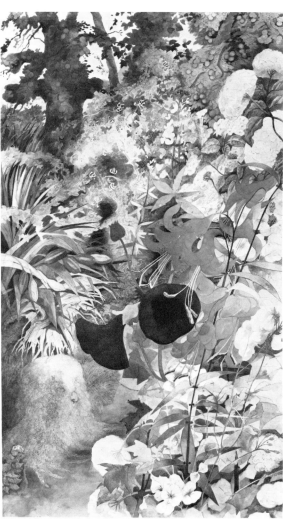

399

400

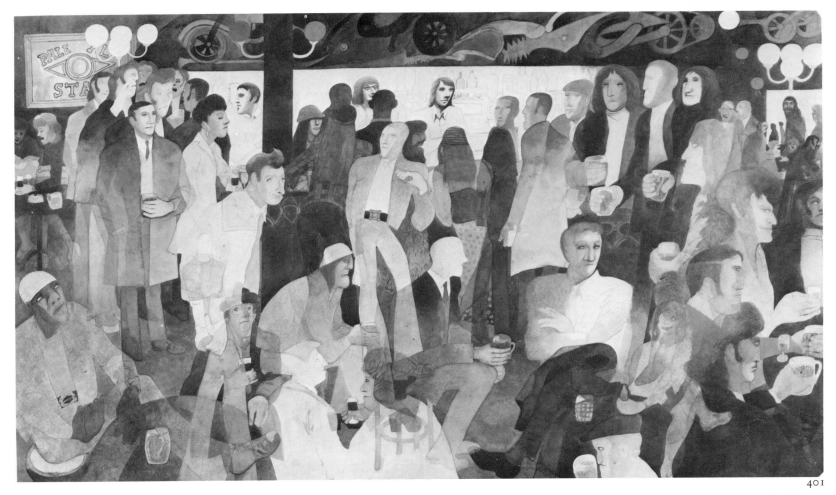

401

402

401. *A Sunday Morning at
the Agricultural Arms,
Islington*. 1974–5.
Watercolour, 78.1 × 135.9.

402. *Sussex Landscape*.
1974–5. Watercolour,
78.1 × 135.9. Signed.

403. *The Tunnel*. 1974–5.
Watercolour, 135.9 × 78.1.
Signed.

403

404. *Cornish Landscape near Zennor.* 1975. Watercolour, 78.1 × 135.9.

404

405. *Harbour, Falmouth.* 1975. Watercolour, 78.1 × 135.9. Signed.

406. *Landscape, Cornwall, with Figures and Tin Mine.* 1975. Watercolour, 78.1 × 135.9. Signed. Colour plate 30.

405

407. *Seeds.* 1975. Watercolour, 78.1 × 135.9. Signed.

407

408

409

408. *A View at Cornwall.*
1975. Watercolour,
78.1 × 135.9. Signed.

409. *Flowers in a
Landscape.* 1975–6.
Watercolour, 78.1 × 135.9.
Signed.

410. *Harvest Festival.*
1975–6. Watercolour,
135.9 × 78.1.

410

411. *Sussex Landscape No. 1.*
1976. Watercolour,
78.1 × 135.9.

411

412. *Sussex Landscape No. 2.*
1976. Watercolour,
78.1 × 135.9.

412

413. *Unfinished Landscape.*
1976. Watercolour,
78.1 × 135.9. Signed.

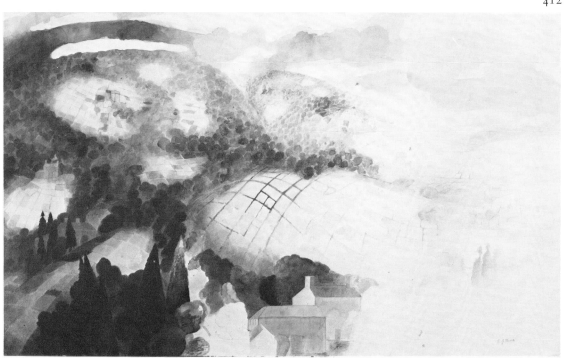

413

Drawings

1

2

3

4

5

6

1. *Betsy Seated*. 1922.
Pencil, 38.1 × 12.7. Signed
and dated 15 May 1922.

2. *Self-Portrait*. 1922.
Pencil, 21.6 × 15. Signed
and dated.

3. *Clothed Female Model*.
1923. Pencil, 55.9 × 38.1.
Signed and dated.

4. *Crowd*. 1923. Pencil,
14 × 21.6.

5. *Female Model*. 1923.
Pencil, 55.9 × 38.1. Signed
and dated.

6. *Male Model*. 1923.
Pencil, 55.9 × 38.1 Signed
and dated.

7

8

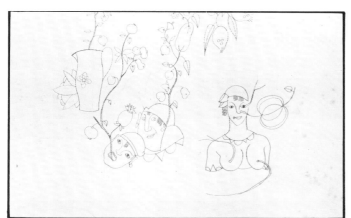

9

10

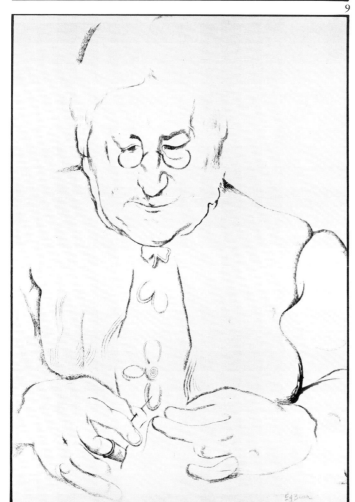

11

12

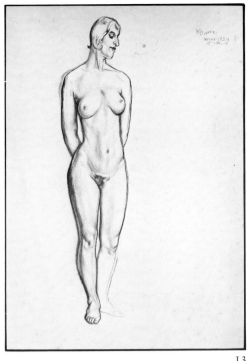

13

14

15

16

17

18

7. *Seated Female Model.*
1923. Pencil, 38.1 × 27.9.
Signed and dated December
1923.

8. *Tarts.* 1923. Pencil,
38.1 × 27.9. Signed.

9. *Girls with Flowers and
Fruit. c.* 1923. Pencil,
20.3 × 34.5.

10. *The Picnic. c.* 1923.
Wash, 35.2 × 38.1.

11. *Nana Sewing.*
1924. Purple and sepia ink,
55 × 38. Signed and dated
March 1924.

12. *The Artist's
Grandmother with a
Jigsaw.* 1924. Purple and
sepia ink, 33.5 × 28. Signed
and dated.

13. *Nude Female Model.*
1924. Ink and chalk,
38.1 × 28. Signed and dated
March 1924.

14. *Betsy with a Cherry
Twig. c.* 1925. Pencil,
55 × 37. Signed.

15. *Man in a Hat. c.* 1925.
Pencil, 55 × 37.5. Signed.

16. *William Chappell.
c.* 1925. Pencil,
50.8 × 42.7.

17. *Drawing Room at
Springfield.* 1925–6. Ink,
55.9 × 38.1. Signed.

18. *Girl and Sailor
Dancing.* 1925–6. Ink and
wash, 38.1 × 17.1. Signed.

19. *Night Club*. 1925–6.
Ink, 38.1 × 27.9. Signed.

20. *Mantelpiece at
Springfield*. *c.* 1927. Ink,
50.8 × 39.8.

19

20

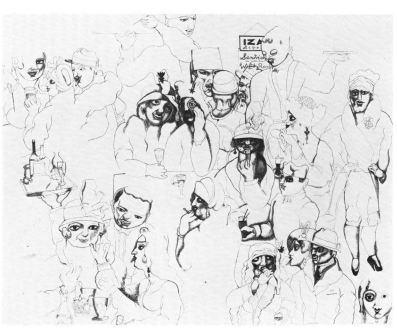

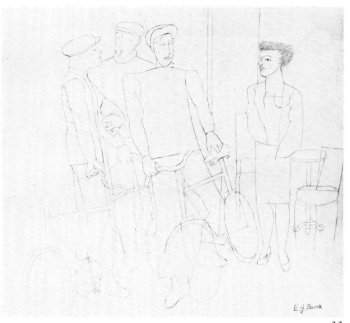

21

22

21. *The Café*. *c.* 1927. Ink,
38.1 × 47.6. Signed.

22. *The Cyclists*. *c.* 1927.
Pencil, 50.2 × 60.2.

23. *The Café*. 1928. Ink,
55.9 × 38.1. Signed and
dated '1928?'.

24. *Havana*. 1928. Ink,
54.6 × 39.5. Signed and
dated '1928?'.

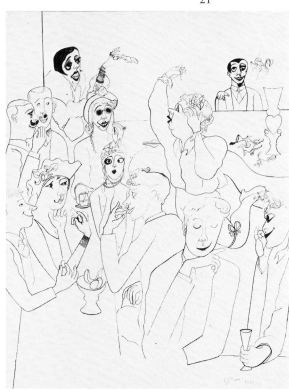

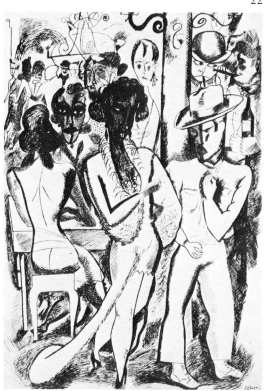

23

24

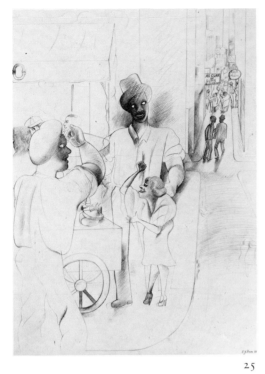

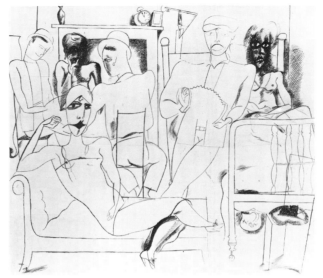

25

26

25. *Ice Cream Stall.* 1928.
Pencil, 73.7 × 53.3. Signed
and dated.

26. *Bedsitting Room.*
1928–9. Ink, 45.7 × 54.6.
Signed.

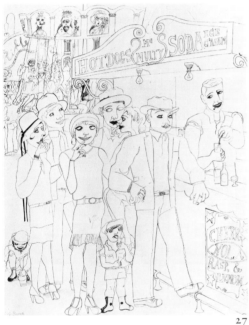

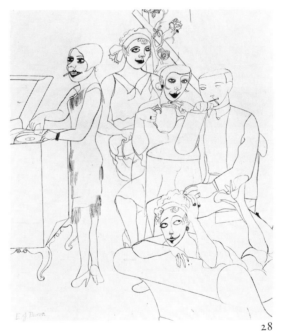

27

28

27. *Funfair.* 1928–9. Ink,
60.3 × 48.3. Signed.

28. *Jazz Fans.* 1928–9. Ink,
43.7 × 36.8. Signed.

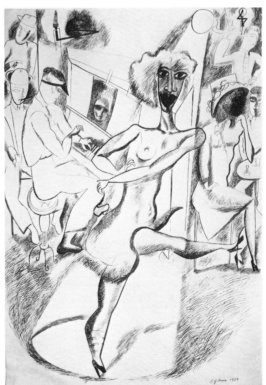

29

30

29. *Les Boys.* 1928–9. Ink,
55.9 × 38.1.

30. *Honky Tonk Girl.*
1929. Ink, 55.6 × 38.1.
Signed and dated.

31. *The Rye Tea Party.*
1929. Ink, 43.5 × 40.
Signed and dated.

32. *Actors.* 1929–30.
Pencil, 55.9 × 38.1.

31

32

33. *Catastrophe.* 1929–30.
Ink, 49.5 × 38.7. Signed.

34. *Dance Hall.* 1929–30.
Ink, 54.6 × 43.2. Signed.

33

34

35. *Dancing Girls in Top
Hats.* 1929–30. Ink,
55.9 × 36.9.

36. *Dandies.* 1929–30. Ink,
33 × 25.4.

35

36

37. *Fantasy Scene*, 1929–30. Pencil, 60.5 × 38.1.

38. *Woman in a Split Skirt*. 1929–30. Pencil, 37.7 × 25.5. Signed.

37

38

39. *Early Night*. 1930. Ink, 49 × 38. Signed and dated.

40. *Sailor Licking Ice Cream on the Quay at Marseilles*. 1930? Ink, 29 × 20.4. Signed.

39

40

41. *Acrobats* (detail). 1930–1. Pencil, 26.6 × 19.8.

42. *Chandelier and Candles*. 1930–1. Pencil, 74.9 × 50.8.

41

42

43. *Chronique Parissien*.
1930–1. Five sketches from
a letter to a friend. Each:
purple ink, 17.8 × 12.7.

43a

43b

43c

43d

43e

44 (recto)

44 (verso)

45

46 (recto)

44. *Coffee Stall* (recto).
1930–1. Pencil,
50.8 × 74.9. *Actors* (verso).
Pencil. Tate Gallery.

45. *Fish Bar*. 1930–1.
Pencil, 56.1 × 38.3.

46. *Jazz Fans* (recto). 1930–1.
Pencil, 61.2 × 46. *Invalid
Chair and Pram* (verso).
Pencil. Graves Art Gallery,
Sheffield.

47. *Men and Women in a
Bar*. 1930–1. Pencil,
60.5 × 38.1.

46 (verso)

47

48. *Nymphs.* 1930–1.
Pencil, 56.1 × 38.3. Signed.

49. *The Party.* 1930–1. Ink,
54.6 × 43.2. Signed.

48

49

50. *The Party* (recto).
1930–1. Pencil and
watercolour, 59.5 × 47.0.
Flowers in a Vase (verso).
Ink.

50 (recto)

50 (verso)

51. *Poster Design for the
London Passenger
Transport Board.* 1930–1.
Ink and watercolour,
50.8 × 35.6.
London, Tate Gallery
Archive.

52. *Roman Holiday.*
1930–1. Pencil, 75 × 55.

GO THERE BY
UNDERGROUND
PICCADILLY LINE

51

52

53. *The Singer.* 1930–1.
Ink, 56.5 × 43.3.

54. *Snack Bar.* 1930–1.
Pencil, 74.9 × 50.8.

53

54

55. *Street Scene.* 1930–1.
Pencil, 60.3 × 50.2. Signed.

56. *Interior.* 1930–1. Pencil
and gouache, 75.5 × 55.5.

55

56

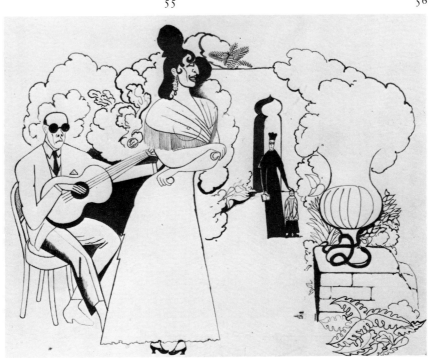

57. *Concerning the
Eccentricities of Cardinal
Pirelli.* c. 1931–2.
Illustration to the novel by
Ronald Firbank. Ink,
36.7 × 33.6.

57

58a

58. Six sheets from a
sketchbook. *c.* 1931–4.
Each: pencil, 12.7 × 17.8 or
v.v. London, Tate Gallery
Archive.

58b

58c

58d

58e

58f

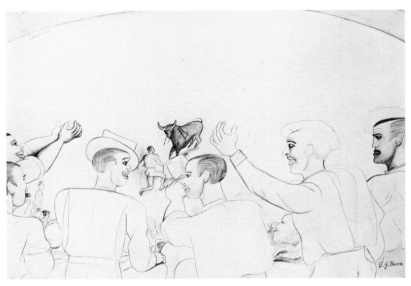

59

60

59. *The Bullring.* 1933.
Pencil, 46.4 × 67.3. Signed.

60. *Broken Bottles. c.* 1933.
Pencil, 38.1 × 60.5.

61. *Composition.* 1933–4.
Ink, 51.4 × 39.4. Signed.

62. *Composition.* 1933–4.
Pencil, 78.7 × 57.2.

61

62

63. *Dance Hall.* 1934.
Pencil, 55.9 × 38.1. Signed.

64. *Figures on a Pavement.*
1934. Pencil and gouache,
63 × 45.8.

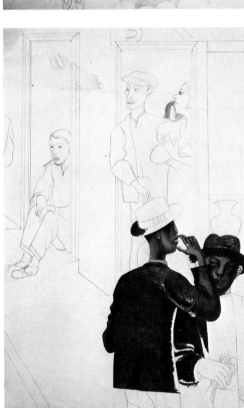

63

64

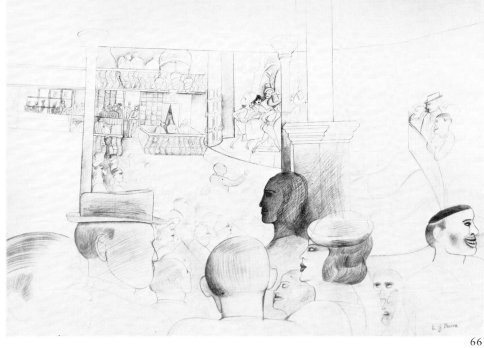

65

66

65. *Music Hall.* 1934.
Pencil, 67.5 × 46.

66. *Musical Comedy,*
Barcelona. 1935? Pencil,
57.2 × 77.5. Signed.

67. *Street Scene.* 1935?
Pencil, 60.3 × 48.3.

68. *The Tenement.* 1935?
Pencil, 60.3 × 48.3. Signed.

67

68

69. *Seamen Ashore,*
Greenock. 1944? Pastel,
76.2 × 54.6.

69

38a

50a

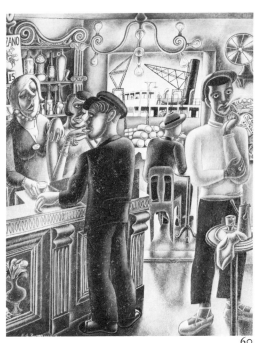

60

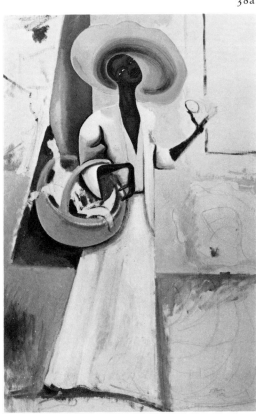

90b

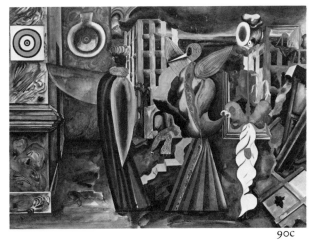

90c

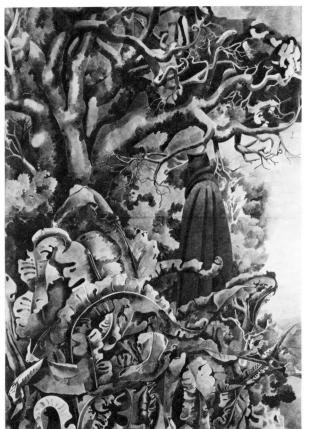

140

List of Exhibitions

Unless otherwise stated the location of exhibitions is London, and, in the case of one-man shows, the exhibits were recent paintings. The month is that in which the exhibition opened.

One-Man Exhibitions

1929, April. Leicester Galleries.
1932, May. Leicester Galleries.
1937, May. Springfield Museum of Art, Massachusetts.
1942, November. Redfern Gallery (partly retrospective).
1947, July. Leicester Galleries.
1949, July. Leicester Galleries.
1952, March. Lefevre Gallery.
1955, January. Magdalene Sothmann Gallery, Amsterdam (retrospective).
1955, April. Lefevre Gallery.
1955, April. Swetzoff Gallery, Boston.
1956, October. Museum of Art, Rhode Island School of Design, Providence.
1957, May. Lefevre Gallery.
1959, May. Lefevre Gallery.
1961, July. Lefevre Gallery.
1963, April. Lefevre Gallery.
1965, May. Lefevre Gallery.
1967, May. Lefevre Gallery.
1969, April. Lefevre Gallery.
1969, October. Lefevre Gallery (drawings).
1971, April. Lefevre Gallery.
1971, July. Treadwell Gallery (woodcuts 1928–9).
1971, October. Lefevre Gallery ('The Early Years').
1971, October. Hamet Gallery (drawings of the 1920s and 1930s).
1973, May. Tate Gallery (retrospective of 143 works).
1973, May. Lefevre Gallery.
1975, May. Lefevre Gallery.
1977, May. Lefevre Gallery (memorial retrospective exhibition).
1977, October. Towner Art Gallery, Eastbourne, Mappin Art Gallery, Sheffield and Sunderland Public Library (retrospective).
1980, March. Lefevre Gallery (mainly paintings done in America in 1955).
1980, April. Anthony d'Offay (early works).
1982, April. Lefevre Gallery (paintings 1975–6).

Group Exhibitions

1927, December. New English Art Club.
1929, October. London Group.
1931, October. Recent Developments in British Painting, Arthur Tooth.
1934, April. Unit One, Mayor Gallery and provincial tour.
1936, June. International Surrealist Exhibition, New Burlington Galleries.
1936, December. Fantastic Art, Dada, Surrealism, Museum of Modern Art, New York.
1938, January. Exposition Internationale du Surréalisme, Galerie des Beaux-Arts, Paris.
1939, July. British Painters. New York World's Fair and North American tour.
1940, June. Surrealism Today. Zwemmer Gallery.
1959, November. Three Contemporary English Artists (with Derrick Greaves and Hubert Dalwood), Whitworth Art Gallery, Manchester University.
1978, January. Dada and Surrealism Reviewed, Hayward Gallery.
1982, February. A Sense of Place: Edward Burra and Paul Nash, Grey Art Gallery, New York University.

Bibliography

The most useful sources of information about Burra are John Rothenstein's book (1945) in the Penguin Modern Painters series; the catalogue of the Tate Gallery retrospective exhibition (1973), with an introduction by John Rothenstein and a group of Burra's letters to his friends; and *Edward Burra. A Painter Remembered by his Friends*, edited by William Chappell (1982).

1929 Reviews of the Leicester Galleries exhibition in *Vogue* (April), and by R. H. Wilenski in *Britannia* (5 April).

1931 Paul Nash, 'The Painter and the Stage', *The Listener* (23 December).

1932 Reviews of the Leicester Galleries exhibition in *The Times* (31 May), by John Armstrong in *The Week-end Review* (4 June), in the *New Statesman* (18 June), and by P. G. Konody in *The Observer* (5 June).

1932 Paul Nash, 'Photography and Modern Art', *The Listener*, (27 July).

1934 Douglas Cooper in *Unit One*. Cassells.

1934 Review of Unit One exhibition by Osbert Lancaster in *Architectural Review* (July).

1937 *Springfield Museum of Art Bulletin* vol. 3 no. 8 (May).

1937 Review of Springfield Museum of Art exhibition in *Art News* (May).

1942 Reviews of Redfern Gallery exhibition by Osbert Lancaster in *The Observer* (29 November), *The Times* (3 December), by R. H. Wilenski in *The Listener* (3 December) and by John Piper in *The Spectator* (4 December).

1945 John Rothenstein, *Edward Burra*. Penguin Modern Painters.

1947 John Davenport, 'Burra Burra land', *Lilliput* (November).

1947 Robin Ironside, *Painting since 1939*. Longmans.

1949 Dorothy Crossley (pseudonym of Richard Buckle), 'Theatre Designs of Edward Burra', *Ballet and Opera* (January).

1949 Review of Leicester Galleries exhibition by Wyndham Lewis in *The Listener* (9 June).

1950 *Museum of Modern Art Bulletin* no. 17, 2–3.

1952 Reviews of Lefevre Gallery exhibition in *The Times* (14 March) and by Nevile Wallis in *The Observer* (16 March).

1952 Conrad Aiken, *Ushant*. Duell, Sloan and Pearce.

1955 Reviews of Lefevre Gallery exhibition by Eric Newton in *Time and Tide* (16 April), in *The Times* (11 May) and by Robert Melville in *Architectural Review* (July).

1955 Reviews of Swetzoff exhibition by James Mellow in *Art Digest* (15 May), by Robert Taylor in the *Boston Herald* (22 May) and in *Time* (May).

1957 Reviews of Lefevre Gallery exhibition in *The Times* (8 May), and by David Sylvester in the *New Statesman* (26 May).

1957 Colin Ballantyne, 'The Birds', *National Gallery of South Australia Bulletin*, vol. 18 no. 3 (January).

1958 *National Gallery of South Australia Bulletin* vol. 21 no. 1 (July).

1959 Review of Lefevre Gallery exhibition by Robert Melville in *Architectural Review* (August).

1961 Review of Lefevre Gallery exhibition in *The Times* (13 July).

1963 Review of Lefevre exhibitions by Keith Roberts in *Burlington Magazine* (February and May).

1964 *Tate Gallery Catalogues. The Modern British Paintings, Vol. 1. A-L.*

1965 Review of Lefevre Gallery exhibition in *The Times* (11 May).

1965 Bryan Robertson and Robert Melville, intro, *The English Eye*, Marlborough-Gerson, New York (November).

1967 Reviews of Lefevre Gallery exhibition in *The Times* (21 April) and by Robert Melville in *Architectural Review* (July).

1969 Review of Lefevre Gallery exhibition by Bryan Robertson in *The Spectator* (18 April).

1971 Barrie Penrose 'Edward Burra' in 'The Grand Recluses', *Observer Colour Supplement* (15 February).

1971 Barrie Penrose, 'The Nude at my Feet' and John Rothenstein, 'Burra's Macabre Humour' in *Observer Colour Supplement* (15 July).

1971 Reviews of Lefevre Gallery exhibition by Christopher Neve in *Country Life* (7 October) and Robert Melville in *New Statesman* (15 October).

1972 *The Tate Gallery 1970–72.*

1973 John Rothenstein, introduction to Tate Gallery

retrospective exhibition catalogue.

1973 Reviews of Tate Gallery exhibition by Caroline Tisdall in *The Guardian* (23 May), Paul Overy in *The Times* (23 May), Richard Cork in the *Evening Standard* (24 May), Peter Campbell in *The Listener* (31 May), William Feaver in *Vogue* (May), Keith Roberts in the *Burlington Magazine* (July), Janet Hobhouse in *Studio International* (July-August), Robert Melville in *Architectural Review* (September).

1973 Janet Watts, interview with the artist, *Guardian* (25 May).

1975 Ian Jeffrey and David Mellor, 'Style and Ideology in British Art and Photography 1900–1940', *Studio International* (July–August).

1976 Obituary, *The Times* (26 October).

1977 George Melly, intro, Lefevre Gallery Memorial exhibition.

1978 Joseph Killorin, editor, *Selected Letters of Conrad Aiken*. Yale University Press.

1978 John Rothenstein, 'Edward Burra', *Unit One* exhibition, Portsmouth Art Gallery.

1980 William Chappell, intro, Anthony d'Offay Gallery exhibition.

1980 Bryan Robertson, intro, Lefevre Gallery exhibition.

1980 Review of Lefevre and d'Offay exhibitions by John McEwen, *Sunday Times Colour Supplement* (30 March).

1981 *Tate Gallery Illustrated Catalogue of Acquisitions 1978–80.*

1981 Charles Harrison, *English Art and Modernism*. Allen Lane.

1982 William Chappell, editor, *Edward Burra. A Painter Remembered by his Friends* (André Deutsch with the Lefevre Gallery). Foreword by George Melly and contributions from William Chappell, Anne Ritchie, John Rothenstein, John Aiken, John Banting, Frederick Ashton, Ninette de Valois, Barbara Ker-Seymer, Clover de Pertinez and Mary Aiken.

1982 Bryan Robertson, intro, New York University exhibition.

List of Paintings in Public Collections

UNITED KINGDOM

Bedford, Cecil Higgins Art Gallery, 109, 180.
Belfast, Ulster Museum, 183.
Bury Art Gallery, 102.
Dundee Art Gallery, 119.
Eastbourne, Towner Art Gallery, 161.
Edinburgh, Scottish National Gallery of Modern Art, 137, 234.
Gloucester Art Gallery, 111.
Hove Art Gallery, 170, 317.
Huddersfield Art Gallery, 198.
Leeds City Art Gallery, 69, 86.
London, Arts Council of Great Britain, 158, 316.
London, British Council, 99, 104.
London, British Museum, 217.
London, Imperial War Museum, 174.
London, Tate Gallery, 63, 68, 107, 108, 146, 156, 157, 231, 387.
London, Victoria and Albert Museum, 1, 100, 181.

University of Manchester, Whitworth Art Gallery, 72, 189.
Nottingham, Castle Museum, 77.
Portsmouth Art Gallery, 91.
Rye Art Gallery, 357.
Southampton Art Gallery, 57.
York City Art Gallery, 235.

ABROAD

Adelaide, National Art Gallery of South Australia, 129, 203.
Fredericton, New Brunswick, Beaverbrook Art Gallery, 208, 250.
Melbourne, National Gallery of Victoria, 162.
New York, Museum of Modern Art, 132.
Ottawa, National Gallery of Canada, 65.
Sydney, Art Gallery of New South Wales, 154, 281.
Wellington, National Art Gallery of New Zealand, 305.

Index